Carmen Argote

James Benning

Diedrick Brackens

Carolina Caycedo

Neha Choksi

Beatriz Cortez

Mercedes Dorame

Celeste Dupuy-Spencer

Aaron Fowler

Nikita Gale

Jade Gordon & Megan Whitmarsh

Lauren Halsey

EJ Hill

Naotaka Hiro

John Houck

Luchita Hurtado

Gelare Khoshgozaran

Candice Lin

Charles Long

Nancy Lupo

Daniel Joseph Martinez

MPA

Alison O'Daniel

Eamon Ore-Giron

taisha paggett

Christina Quarles

Michael Queenland

Patrick Staff

Linda Stark

Flora Wiegmann

Suné Woods

Rosha Yaghmai

MADE IN L.A. 2018

**ANNE ELLEGOOD AND
ERIN CHRISTOVALE**

**HAMMER MUSEUM
UNIVERSITY OF CALIFORNIA,
LOS ANGELES**

**DELMONICO BOOKS · PRESTEL
MUNICH LONDON NEW YORK**

CONTENTS

[I]
Jade Gordon &
 Megan Whitmarsh
Luchita Hurtado
Naotaka Hiro
Mercedes Dorame
Suné Woods
Nancy Lupo
Flora Wiegmann
Carmen Argote
James Benning
Celeste Dupuy-Spencer
Christina Quarles
Diedrick Brackens
Aaron Fowler
Nikita Gale

[II]
Neha Choksi
Charles Long
Alison O'Daniel
Daniel Joseph Martinez
Michael Queenland
Rosha Yaghmai
Linda Stark
John Houck
taisha paggett
Patrick Staff

[III]
Candice Lin
Eamon Ore-Giron
Gelare Khoshgozaran
Carolina Caycedo
Beatriz Cortez
EJ Hill
Lauren Halsey
MPA

FOREWORD

Ann Philbin

Made in L.A. 2018 is the fourth iteration of our biennial showcasing the work of artists living in Los Angeles. The biennial has become a vital part of the Hammer's mission and its commitment to being a center for community engagement. The exhibition is a much-anticipated opportunity to celebrate and, more important, to look deeply at the incredible abundance of meaningful cultural activities happening around us. Like its predecessors, this exhibition shines a light on some of the most dynamic and distinctive work being made today by an array of artists who exemplify the diversity that makes our city such a rich and fertile creative landscape. The thirty-three artists presented—two of whom are a collaborative—are from a variety of places around the world, have distinct life experiences, and work across numerous disciplines and mediums. They range in age from twenty-nine to ninety-seven, have different racial and ethnic backgrounds, and identify across the spectrum of gender. They make paintings, drawings, and sculptures; shoot photographs and videos; and move their bodies through dance or other forms of performance. But they all have one thing in common (besides adding immensely to the creative lifeblood of Los Angeles): they choose to use their work to engage with the complex, sometimes overwhelming, but always fascinating moment in which we live. This year's exhibition, while not claiming a political position, highlights the work of artists who are inevitably—and perhaps urgently—grappling with the concerns, shared by so many, of what it means to be a citizen at this time. I have always believed that artists not only help open our eyes to the world around us but also enhance our understanding of its nuances and contours, and this group of artists is particularly dedicated to this task.

Made in L.A. 2018 is curated by our senior curator, Anne Ellegood, and the newest curator to join our team, Erin Christovale. Having joined the Hammer in 2009, Ellegood has been committed to exploring the city's incredibly rich community of artists since her arrival. Raised in Long Beach and a lifelong resident of the region, Christovale brings a fresh eye and unique perspective to the cultural activities happening here. Both are unwavering advocates and interlocutors for artists in our city, and have worked in close dialogue with every artist in the exhibition. The wealth of talent and commitment among artists here is truly astounding, evident from the more than two hundred studio visits undertaken for this exhibition. The Hammer remains dedicated to showcasing local artists' work through our sustained commitment to a regional biennial.

Since the launch of Made in L.A. in 2012, Pamela and Jarl Mohn have been steadfast supporters and tireless champions of the art and artists here. Three awards are presented in conjunction with Made in L.A.: the Career Achievement Award and the Mohn Award, which are selected by a professional jury composed of curators of contemporary art, and the Public Recognition Award, which is determined by the voting public. All three awards, as well as additional support for the exhibition, are underwritten by the Mohn Family Foundation. We are grateful to Pamela and Jarl Mohn for their outstanding generosity and recognition of artists and their ongoing partnership with the Hammer through Made in L.A. The Hammer Circle, an engaged and

enthusiastic patron group, has grown with each iteration of the exhibition, and their backing and encouragement are fundamental to the continued success of the project. Special thanks to the Hammer Circle co-chairs Tracy O'Brien and Kristin Rey, who played a large role in expanding the group and organizing great events. Major support is provided by The Andy Warhol Foundation for the Visual Arts, and we are thankful to the Pasadena Art Alliance for its dedicated patronage of the biennial. A number of key individuals also made this exhibition possible. Eugenio López Alonso, Vera Campbell, Kelsey Lee Offield, and Darren Star made considerable contributions. Generous funding is also provided by Bill Hair, Dori and Charles Mostov, Mark Sandelson and Nirvana Bravo, Wendy Stark Morrisey and Allison Gorsuch, Kerry and Simone Vickar, Teddy and Emily Greenspan, Stephen O. Lesser, and Kimm and Alessandro Uzielli.

I want to acknowledge the enthusiasm, hard work, and vision of curators Anne Ellegood and Erin Christovale. Their partnership was a true collaboration, and the cohesiveness of their approach is reflected in the exhibition, which is innately heterogenous but with a strong shared sensibility. They have selected a group of genuinely compelling, ambitious, and intelligent artists, and have remained committed to showing their work in the best possible light. Their exceptional perspectives offer insights into the cultural strength of our city. Made in L.A. is a huge undertaking for us, and without our incredibly gifted and dedicated staff, none of this would have been possible. I am deeply appreciative of the work of individuals at every level of the institution. Lastly, I extend my gratitude to the artists in *Made in L.A. 2018*. I am in awe of the work they do and the important contributions they make to our city and, indeed, to the Hammer. We pride ourselves on our close relationships with artists and on maintaining our deep and abiding dedication to bringing their work to wider audiences. Thank you for being a part of *Made in L.A. 2018* and offering your vision and viewpoints to the conversation about Los Angeles and beyond.

Ann Philbin
Director

INTRODUCTION

Anne Ellegood and
Erin Christovale

For all the eclecticism of form, subject matter, and approach that makes up a large group show such as a biennial, it might be argued that *Made in L.A. 2018* has a sensibility that responds to the almost surreal historic era we currently find ourselves in. Since the Hammer's last Made in L.A., in the summer of 2016, the world has inexorably changed. Few could have predicted what has unfolded over the past two years since the US presidential election of 2016. This dramatic shift has left many of us feeling emboldened and committed to direct political action, while at the same time contending with what can be a paralyzing mixture of astonishment, fear, anxiety, and anger. We've learned that a lot can happen in two years. We have witnessed the meddling in our elections through the spread of disinformation over social media; the banning of Muslims from entering the country and the deportation of people who have lived in the United States for decades; the shooting of numerous black and brown citizens at the hands of those meant to protect them; a criminal denial of the climate change that is so readily evident in California as one natural disaster of flooding, fires, or drought accompanied by record high temperatures is outdone by the next; and the continued erosion of women's and transgender people's ability to control their own bodies. The list goes on and on. The art world itself has had its own reckoning, as well-known figures have been outed for predatory abuses of power. An open letter titled "Not Surprised" was released in October of last year and, at last count, was signed by more than five thousand individuals in the arts who have been targets of sexual harassment or assault and those who support them. The groundswell of revelations of systemic sexual harassment and racial antagonisms that are deeply embedded in basically all our institutions, both public and private, has catalyzed new undertakings such as #metoo and further underscored the critical work of existing movements like #blacklivesmatter.

Against this national backdrop, *Made in L.A. 2018* focuses a lens on the particularities of the local in both the present moment and the past. When Made in L.A. comes around every two years, the question of how this version might be different from the one before always looms over the research the curators do. Numerous studio visits and conversations are punctuated with ongoing dialogue about the political climate and the potential of a biennial to reflect the time and place in which it unfolds. California, like our larger society and our planet, faces many challenges but has also become a leader in the resistance to the reliance on coal and gas, to the expansion of a wall along our border with Mexico, and to the swift deportation of residents without due process, among other issues. And artists are thinking about and living these questions as much as anyone.

Los Angeles as a space is multilayered and potent; its topography is as prominent as its cultural landmarks, and both are marked by the waves of people who have called it home. Prior to European contact, nearly one-third of all Native Americans

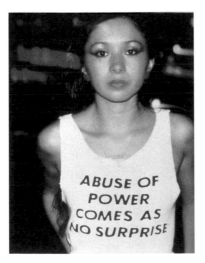

Jenny Holzer,
Truisms,
1977-79

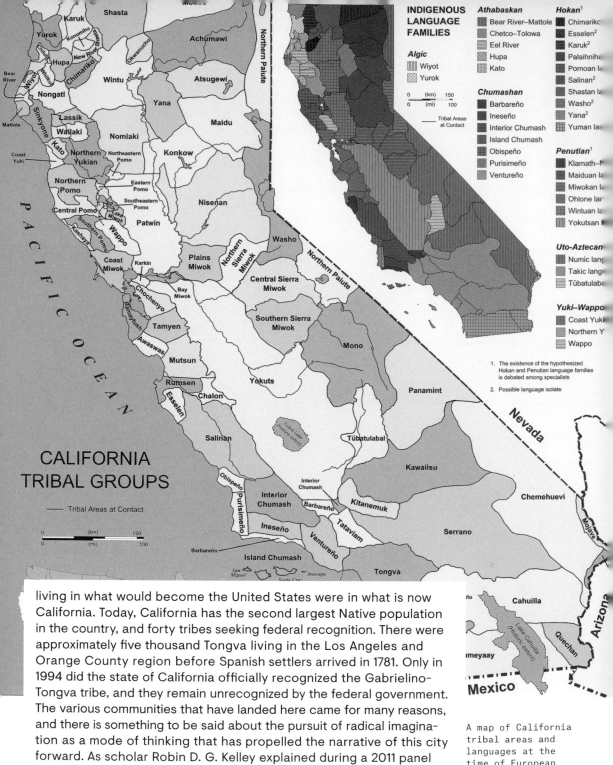

CALIFORNIA TRIBAL GROUPS

Tribal Areas at Contact

INDIGENOUS LANGUAGE FAMILIES		

Algic
- Wiyot
- Yurok

Athabaskan
- Bear River–Mattole
- Chetco–Tolowa
- Eel River
- Hupa
- Kato

Chumashan
- Barbareño
- Ineseño
- Interior Chumash
- Island Chumash
- Obispeño
- Purisimeño
- Ventureño

Hokan[1]
- Chimariko
- Esselen[2]
- Karuk[2]
- Palaihniha
- Pomoan[1]
- Salinan[2]
- Shastan la
- Washo[2]
- Yana[2]
- Yuman lan

Penutian[1]
- Klamath–M
- Maiduan la
- Miwokan la
- Ohlone lar
- Wintuan la
- Yokutsan M

Uto-Aztecan
- Numic lang
- Takic lang
- Tübatulaba

Yuki–Wappo
- Coast Yuki
- Northern Y
- Wappo

1. The existence of the hypothesized Hokan and Penutian language families is debated among specialists
2. Possible language isolate

living in what would become the United States were in what is now California. Today, California has the second largest Native population in the country, and forty tribes seeking federal recognition. There were approximately five thousand Tongva living in the Los Angeles and Orange County region before Spanish settlers arrived in 1781. Only in 1994 did the state of California officially recognized the Gabrielino-Tongva tribe, and they remain unrecognized by the federal government. The various communities that have landed here came for many reasons, and there is something to be said about the pursuit of radical imagination as a mode of thinking that has propelled the narrative of this city forward. As scholar Robin D. G. Kelley explained during a 2011 panel titled "Race, pLAce, and bLAck L.A.": "So much of what black Los Angeles is, is constructed in imagination ... in 1965 black Los Angeles becomes Watts, in the 1980s it becomes South Central, Compton, and it becomes Inglewood.... The communities here have always been in conversation and engagement with the Asian Pacific American communities, with the Latino communities, etc. Places that we identify as

A map of California tribal areas and languages at the time of European contact

Facing: Don Pío Pico, ca. 1840

'black' are not even black, and it's that kind of relationship, that kind of multiethnic, multiracial, Pacific rim, north of Mexico relationship which constitutes, I think, a unique, and always in the process of remaking, black community."[1] This idea of cultural exchange, even if sometimes contentious or hierarchical, is at the heart of this sprawling yet segregated, highly mobilized, and intuitive city.

Los Angeles holds many histories. Pío Pico was the last governor of California under Mexican rule in 1845–46; his family originally came from Sinaloa, Mexico, and settled in what is now known as the San Gabriel Valley. Pico and others activated the foundations of Los Angeles, where the spectrum of people who came together cultivated alliances and hybridized new languages that set the tone for the subsequent infrastructure and commerce that would make the city what it is today. Bridget "Biddy" Mason, an African American woman who was brought to Los Angeles as a slave, fought for her freedom in court upon realizing she was technically a free person because of the Compromise of 1850 whereby California was admitted to the Union as a free state. Mason went on to become a real estate mogul, philanthropist, and founder of the city's First African Methodist Episcopal Church, making her one of the most successful women of her time.

Personal narratives of Los Angeles intertwine with the freeways that divide the neighborhoods. But the city is also organically broken up by its fault lines: the San Andreas fault, the San Jacinto fault, and the Elsinore fault, which splits into two segments near Chino and Whittier. Fault lines, like freeways, rely on bursts of energy for activation, generating movement and continuity from one edge of the city to the other. The tectonic plates that foster this movement create earthquakes that rupture the core of the city, only to foster regeneration time and time again. This is not dissimilar to the wildfires that claim areas such as parts of Santa Barbara and Ventura County, usually generated by the strong Santa Ana winds, which originate from high pressure over the Great Basin and upper Mojave Desert. This

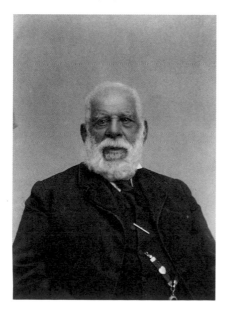

cycle of environmental regeneration caused by the conditions of ocean, mountains, wind, and land has defined this terrain for many years, even as the allure of the city's hollow-lined palm trees, year-round blooms of bougainvillea, and desert sensibilities prevails in the public imagination.

This is the framework for the curatorial research that led to the selection of artists and artworks for *Made in L.A. 2018*. We recognized early in the process that our expectation was not that artists should take up specific issues from the daily news cycle or feel a responsibility to address (or redress) politics per se. We were not looking for a literal correlation between current events and an artist's output, and we did not set out to make a "political show" that would somehow illustrate or represent political

ELLEGOOD AND CHRISTOVALE

positions or opinions. Yet we also knew that the context surrounding the development of the exhibition would inevitably, and necessarily, inform the practices we gravitated toward, if simply for the reason that they somehow felt more urgent, more engaged, and more "of the moment." As an alternative to the polarizing and divisive thinking that has come to characterize much of what occurs in contemporary culture, this exhibition argues for complexity, thoughtfulness, and ambiguity, even as it endorses strong opinion and heartfelt belief when needed. The result, we believe, is a truly diverse group of artists whom we consider to be deeply engaged with vital aspects of our culture today—individuals who embrace the notion that art has a role to play in social discourse and make evident that artists are often some of our most active citizens.

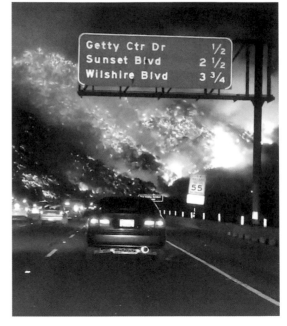

The Skirball Fire near the 405 Freeway, December 6-15, 2017

While *Made in L.A. 2018* intentionally has no overarching theme, or even a subtitle that would offer guidance or suggest an avenue into the group dynamic of the exhibition, there are certainly a number of shared interests, viewpoints, and ethics of making among the artists—some that we recognized early on and others that were revealed only through the artists' embarking on the creation of new works. From endeavors to engage with historically overshadowed ancient practices in order to reactivate them; to reconsiderations of the fundamental importance and vitality of community, family, and sense of place; to explorations of our relationships with the land rooted in ceremony and ritual; to examinations of the inextricable connections between the environment, capital expansion, and violence—the works on view engage meaningfully with the past in order to grapple with the present.

As a form of exhibition, biennials are particularly suited to this impulse to take up our present conditions. The majority of works included are new, created for the show with the knowledge that they will be shown in the artists' hometown among, and for, their peers, their mentors, and, of course, strangers too. Made in L.A.'s focus on the local has allowed us to work closely with the artists, engaging in countless conversations over many months, from the initial studio visits through the development and realization of their works. This is a great privilege of being a curator, and nothing is more gratifying than being in dialogue with artists for whom you have great admiration.

An exhibition of this scale requires the efforts, commitment, and support of innumerable people, too many to list in detail here. *Made in L.A. 2018* inhabits every gallery at the Hammer, occupies our lobby wall, and flows into our outdoor spaces. As someone pointed out to us, it's like installing seven exhibitions at once. It took the energies

and skills of every department and every staff person at the Hammer to realize this exhibition, and it would not have been possible without our extraordinarily creative, collegial, and committed staff, who are, simply put, the best at what they do (see staff acknowledgments on page 210). Of course, we are all inspired and motivated by the example set by our visionary director, Ann Philbin. While the majority of the work on view is new and comes directly from the artists' studios, there are a few lenders to whom we are grateful for their willingness to share their beloved works, and numerous gallerists whose support and efforts on behalf of the artists and the exhibition we very much appreciate (see lenders list and special thanks on page 213). We are thrilled to have the voices, keen intellect, and passion of a number of our colleagues included in the pages of this book, and are incredibly thankful to Commonwealth Projects for their eye-catching and inventive design. Finally—perhaps it goes without saying but nonetheless must be said— we are indebted to and, indeed, illuminated by the artists included in *Made in L.A. 2018*. We are honored to have worked with such a brilliant, dedicated, and generous group of artists. It's been a blast.

1. Held at the Hammer Museum, Los Angeles, December 8, 2011, in conjunction with the exhibition *Now Dig This! Art and Black Los Angeles, 1960-1980* (2011), curated by Kellie Jones, https://hammer.ucla .edu/programs-events/2011/12 /race-place-and-black-la/.

INDEX OF ARTISTS

DIMENSIONS ARE GIVEN IN THE FOLLOWING
ORDER: HEIGHT, WIDTH, DEPTH.

UNDERLINED TITLES INDICATE WORKS INCLUDED
IN THE EXHIBITION AS OF APRIL 2018.

CARMEN ARGOTE

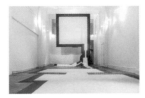
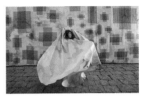

Top, left to right: *720 Sq. Feet: Household Mutations, Part B*, 2010. Carpet from the artist's childhood home, house paint. 180 × 84 in. (457.2 × 213.4 cm). Installation view, Gallery G727, Los Angeles; *Oh wow… The Marfa Sky*, 2017. Acrylic on wearable muslin. 36 × 66 in. (91.4 × 167.6 cm). [Background: *Hunting and Gathering*, 2017. Acrylic on muslin, cardboard boxes. Foreground: Rafa Esparza, *Tierra. Sangre. Oro.*, 2017. Adobe brick. 288 × 144 × 18 in. (731.5 × 365.8 × 45.7 cm).] Installation view, *Tierra. Sangre. Oro.*, Ballroom Marfa, Texas, August 25, 2017-March 18, 2018; **Middle:** *Place On-fold*, 2017. Acrylic on muslin fabric, garments, patterns, sewing, pattern-making tools. Dimensions variable. Installation view, *2017 California-Pacific Triennial: Building As Ever*, Orange County Museum of Art, Newport Beach, May 6-September 3, 2017; **Bottom:** *Platform with Mobile Unit*, 2017. Platform, coffee makers. 144 × 144 × 54 in. (365.8 × 365.8 × 137.2 cm). Installation view, *Pyramids*, Panel LA, September 24-October 29, 2017.

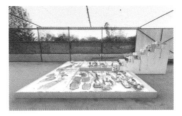

JAMES BENNING

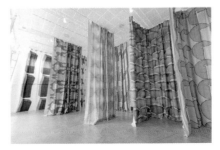

Top, left to right: *Found Fragments (scorched earth, Ash 01, RED CLOUD)*, 2016. Three-channel video installation. Dimensions variable. Color, black and white, 75 min. (loop); *La Higuera*, 2016. House paint on burned pressboard. 16 × 16 in. (40.6 × 40.6 cm). **Bottom, left to right:** *Criminal Complaint*, 2017 (detail). Framed photograph, document, rusted alternator. Dimensions variable; *Found Fragments II*, 2017. Found flag, September 10, 2016. 13 × 13 in. (33 × 33 cm).

DIEDRICK BRACKENS

P. 80

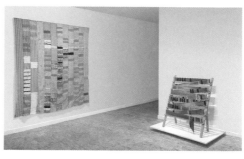

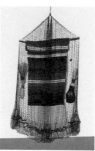

Top, left to right: *not every passage/position is comfortable*, 2014. Woven nylon, redwood. 38 × 58 × 6 in. (96.5 × 147.3 × 15.2 cm); *blow*, 2015. Woven tea-dyed cotton, nylon yarn. 51 × 35 in. (129.5 × 89 cm); *This is Real Life*, installation view, Johansson Projects, Oakland, March 5-April 23, 2015; **Bottom:** *sleep don't come easy*, 2016. Woven cotton, nylon, chenille yarn, cotton fabric. 61 × 52 in. (154.9 × 132.1 cm).

CAROLINA CAYCEDO

P. 176

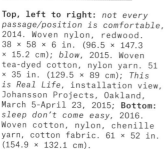
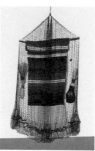
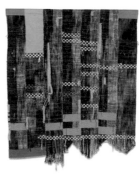
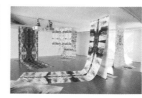

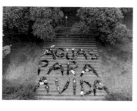
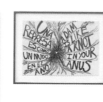
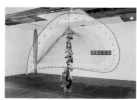

Top, left to right: *Aguas Para A Vida (Water Is Life)*, collective action, *32ª Bienal de São Paulo: Incerteza Viva (Live Uncertainty)*, November 5, 2016; *Cosmotarraya Yaqui*, 2016. Hand-dyed artisanal fishing net, lead weights, wood stick, cotton poncho, leather maracas, dry chili pepper. 35 $7/16$ × 21 $21/32$ × 3 $15/16$ in. (90 × 55 × 10 cm). Solomon R. Guggenheim Museum, New York; *Dam Knot Anus/ Nudo represa ano*, 2016. Pencil on paper. 15 $1/2$ × 20 × 1 $1/2$ in. (39.4 × 50.8 × 3.81 cm); *Water Portraits/This Is Not Water*, 2016. HD video, printed cotton canvas. Dimensions variable.

Color, sound, 5:15 min. Installation view, *El Origen de la Noche*, Museum of Art, National University of Colombia, Bogotá; **Bottom:** *To Drive Away Whiteness/ Para alejar la blancura*, 2017. Hand-dyed artisanal fishing net, lead weights, hand-dyed jute cord, plastic and glass bottles, liquor, banknotes, seeds, chili peppers, achiote, sand, dried kelp seeds, water (Pacific Ocean, Colorado River, and Los Angeles River), hibiscus, black beans, human hair, ginseng, paper. 89 × 136 × 107 in. (226.1 × 345.4 × 271.8 cm).

NEHA CHOKSI P. 116

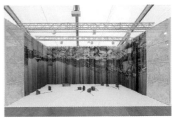

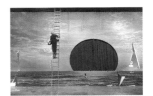

Top, left to right: *The Weather Inside Me (Bombay Sunset)*, 2007-10 (detail). Video installation with 9 DVDs played through DVD players with time code counters on old CRT color television sets, 1 photograph. Dimensions variable. Color, silent, 39:40 min. (synced loop); *Dust to Mountain*, 2016. 4K video installed on wedge at the angle of the artist's kick, sound, sheer fabric curtains. Dimensions variable. Color, sound, 2:50 min. (loop); *Stone Breath Mountain Dust*,

installation view, Frieze London, October 6-9, 2016; **Bottom:** *The Sun's Rehearsal/ In Memory of the Last Sunset*, 2016. Image on wallpaper digitally generated by OmniCosm Studios, seven photographically generated images on wallpaper, freestanding wall with cutout, curtain. Activated by performance and interaction by Alice Cummins, Carriageworks, Sydney, March 15-19, April 9-10, and May 28-29, 2016. Commissioned by the 20th Biennale of Sydney.

BEATRIZ CORTEZ P. 180

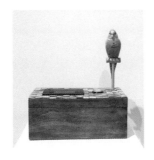

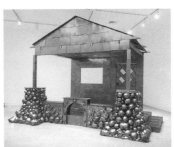

Top, left to right: *The Fortune Teller (Migrant Edition)*, 2015. Found box with wood and linoleum, Arduino Uno, thermal printer, thermal paper, mechanical bird. 12 × 4 × 12 in. (30.5 × 10.2 × 30.5 cm); *The Untimely Conversation Box*, 2015. Wood, broken glass mirror, glue, Arduino Uno, thermal printer, thermal paper. 12 × 6 × 8 in. (30.5 × 15.2 × 20.3 cm); *The Lakota Porch: A Time Traveler*, 2017. Welded steel and sheet metal. 204 × 144 × 96 in.

(518.2 × 365.8 × 243.9 cm); **Bottom:** Beatriz Cortez and Rafa Esparza, *Nomad 13*, 2017. Adobe bricks, steel, concrete, hammer, plastic, paper, soil, plants: corn, black bean, prickly pear, sorghum, amaranth, quinoa, chayote squash, chia, chili pepper, yerba buena, yerba santa, sage, ceiba tree. 104 × 84 × 96 in. (264.2 × 213.4 × 243.8 cm). Installation view, *Mundos Alternos*, UCR ARTSblock, Riverside, CA, September 16, 2017-February 4, 2018.

MERCEDES DORAME

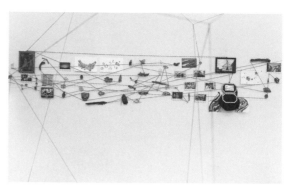

Top, left to right: _My Relatives I Sing for You–Nehiinkem, Čeʔeeʔaxre_, 2010. Archival pigment print from 120mm film. 24 × 24 in. (61 × 61 cm); _With Outstretched Wings–Čawaayavet_, 2010. Archival pigment print from 120mm film. 24 × 24 in. (61 × 61 cm); _Coordinates_, 2012. Fuji Instax photographs, watercolor drawings, red yarn, rocks, glass, feathers, broken pottery and other found items. Dimensions variable; **Bottom, left to right:** _Coyote Dance with Me–Iitar Nečoova Yakeenax_, 2017. Archival pigment print from 120mm film. 24 × 24 in. (61 × 61 cm); _To the Land of the Dead–Shiishonga_, 2017. Archival pigment print from 120mm film. 24 × 24 in. (61 × 61 cm).

CELESTE DUPUY-SPENCER

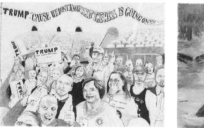

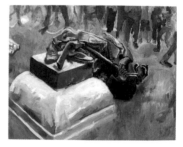
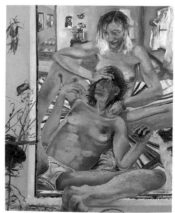

Top, left to right: _Trump Rally (And Some of Them I Assume Are Good People)_, 2016. Pencil on paper. 24 × 30 in. (61 × 76.2 cm); _Cajun Navy, August 2016_, 2017. Oil on canvas. 19 × 16 in. (50.8 × 40.6 cm); _Durham, August 14, 2017_, 2017. Oil on canvas. 28 × 35 in. (71.1 × 88.9 cm). Collection of Jeffrey Deitch; **Bottom:** _Sarah_, 2017. Oil on canvas. 65 × 50 in. (165.1 × 127 cm). Collection of Dean Valentine.

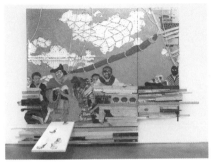

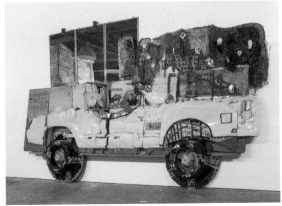

Left: *Started from the Bottom Now We're Here*, 2013. Cotton balls, rope, wood, diving board, shopping bag, doll head, tarp, tennis shoe boxes, paper, photograph, coffcc, oil paint, acrylic paint, brown footprints on unfinished wooden doors. 96 × 133 × 70 in. (243.8 × 337.8 × 178 cm); **Right:** *El Camino*, 2017. Acrylic paint, enamel paint, car parts, hair weave, mirrors, CDs, fans, fitted cap, tires, poker tables, speakers, digital printout, and concrete cement on conference tables. 132 × 168 × 48 in. (335.3 × 426.7 × 121.9 cm).

NIKITA GALE

P. 88

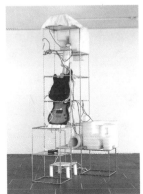

Top, left to right: *LOW MAINTENANCE*, installation view, University of California, Los Angeles, 2016; *BIG BAD PICKUP*, 2017. Mixed media. 82 × 42 1/2 × 31 1/2 in. (208.3 × 108 × 80 cm); **Bottom:** *RIFF FATIGUE*, installation view, Artist Curated Projects, Los Angeles, 2017.

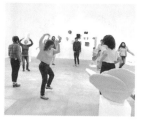

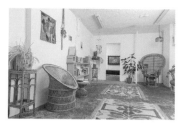

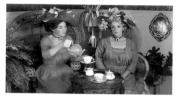

Top, left to right: *Rainbow of Desire-Theater of the Oppressed Workshop*, 2017. Performance and participatory workshop as part of *Statues and Attitudes*, Human Resources, Los Angeles, February 3-5, 2017; *Statues and Attitudes*, 2017. Acrylic, plaster, Aqua-Resin, papier-mâché. Dimensions variable. Installation view,

Statues and Attitudes, Human Resources, Los Angeles, February 3-5, 2017; *Statues and Attitudes*, installation view, Human Resources, Los Angeles, February 3-5, 2017; **Bottom, left and middle:** *Elsewhen*, 2018. Video, color, sound, 6:28 min.; **Bottom, right:** *Ourchetypes*, 2018. Video, color, sound.

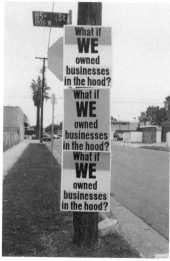

Top, left to right: *What If WE Owned Businesses in the Hood?*, 2012. Screen print. 30 × 22 in. (76.2 × 55.9 cm); *Kingdom Splurge*, 2014 (detail). Mixed media. 288 × 480 in. (731.5 × 1219.2 cm). Installation view, Yale School of Art, New Haven, 2014; **Middle:** *Kingdom Splurge*, 2014 (detail); **Bottom, left to right:** *Kingdom Splurge*, 2015 (detail). Gypsum, plaster, pigment, acrylic paint. 264 × 72 × 10 in. (670.6 × 182.9 × 25.4 cm). Installation view, *Everything, Everyday: Artists in Residence 2014-2015*, Studio Museum in Harlem, New York, July 16-October 26, 2015; *Kingdom Splurge*, 2015 (detail).

EJ HILL

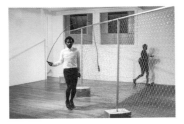
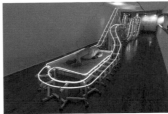
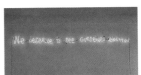

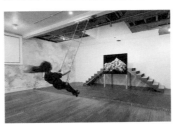

Top, left to right: *The Fence Mechanisms*, 2014. Chain-link fencing, concrete, beaded jump rope. Installation and durational performance. Dimensions variable. Performed at Commonwealth and Council, Los Angeles, October 25, 2014; *A Monumental Offering of Potential Energy*, 2016. Installation and durational performance. 108 × 492 × 85 in. (274.3 × 1249.7 × 216 cm). Performed at the Studio Museum in Harlem, New York, July 14-October 30, 2016; *A Declaration*, 2017. Neon. 8 × 100 in. (20.3 × 254 cm). Collection of Arthur Lewis and Hau Nguyen; **Bottom, left to right:** *The Necessary Reconditioning of the*

Highly Deserving, installation view, Commonwealth and Council, Los Angeles, March 18-April 29, 2017; *Pillar*, 2017. Wood, PVC. Dimensions variable. 57th Venice Biennale, Palazzo Contarini Polignac, May 12-August 13, 2017.

NAOTAKA HIRO

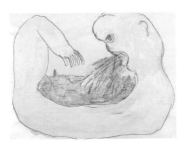
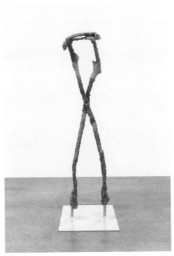

Top, left to right: Untitled, 2014. Watercolor and graphite on paper. 18 × 24 in. (45.7 × 60.1 cm); *Tool (Crossed Arm Above Head)*, 2016. Bronze, steel stand. 80 × 15 × 6 in. (203.2 × 38.1 × 15.2 cm). Collection of Beth Rudin DeWoody; *Untitled (Crawl #2)*, 2017. Canvas, fabric dye, oil pastel, rope, grommets. 108 × 84 in. (274.3 × 213.4 cm); **Bottom:** *Untitled (Walkabout)*, 2017. Canvas, fabric dye, oil pastel, rope, grommets. 108 × 84 in. (274.3 × 213.4 cm).

JOHN HOUCK

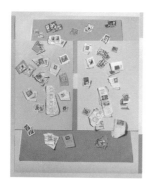

Top, left to right: *Copper Mountain*, 2014, from the series A History of Graph Paper, 2013-17. Archival pigment print. 29 × 23 in. (73.7 × 58.4 cm); *First Set*, 2015. Archival pigment print. 22 1/2 × 28 1/2 in. (57.2 × 72.4 cm); **Bottom, left to right:** *John Houck: The Anthologist*, installation view, Dallas Contemporary, Dallas, January 15-March 12, 2017; *The Adjacent End*, 2018. Archival pigment print. 53 × 42 in. (134.6 × 106.7 cm).

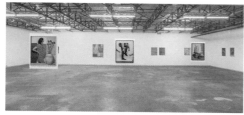

LUCHITA HURTADO

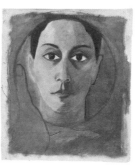

Top, left to right: Untitled, ca. 1945. Wax crayon, ink, and watercolor on paper. 12 7/8 × 10 7/8 in. (32.7 × 27.6 cm). Museo de Arte Latinoamericano de Buenos Aires; *Woman's World*, 1948. Crayon, ink, and watercolor on paper. 12 × 9 in. (30.5 × 22.9 cm). Private collection, Buenos Aires; Untitled, 1960. Ink on paper. 13 1/4 × 9 3/4 in. (33.7 × 24.8 cm); *Untitled (self-portrait)*, 1968. Oil on linen. 32 1/2 × 26 3/4 in. (82.5 × 67.9 cm); **Middle:** Untitled, 1969. Oil on canvas. 21 × 32 in. (53.3 × 81.3 cm); **Bottom:** Untitled, 1970. Oil on canvas. 30 × 50 in. (76.2 × 127 cm).

GELARE KHOSHGOZARAN

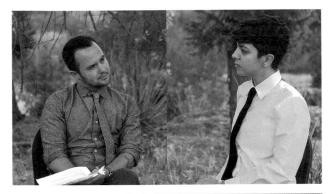

Top, left to right: *The Hemlock*, 2015. HD video, color, sound, 9:10 min.; *Cosmos*, 2016. Two-channel video installation, HD and livestream. Dimensions variable. Color, sound, 15:40 min.; **Bottom, left to right:** *UNdocumentary*, 2016. Performance, with Andre Keichian and Jimena Sarno. LA Municipal Art Gallery, December 16, 2016; *U.S. Customs Demands to Know*, 2016-ongoing. Postal packages, LED lights. Dimensions variable.

CANDICE LIN

Top, left to right: *Sycorax's Collection (Herbarium)*, 2011. Etching, watercolor, dried herbs. 11 × 13 in. (28 × 33 cm); *Female Penis/Beast of Burden*, 2015. Graphite, archival pigment printed images, dried plant, silkscreened text on paper, walnut frame. 33 × 25 ³/₄ × 2 ³/₄ in. (83.8 × 65.4 × 7 cm) framed. Collection of Beth Rudin DeWoody; *Recipe for Spontaneous Generation: Baby Mice*, 2015. Fabric, dried wheat, baby mice, alcohol, glass jar, airlock, copper pipe. 26 × 4 × 4 in. (66 × 10.2 × 10.2 cm). Installation view, Ghebaly Gallery, Los Angeles, 2015; **Bottom:** *System for a Stain*, 2016. Wood, glass jars, cochineal, poppy seeds, metal castings, water, tea, sugar, copper still, hot plate, ceramic vessels, mortar and pestle, Thames mud, jar, microbial mud battery, vinyl floor. Dimensions variable. Commissioned by Gasworks, London. Installation view, Gasworks, London, 2016.

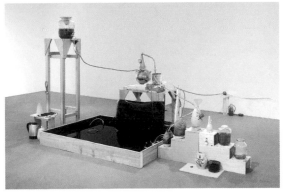

INDEX OF ARTISTS

CHARLES LONG

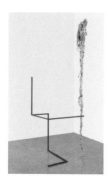
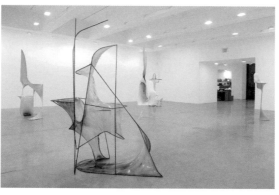

Top, left to right: Untitled, 2009. Papier-mâché, plaster, steel, acrylic, river sediment, debris. 127 × 36 × 40 in. (322.6 × 91.4 × 101.6 cm). Hammer Museum, Los Angeles. Purchase; *Minimal Surfaces Ocean of Hours*, installation view, Tanya Bonakdar Gallery, New York, February 25-April 7, 2012; Untitled, 2012. Aqua-Resin fiberglass and latex paint over steel with found objects. 40 × 74 × 32 in. (101.6 × 188 × 81.3 cm). Collection of Fred and Nancy Poses; **Bottom:** *PaleTwinPureIntimacy2*, 2016. Platinum silicone with pigment, stainless steel, pedestal. Overall: 72 × 23 × 18 in. (182.9 × 58.4 × 45.7 cm), sculpture: 32 × 20 × 13 1/2 in. (81.3 × 50.8 × 34.3 cm), pedestal: 40 × 20 1/2 × 15 1/2 in. (101.6 × 52.1 × 39.4 cm).

NANCY LUPO

AAA, 2016. Forks (ECOSOURCE Plant Starch, Eco-gecko, Perfect Stix Green, Bambu, 120 Silver Visions Silver Serving Forks, Visions Clear Forks, Fineline Platter Pleasers, Comet Petites, Clear Sabert Serving, etc.), dental floss (RADIUS cranberry, Listerine Ultraclean, Dr. Fresh Waxed, Rite Aid Spearmint Waxed, Rite Aid Mint Waxed, CVS Waxed and Unwaxed, Well at Walgreens, etc.), pine needles, orange and mint chocolate break-apart balls (Ferrara Candy Orange Milk, Mint, Dark, Peppermint, Terry's Chocolate Orange), 120 gum-paste carnations (extra large, large, medium, small), 4 emu eggs (half and whole), 5 rhea eggs, stress balls, fake lemons, lemons, Meyer lemons, oranges, a watermelon, a cantaloupe, a lime, a tomatillo, avocados, green and yellow Peanut M&M's, rosemary, green twist ties, wasabi peas, Jordan almonds, 30 cabinet shelves, Magic-Sculpt, Fresh Step kitty litter, aluminum roof tar, aluminum ball chain, various lead sinkers, a corsage (sometimes), 36 Nylabone DuraChew Textured Ring Dog Chews, 23 Nylabone DuraChew Textured Ring Dog Chews (Holiday), 30 Nylabone DuraChew Textured Ring Dog Chews cast in aluminum and some painted, 19 Nylabone DuraChew Medium Textured Tugs cast in aluminum. Dimensions variable. Installation view, *All Always Already*, 3400 West Washington Boulevard, Los Angeles, February 12-March 17, 2017;

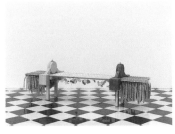

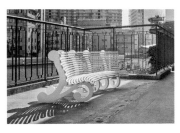

Left to right: *Bench 2016*, 2016. Fiberglass, pine 2x3's, coated steel shelving, nuts, bolts, washers, clips to hold spray millet, spray millet, plugs, dental floss (Colgate Total, Desert Essence, LTV Reach Access, Oral-B Glide Pro Health Comfort Plus, Oral-B Glide White and Whitening + Scope, Oral-B Complete Satin Tape, Oral-B Pro Health Deep Clean, Oral-B Glide Pro Health Original, Oral-B Glide Pro-Health Clinical Protection, Oral-B Essential Cavity Defense, RADIUS Natural Silk, RADIUS Cranberry, RADIUS Mint, Tom's of Maine, Naturally Waxed Antiplaque Flat, Well at Walgreens, Well at Walgreens High-Tech, etc.). 27 1/$_2$ × 90 × 29 1/$_2$ in. (69.8 × 228.6 × 74.9 cm); *Balenciaga*, 2018 (detail). Two 10-gallon Rubbermaid Brute containers, Balenciaga dresses, chop frills, rainbow thread, cotton balls, gesso. 18 × 15 1/$_2$ × 17 1/$_2$ in. (45.7 × 39.4 × 44.5 cm) and 19 1/$_2$ × 17 1/$_2$ × 17 3/$_4$ in. (49.5 × 44.5 × 45.1 cm); *Bench 2017 (pink, concave)*, 2018. Steel, rubber feet, Fluorocarbon Metallic paint. 35 7/$_{16}$ × 74 3/$_4$ × 25 3/$_{16}$ in. (90 × 190 × 64 cm).

DANIEL JOSEPH MARTINEZ

P. 128

Top: *Museum Tags: Second Movement (overture); or, Overture con claque (Overture with Hired Audience Members)*, 1993. Paint and enamel on metal. Dimensions variable. Installation view, *1993 Whitney Biennial*, Whitney Museum of American Art, New York, March 4-June 3, 1993; **Middle, left to right:** *The House America Built*, 2004. SmartSide, plywood, dimensional lumber, Martha Stewart Signature Paint. Dimensions variable. Installation view, *Home— So Different, So Appealing*, Los Angeles County Museum of Art, June 11-October 15, 2017; *IF YOU DRINK HEMLOCK, I SHALL DRINK IT WITH YOU or A BEAUTIFUL DEATH; player to player, pimp to pimp. (As performed by the inmates of the Asylum of Charenton under the direction of the Marquis de Sade)*, 2016. Mixed media. Dimensions variable; **Bottom:** *The Soviet memorial park in the district of Schönholz. The Soviet War Memorial in Schönholzer Heide (German: Sowjetisches Ehrenmal in der Schönholzer Heide) in Pankow, Berlin, was erected in the period between May 1947 and November 1949 and covers an area of 30,000 m². The memorial contains the biggest Soviet cemetery in Berlin, which is also the biggest Russian cemetery in Europe outside of Russia.*, 2017. Medium-format black-and-white film printed digitally on Hahnemule Fine Art Baryta, Gloss 315gsm paper. 60 × 72 in. (152.4 × 182.9 cm).

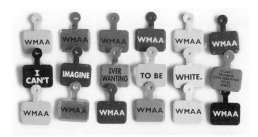

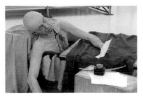

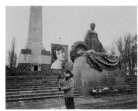

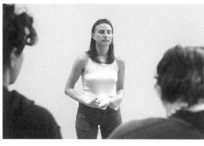
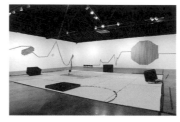

Top, left to right: *Initiation*, 2011. Performance during *Directing Light onto Fist of Father*, Leo Koenig Inc., September 15-November 12, 2011; *Nothing to You*, installation view, part of the Sound Is Matter program at Disjecta Contemporary Art Center, TBA Festival, Portland, Oregon, September 12-18, 2015; **Bottom, left to right:** *Untitled Red #5*, 2015. Injket print. 7 × 7 in. (17.8 × 17.8 cm); *THE INTERVIEW: Red, Red Future*, 2016. Live conversation, telephone, table, chair, inkjet print, stone. Installation view, Whitney Museum of American Art, New York, with artworks commissioned by Contemporary Arts Museum, Houston, February 27-June 5, 2016; *Orbit*, 2017. Performance. Ten consecutive days, Whitney Museum of American Art, New York, February 9-19, 2017.

ALISON O'DANIEL

P. 124

Top and middle rows: *The Tuba Thieves*, 2013-ongoing. HD video, 16mm, VHS, sound, running times variable per iteration. Musical scores: Christine Sun Kim, Steve Roden, and Ethan Frederick Greene. Cinematography: Meena Singh, Soraya Sélène Burtnett, and Judy Phu. Starring: Nyke Prince; **Bottom, left to right:** *All Component Parts (Listeners)*, installation view, Passerelle Centre d'art contemporain, Brest, France, September 26, 2015-January 2, 2016; *Room Tone*, installation view, presented at the Knockdown Center, New York, in collaboration with Art in General, New York, March 26-May 8, 2016. Commissioned by Art in General, New York.

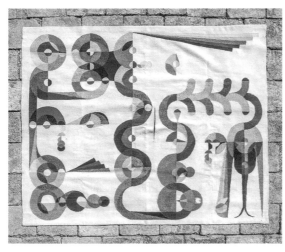

Top, left to right: Los Jaichackers (Eamon Ore-Giron and Julio César Morales), *Subterranean Homesick Cumbia*, 2014. Two-channel HD video with stereo audio. Color, sound, 23 min.; *Top Ranking*, 2015. Flashe on linen. 66 × 56 in. (167.6 × 142.2 cm). Private collection; *Infinite Regress XXIX*, 2017. Flashe on linen. 18 × 14 in. (45.7 × 35.6 cm). Private collection; *Infinite Regress XXXI*, 2017. Flashe on linen. 18 × 14 in. (45.7 × 35.6 cm). Private collection; **Bottom:** *Talking Shit with Quetzalcoatl/I Like Mexico and Mexico Likes Me*, 2017. Woven wool. 78 × 96 in. (198.1 × 243.8 cm). [Background: Rafa Esparza, *Raised Adobe Ground for Talking Shit with Quetzalcoatl*, 2017. Adobe brick. 171 × 130 in. (434.3 × 330.2 cm).]

TAISHA PAGGETT

P. 148

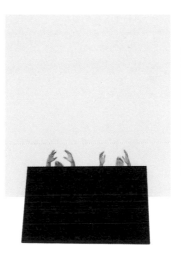

Top, left to right: taisha paggett and Yann Novak, *A Composite Field*, 2012. Performance. MAK Center, Mackey Garage Top, Los Angeles, January 20, 2012; taisha paggett, Ashley Hunt, and Kim Zumpfe with WXPT, *Demonstration Score #3 (duets)*, 2015. Performance during *The School for the Movement of the Technicolor People*, Los Angeles Contemporary Exhibitions, October 21-December 6, 2015; taisha paggett and WXPT, *evereachmore*, 2015. Performed at the Los Angeles River, May 30-31, 2015, produced by Clockshop, Los Angeles; **Bottom, left:** taisha paggett and Yann Novak, *Mountain, Fire, Holding Still*, 2016. Performed at the Getty Villa, Los Angeles, 2016.

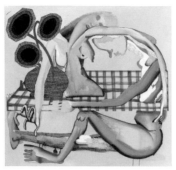

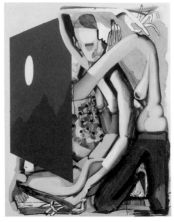

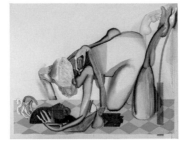

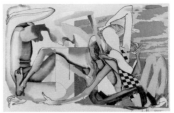

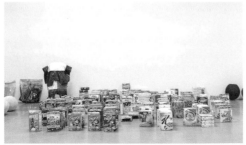

Top, left to right: *It's Gunna Be Alright, 'Cause Baby, There Ain't Nuthin' Left*, installation view, Yale School of Art, New Haven, January 2016; *I Wake With Yew in Mourning*, 2017. Acrylic on canvas. 50 × 52 in. (127 × 132.1 cm). Rubell Family Collection, Miami; *Moon (Lez Go Out N' Feel Tha Nite)*, 2017. Acrylic on canvas. 50 × 40 in. (127 × 101.6 cm); **Bottom, left to right:** *A Shaddow of Whut I Once Was*, 2017. Acrylic on canvas. 48 × 60 in. (121.9 × 152.4 cm); *…Tha Color of Tha Sky (Magic Hour)*, 2017. Acrylic on canvas. 55 × 80 in. (139.7 × 203.2 cm). Rubell Family Collection.

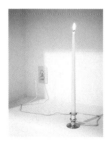

Left to right: *Untitled (Candle Piece)*, 2004. Plywood box, gypsum board, paint, electrical hardware, candle holder, white candle. 36 × 46 × 30 in. (91.4 × 116.8 × 76.2 cm); *Rudy's Ramp of Remainders (Cereal Ramp)*, 2012. US Cereals from General Mills, Kellogg's, Post, and Quaker companies, 2012: Cheerios, Apple Cinnamon Cheerios, Multi Grain Cheerios, Honey Nut Cheerios, Banana Nut Cheerios, Chocolate Cheerios, Fruity Cheerios, Cheerios Oat Cluster Crunch, Multi Bran Chex, Honey Nut Chex, Rice Chex, Wheat Chex, Chocolate Chex, Cinnamon Chex, Kix, Berry Berry Kix, Boo Berry, Frankenberry, Chocula, Lucky Charms, Chocolate Lucky Charms, Trix, Cocoa Puffs, Cookie Crisp, Cookie Crisp Sprinkles, Double Chocolate Cookie Crisp, Oatmeal Crisp, Total Raisin Bran, Fiber One, Fiber One Frosted Shredded Wheat, Fiber One Caramel Delight, Fiber One Honey Nut Clusters, Fiber One Raisin Bran Clusters, Honey Nut Clusters, Raisin Nut Bran, Cinnamon Toast Crunch, Basic 4, Wheaties, Whole Grain Total, Golden Grahams, Reese's Puffs, Dora the Explorer, All-Bran Original, All-Bran Bran Buds, All-Bran Extra Fiber, Apple Jacks, Bran Flakes, Cinnabon, Cinnamon Mini Buns, Kellogg's Frosted Krispies, Cocoa Krispies, Rice Krispies Treats Cereal, Corn Flakes, Complete Wheat Bran Flakes, Corn Pops, Crispix, Crunch, Caramel Nut Crunch, Cran-Vanilla Crunch, Toasted Honey Crunch, Crunchy Nut, Crunchy Nut: Golden Honey and Nuts, Crunchy Nut: Nuts and Honey Os, Froot Loops, Frosted Flakes, Frosted Mini Wheats, Mini-Wheats Raisin, Mini-Wheats Vanilla Creme, Frosted Mini Wheats with Brown Sugar, Frosted Blueberry Muffin, Frosted Cinnamon Streusel, Frosted Maple and Brown Sugar, Frosted Strawberry Delight, Honey Loops, Honey Smacks, Krave, Mueslix with Raisins, Dates & Almonds, Cracklin' Oat Bran, Raisin Bran, Raisin Bran Crunch, Smart Start, Smorz, Special K Original, Special K Chocolatey Delight, Special K Chocolatey Strawberry, Special K Cinnamon Pecan, Special K Red Berries, Special K Vanilla Almond, Special K Fruit & Yogurt, Special K Brown Sugar Gluten Free, Oats & Honey, Touch of Honey Granola, Chocolate Almond, Cranberry Granola, Protein, Cinnamon Brown Sugar Crunch Protein, Apple Cinnamon Crunch, Cap'n Crunch, Cap'n Crunch's Crunch Berries, Peanut Butter Crunch, Oops! All

Berries, Alpha Bits, Bran Flakes, Cocoa Puffs, Cinnamon Pebbles, Cocoa Pebbles, Fruity Pebbles, Golden Crisp, Grape Nuts, Great Grains Banana Nut, Great Grains Cranberry Almond Crunch Crunch, Great Grains Crunchy Pecans, Great Grains Digestive Blends - Berry Medley, Great Grains Digestive Blends - Vanilla, Great Grains Protein Blend - Cinnamon Hazelnut, Great Grains Protein Blend - Honey, Oats & Seeds, Great Grains Raisins, Dates & Pecans, Honey Bunches of Oats - Honey Roasted, Honey Bunches of Oats - Raisin Medley, Honey Bunches of Oats - with Almonds, Honey Bunches of Oats - with Cinnamon Bunches, Honey Bunches of Oats - with Real Strawberries, Honey Bunches of Oats - with Vanilla Bunches, Honey Bunches of Oats - with Pecan Bunches, Honey Bunches of Oats - Fruit Blends - Banana Blueberry, Honey Bunches of Oats - Fruit Blends - Peach Raspberry, Honey Bunches of Oats - Granola - Honey Roasted, Honey Bunches of Oats - Granola - Raspberry, Honey Bunches of Oats - Granola - Cinnamon, Honey Bunches of Oats - Granola - Protein Chocolate, Honeycomb, Oh's, Oreo O's, Poppin' Pebbles, Selects Blueberry Morning, Selects Cranberry Almond Crunch, Shredded Wheat, Shredded

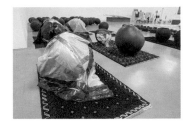

Wheat - Original Spoon Size, Shredded Wheat - Honey Nut Spoon Size, Shredded Wheat - Wheat 'n Bran Spoon Size, Shredded Wheat - Lightly Frosted Spoon Size, Shredded Wheat - Frosted Cinnamon Roll, Shredded Wheat - Frosted Mixed Berry, Shredded Wheat - Frosted S'mores Bites, Life Cereal. Dimensions variable. Installation view, *Michael Queenland: Rudy's Ramp of Remainders*, Santa Monica Museum of Art, September 15- December 22, 2012; *Rudy's Ramp of Remainders (Group 1)*, 2012. Afgan prayer rugs, customized quilted contractor trash bags, kitchen trash bags, clothing and uniform scraps, duct tape. Dimensions and arrangement variable. Installation view, *Michael Queenland: Rudy's Ramp of Remainders*, Santa Monica Museum of Art, September 15- December 22, 2012; *Untitled*

(Legible/Illegible), 2017. Marble, granite, dye, sublimation tile, wood, metal frame. 64 $^1/_4$ × 32 $^1/_4$ × 1 in. (163.2 × 81.9 × 2.5 cm). Installation view, *Roam*, Kristina Kite Gallery, Los Angeles, December 9, 2017-February 10, 2018.

PATRICK STAFF

P. 152

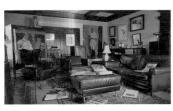

Top, left to right: *The Foundation*, 2015. Video, multimedia installation. Color, sound, 28 min. Dimensions variable; *The Foundation*, 2015. Installation view, Spike Island, Bristol, July 4-September 20, 2015; Patrick Staff and Cara Tolmie, *Litmus Shuffle*, 2016. Performance. KW Institute for Contemporary Art, Berlin, April 7, 2016. **Bottom, left to right:** *Weed Killer*, 2017. Video, multimedia installation. Dimensions variable. Color, sound, 17 min.; *Bathing (Drunkenness)*, 2018. Performance. Company Projects, Minneapolis, March 1, 2018. Produced by FD13, Minneapolis.

INDEX OF ARTISTS

LINDA STARK

Top, left to right: *Fleshtones Weave*, 1992. Oil on canvas. 11 × 11 × 1 ¹/₂ in. (27.9 × 27.9 × 3.8 cm). Collection of Brett Green and Martha Jackson; *Ruins*, 2008. Oil on wood and canvas over panel. 36 × 36 × 2 ¹/₂ in. (91.4 × 91.4 × 6.6 cm). Collection of Allie Furlotti; *Fixed Wave*, 2011. Oil on canvas over panel. 36 × 36 × 2 ¹/₄ in. (91.4 × 91.4 × 5.7 cm). Hammer Museum, Los Angeles, Gift of the Artist Acquisition Fund; **Bottom, left to right:** *Bastet*, 2016. Oil on canvas over panel. 36 × 36 × 2 in. (91.4 × 91.4 × 5.1 cm); *Self-Portrait with Ray*, 2017. Oil on canvas over panel. 36 × 36 × 2 in. (91.4 × 91.4 × 5.1 cm).

FLORA WIEGMANN

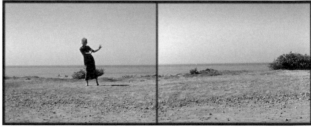
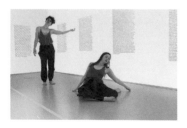

Top, left to right: *Sketch for Wandering, Left Camera*, 2009. Archival photo, ink. 3 ⁵/₈ × 5 ⁵/₈ in. (9.2 × 14.3 cm); *Wandering (still)*, 2010. Dual-screen 16mm film transferred to digital. Color, sound, 11:24 min.; **Bottom, left to right:** *Dyslexicon*, 2014. Text and performance, c. nichols project, April 2-30, 2014; *Halo of Consciousness/L'Auréole de la Conscience*, 2016. Performance, with Rebecca Bruno, Union Station, Seattle, August 5, 2016. Produced by Seattle Art Fair.

Top row: *A Feeling Like Chaos*, 2015. Two-channel video installation. Dimensions variable. Color, sound, 4:06 min.; **Bottom, left and middle:** *Falling to get here*, 2017. Single-channel video installation. Dimensions variable. Color, sound, 9:39 min.; **Bottom right:** *We was just talking*, 2017. Single-channel video installation. 144 × 144 in. (365.8 × 365.8 cm). Color, sound, 5:05 min. Installation view, *When a heart scatter, scatter, scatter*, The Everson Museum of Art, Syracuse, New York, September 16-December 31, 2017.

ROSHA YAGHMAI

P. 136

Top, left to right: *Cave by Fire (black awning)*, 2016. Cast fiberglass, enamel, silverleaf, tinfoil. 81 3/4 × 58 × 9 in. (207.6 × 147.3 × 22.9 cm); *Optometer, Door*, 2016 (detail). Gas pipe, rust, assorted corrective lenses. 96 × 21 × 3 in. (243.8 × 53.3 × 7.6 cm). Collection of Erika Glazer; **Bottom, left to right:** *The Courtyard*, installation view, Kayne Griffin Corcoran, Los Angeles, May 9-July 8, 2017; *Pipe #4*, 2017 (detail). Resin, corrective lenses, produce bags, aluminum, miscellaneous debris, steel, rust. 68 × 28 1/2 × 27 1/4 in. (172.7 × 72.4 × 69.2 cm) Los Angeles County Museum of Art. Gift of Stacy and John Rubeli.

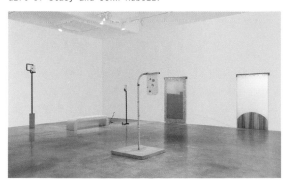

ARTISTS

JADE GORDON & MEGAN WHITMARSH
LUCHITA HURTADO
NAOTAKA HIRO
MERCEDES DORAME
SUNÉ WOODS
NANCY LUPO
FLORA WIEGMANN
CARMEN ARGOTE
JAMES BENNING
CELESTE DUPUY-SPENCER
CHRISTINA QUARLES
DIEDRICK BRACKENS
AARON FOWLER
NIKITA GALE

MEGAN WHITMARSH & JADE GORDON

"To collaborate" means to work jointly together, to cooperate, ally, unite, and it is precisely the act of joining together, of intersecting voices and ideas, that motivates Jade Gordon and Megan Whitmarsh's collaborative practice. Together, they produce videos, sculptures, installations, and socially engaged performances and workshops that are rooted in feminist discourse and activism. They draw upon techniques that foster engagement with the group rather than focusing on the individual, seeking a flattening of hierarchy in an effort to activate everyday citizens. Their interactive installations disrupt hierarchy in the gallery as well, transforming it into a space where art can be a tool for dialogues that galvanize viewers through thoughtful participation rather than passive looking.

Statues and Attitudes (2017), which took place over three days at Human Resources, a nonprofit art space in downtown Los Angeles, was described by the artists as an "imaginary educational institute and retreat center," and consisted of videos, sculptures, a free reading room curated by the Feminist Library on Wheels, and a robust schedule of interactive workshops. The videos addressed topics such as self-help and self-care, New Age spirituality, alternative therapies, and healing, and the objects on view consisted of soft sculptures, masks, and a free takeaway broadsheet written by the artists. One of the short videos, The Open Door, appeared to be a therapy-session dialogue between two young women (played by Gordon and Whitmarsh) who question their happiness and fulfillment. The video cuts from Gordon and

01

Whitmarsh, wearing unitards and wigs, to stock footage of lush forests, waterfalls, and beaches, and is set to an ambient soundtrack that one might expect to hear in a healing center or at a spa retreat. While *The Open Door* is campy and makes subtle jabs at the New Age culture in Southern California, it is also sincere, expressing familiar worries, regrets, and feelings.

The dialogue, both awkward and clever, lacks the fluidity of a typical conversation between friends, calling attention to the very constructedness of the exchange. The script, in fact, is composed of collaged text excerpts written by the architect Buckminster Fuller, midwife Ina May Gaskin, and visual artists Louise Bourgeois, Sister Corita Kent, and Eva Hesse. Weaving together the threads of these quotes and original writings, Gordon and Whitmarsh suggest that we can look for and even find guidance and wisdom in our own words and in the words of others.

Though somewhat tongue-in-cheek in its approach, the exhibition and accompanying programs offered a space for art to function as a form of activism and engagement, connecting individuals, creating communities, and fostering productive exchanges. The workshops were indebted, in part, to feminist consciousness-raising techniques that coalesced during second-wave feminism in the 1970s and to the ideas forwarded by Augusto Boal, the Brazilian dramatist and founder of the Theater of the Oppressed, in the 1960s. Both influences reflect a commitment to empowering people in an effort to imagine and perhaps even build a society free from hierarchy, patriarchy, and oppression.

Gordon and Whitmarsh's installation in *Made in L.A. 2018* is an "institute" focusing on therapies and courses for self-discovery and introspection. Videos, fabric sculptures, and masks encourage active viewing. The videos, in particular, take us further into our shared past, from the biblical Garden of Eden to the turn of the twentieth century, subverting the Judeo-Christian myth of the degenerative female body in one and locating feminist ideas in the Victorian era in another. Utilizing text from sources such as *Our Bodies, Ourselves*, Clarice Lispector, Gloria Anzaldúa, Yoko Ono, and others, as well as their own writings culled from dreams, journals, and conversations with their children, Gordon and Whitmarsh connect the past with the present through intergenerational dialogue. —MACKENZIE STEVENS

02

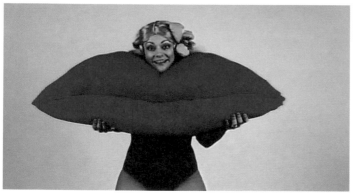

03

04

05

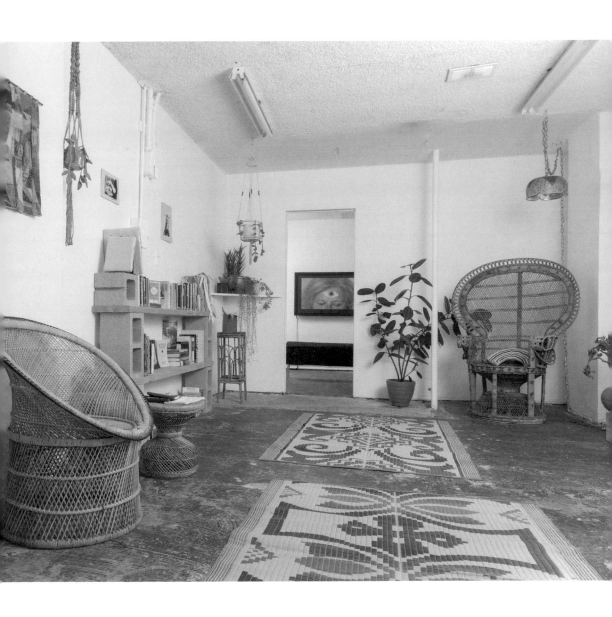

GORDON & WHITMARSH

HURTADO LUCHITA

Luchita Hurtado's career, which spans more than seven decades, is marked by her keen sense of color and form and a rigorous commitment to experimenting with different styles, techniques, and materials. She often pairs unlikely materials, such as ink and watercolor, to visually stunning effect; her canvases are sometimes cut apart and stitched back together and occasionally incorporate text.

Hurtado emigrated from Caracas, Venezuela, to New York in 1928 to join family. She attended Washington Irving High School, where she focused on art, and later studied at the Art Students League. Hurtado has associated and formed communities with artists and intellectuals every place she has lived—first New York, then Mexico, the San Francisco Bay Area, Santa Monica, and Taos. In the early 1940s, while living in New York, she spent time with artists as diverse as Rufino Tamayo, Isamu Noguchi, Marcel Duchamp, John Cage, Robert Motherwell, and Mark Rothko. Hurtado's artistic practice began during this period, and many of the works from the early 1940s intimate the direction her art would take over the next few decades: primarily drawings, paintings, and mixed-media works containing biomorphic and geometric forms.

In the late 1940s, after several trips to Mexico, Hurtado relocated there with the Austrian painter Wolfgang Paalen, and the two would later marry. Paalen wanted to incorporate ideas from science, religion, and indigenous sources in the creation of art and developed the concept of Dynaton, meaning "the possible" in Greek. In addition to associating with the artists who had coalesced around Paalen in Mexico after he emigrated from Europe in the late 1930s, Hurtado formed her own network of friends and colleagues, many of whom had come there from Europe during World War II, including Leonora Carrington, Frida Kahlo, Diego Rivera, Rosa Roland, and Remedios Varo. Hurtado, too, was invested in mysticism and spirituality, the environment, and the body, and these interests inform her work from the 1940s on.

Hurtado and Paalen relocated in 1950 to Northern California, where Paalen formed a community of artists invested in Eastern mysticism and philosophy, and who wanted to make work that gave visibility to energy and nat-ural forces. Although Hurtado was not part of the Dynaton

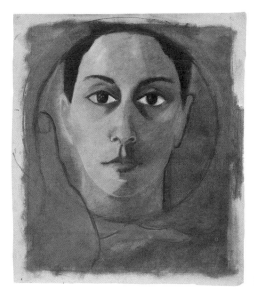

01

Group—as they called themselves—she associated with them, sharing her ideas about nature, humanity, and spirituality. These interests are evident in her paintings from this generative period, as in the radiant *Green Glows the Moon* (ca. 1949) or the organic and lyrical *Woman's World* (1948). When Hurtado and Paalen separated, she moved to Southern California, settling permanently in Santa Monica Canyon in the early 1950s. Dynaton artist Lee Mullican would soon join her, and they would later marry.

Southern California and, later, Taos (where she and Mullican would often stay in the summer) were fruitful working environments for Hurtado. A series of paintings she produced during the 1960s and early 1970s demonstrate a clear shift toward a more naturalistic representation of the human body, and a series of untitled works on paper from 1960 are meditations on sexuality and human relations. Figures crouch, bend, embrace, and confront one another in a number of these vivid ink-on-paper drawings. In the late 1960s Hurtado began painting her own naked body as viewed from above, producing dozens of works from this perspective. She considers these to be "an affirmation of self," an assertion of her own presence and power, and indeed this series coincides with the rise of the women's liberation movement in the United States. Some of Hurtado's body landscapes revel in the ordinary, with her breasts, arms, hands, and feet functioning as the backdrop for daily life; in others, her body merges with the landscape, her breasts standing in for sand dunes and her navel becoming a hole in the ground, reminding us of the interconnectedness of our bodies and the natural world. Hurtado's contribution to *Made in L.A. 2018* includes a selection of these body landscapes from the 1960s and 1970s alongside a series of surrealist landscapes made in the 1970s. —MS

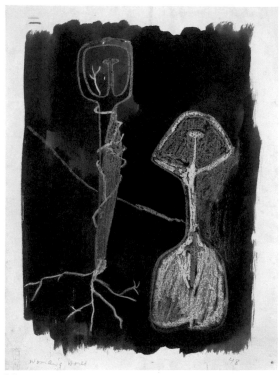

02

03

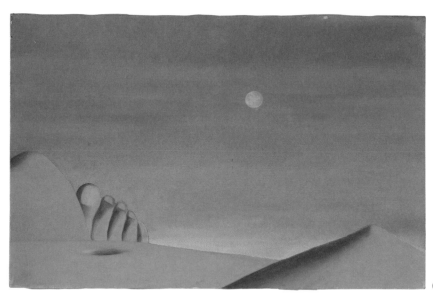

04

05

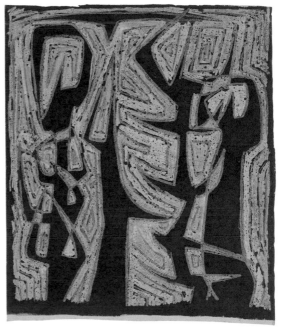

06

HURTADO

NAOTAKA HIRO

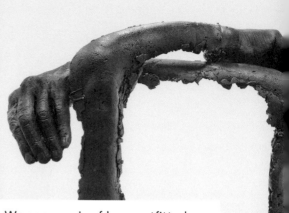

We see a pair of legs outfitted in black tights, and we hear the sound of breathing—heavy panting, really—and of liquid being sprayed against a surface. Is the figure in a bag or some large container? What is she or he doing? As Naotaka Hiro's short video *Peaking* (2016) unfolds, we come to realize that it is documentation of the artist's unique method of making paintings. In fact, *Peaking* provides a rare glimpse into his choreographed process, which often takes place over long periods of time and frequently in total solitude in his studio.

Over the past two decades, Hiro has focused largely on making works that stretch his body's capabilities to the limit. His sculptures map particular sections of the surface of his body, while his paintings record his movements within or on top of the canvas. Both processes are meant to function as mediating devices that allow Hiro to document and "engage with the parts of his body he knows are there but cannot actually see without a mirror or camera," as he puts it. He is interested in the limits of visual perception, reveling in the fragment or the partial representation, acknowledging that art may provide a particularly useful means through which to understand our bodies and ourselves more fully.

In *Untitled (Crawl #2)* (2017), we see indications of Hiro's movements on the canvas where he crawled in a circle for a predetermined and extended period of time while tracing this repetitive action with oil sticks. In *Untitled (Walkabout)* (2017), two large holes disrupt the surface of the canvas and interlacing ropes frame the edges, evidence of a strenuous physical process whereby the artist cinched himself inside of the canvas to make the work. Hiro's sculptures are also process-driven. In *Tool (Crossed Arm Above Head)*

01

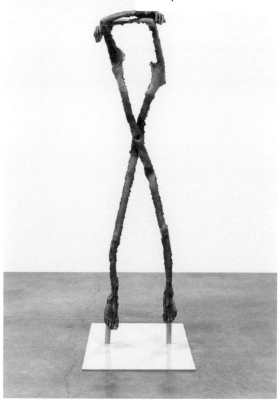

02

(2016), for example, the body is represented by one endless stream of cast bronze. Hiro's hands and feet are the only recognizable body parts, punctuating the top and bottom of the sculpture.

His drawings, which are the crux of his practice, visualize new kinds of bodies, with limbs, hair, and protuberances stretched and contorted into shapes or impossibly awkward positions. The fragments never coalesce into a fully formed, normalized body; rather, they illuminate our fractured sense of self while celebrating the ways in which our bodies are simultaneously beautiful and grotesque. Torsoless limbs are connected to each other; bodies are upended, flipped on their sides, or twisted and turned, at times spewing bodily fluids. The leaking and excreting body is central to philosopher Julia Kristeva's now canonical book *Powers of Horror: Essays on Abjection*, first published (in French) in 1980. For Kristeva, the abject body signifies a loss of control as well as a violation of wholeness and the sense of propriety on which our society is constructed. The abject elements in Hiro's drawings remind us that our bodies are vulnerable, consisting only of skin, bone, and liquids, while questioning notions of decorum and polite behavior.

Hiro's contribution to *Made in L.A. 2018* will include a number of new paintings, drawings, and a new body sculpture. —MS

HIRO

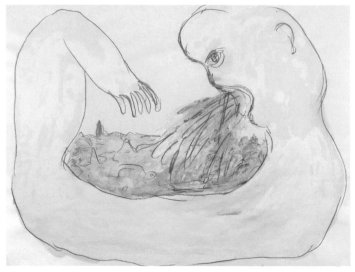

03

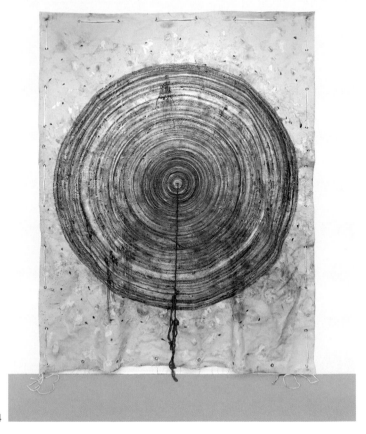

04

MADE IN L.A. 2018

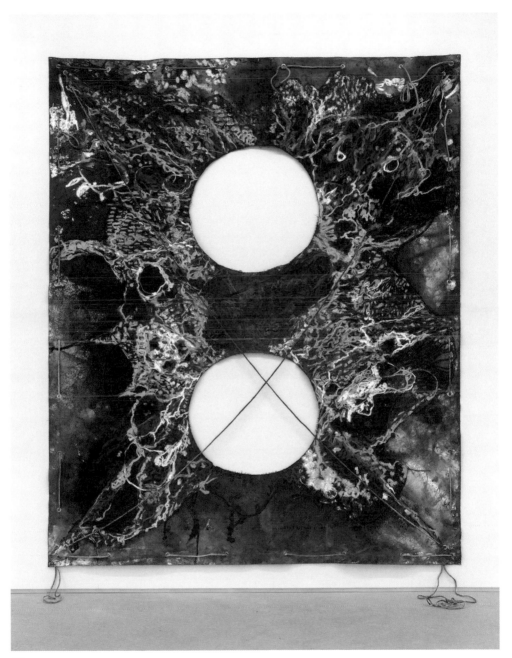

05

HIRO

DORAME

MERCEDES

Mercedes Dorame recalls the day she discovered that her people no longer existed. She was an undergraduate at UCLA, studying American literature and culture, when she happened upon a library book about indigenous people. The book stated that the Gabrielino-Tongva tribe had succumbed to widespread disease and perished quite some time ago. The Gabrielino-Tongva tribe is one of the founding communities of Native Americans in Los Angeles; at one point their territory covered an expanse from Malibu to San Bernardino to Aliso Creek. They have inhabited the Los Angeles basin for more than eight thousand years, and even though they were officially recognized by the state of California in 1994, they are still not recognized federally, which means that as a collective group they have limited access to federal funding and no designated reservation land.

Dorame is highly attuned to the tumultuous legacy the Tongva people have been handed and how a lack of land and resources can slowly pull a people apart. Within this context, she uses the camera as her main tool to capture and document the community and the family that raised her. Dorame also serves as a "cultural resource consultant," a task she usually takes on with her father, in which they visit Native cultural or sacred sites that are in the midst of construction for new development. While on these sites, they are enlisted by local officials, private entities, and/or developers as experts to identify materials, artifacts, village sites, and occasionally burial sites that are to be excavated, relocated, and, most important, resanctified through ceremony. Dorame has been documenting this sometimes contentious process of cultural resource consulting, capturing the various sites, cultural markers, and community members who work in these spaces.

Another location that Dorame has been working with for several years is her grandparents' home in Malibu. Situated at the top of a cliff's edge overlooking the ocean, this house holds many memories of the artist's childhood and is connected to sacred land the Tongva once inhabited. The home, however, belongs to the parents of Dorame's mother, who

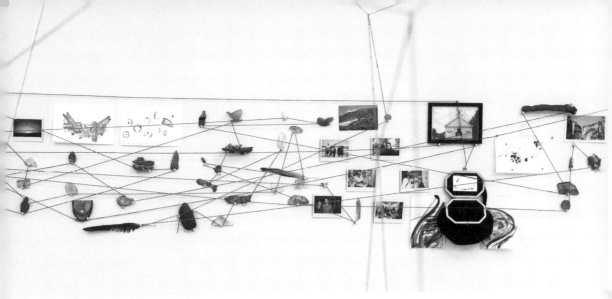

01

is non-Native, which makes the space a complicated nexus that ties back to both of the artist's familial lineages. Dorame activates the land and sprawling hillside surrounding this home by creating graceful interventions that often utilize organic materials such as red yarn, cinnamon, sage, crow feathers, large abalone shells, and coyote pelts. These interventions evoke ritual in that the items are often collected and placed carefully in order to acknowledge the land and capture a moment of vitality.

For *Made in L.A. 2018*, Dorame will bring together both bodies of work to generate a larger discourse around Native rights, notions of indigeneity, and Western implications of land ownership/access. She will also create her interpretation of cogged stones, artifacts found in Tongva territory, and an installation referencing the constellation Orion and the Yovaar, a Tongva ceremonial space.
—ERIN CHRISTOVALE

02

03

MADE IN L.A. 2018

04

05

DORAME

Suné Woods is interested in the breadth of intimacy and how it is achieved and relayed through interpersonal relationships and political events. She considers the duality of intimacy, with its potential for immense love and, at the same time, unrelenting violence. Woods uses familial dynamics, speculative narratives, and historical happenings to further underscore this potency.

In her two-channel video piece *A Feeling Like Chaos* (2015), a lone sage adorned with a rugged fur coat seems to wander aimlessly through the forest. The sage's journey is cut intermittently with various collages created by Woods, such as a grotesque fish eyeball, guns with scaly skin, microscopic bacteria, and artillery soaked in blood. This tapestry of imagery contextualizes the sage's existence as both a journey fraught by the weary encounters of the world and an ongoing trajectory of domination and violence. There are moments when the sage shape-shifts to become a wild fairy, laughing at the sound of a large military aircraft flying overhead, and moments of solace when the sage encounters another being on her journey and is delightfully held and licked with love. This piece seeks to embody the often larger social constructs and political systems that enforce conflict and colonialism.

In Woods's video *Falling to get here* (2017), a collaboration with writer and scholar Fred Moten, she looks to griot traditions and syncopated movements to ruminate on the delicate nature of relationships. Homing in on the idea of asymptote—a line whose distance from an associated curve gets closer to zero as it accelerates toward infinity—the piece weaves together several vignettes of experiences that speak to the complexities of diaspora, black intimacy, and the power structures that have historically oppressed and dissuaded it. The film opens with a young woman covered in a crushed-velvet tunic as her body contorts and writhes on a bare white mattress. Several voices seem to hover over her as they ask, sometimes in unison and sometimes as if running circles around her body, "Why can't you wait on me?" Their longing questions float back and forth with her movement, which is suspended in an incessant discomfort with no release. One is unsure whose voices are tending to her gestures: are they the vocal archives of her ancestors or the longing call of a distant lover? In the interplay of various imagery, including two interlocked women spiraling in a pool of

water and an impregnated male seahorse seeming to contemplate his existence, the spectrum of gender, identity, and bodily expectation starts to decompose as the essence of just being takes precedence.

For *Made in L.A. 2018*, Woods will create an aquatic-inspired environment in dedication to the various deities and mythologies devoted to the depths and intricacies of the ocean. Woods looks to invoke the spiritual realms and healing forces of water in its relationship to ancient ways of existing, while also commentating on the current impact of global warming caused by human intervention. Woods will employ five individual films that will intersect with one another on a circular loop, weaving together an evolving narrative of stories tied to the installation that will house them. The latter will be fabricated with a collection of recycled construction and industrial tarps that will form a tapestry in which the public can immerse their bodies as the moving images are projected on the fabric. —EC

01

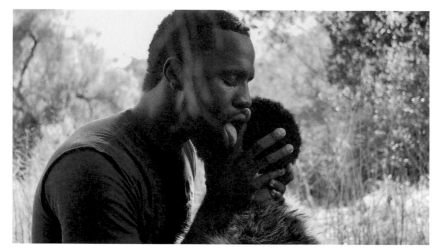

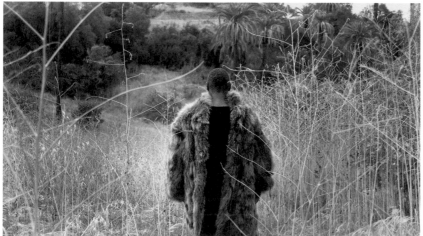

02

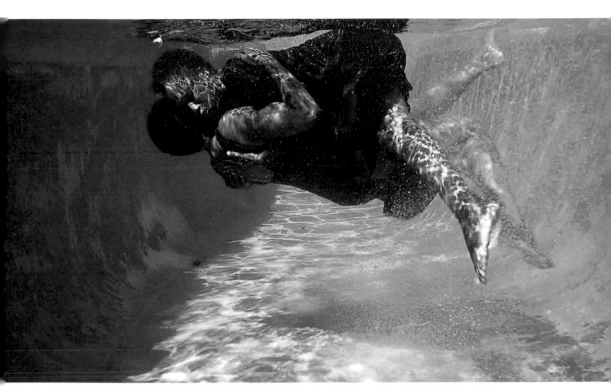

03

Nancy Lupo's works consist of intricate networks of materials, objects, and spaces. They address notions of consumption and containment, and often comprise organic materials such as foodstuffs and other banal items, including dental floss, ear candles, and trash containers, in various states of rot or use. Lupo's works are multisensorial and affective, attributes that are foregrounded by her distinctive choice of materials, some of which change over time. Her works encourage us to think deeply about everyday objects and their primary functions, as well as the latent scripts that dictate our movements and behaviors in seemingly innocuous spaces and contexts. Her work simultaneously points to and intervenes in the rituals and rhythms that make up and shape our daily lives.

Lupo's installations are often site-specific, responding to a particular locale or venue. In January 2018 she presented *No Country for Old Men* at Antenna Space in Shanghai, which included iterations of a park bench that Lupo had noticed along Shanghai's main commercial shopping street, Nanjing Road. The matrix of benches installed across the gallery floor consisted of 3,653 "ribs," collectively standing in for each day of the past decade and thereby marking the passage of a specific period of time. The ribs were produced in a range of sizes from, roughly, that of a Kraft "Jet-Puffed" marshmallow to a three-quarter-scale version of the original bench on Nanjing Road. As with the ribs in our bodies, each part is essential to the whole, functioning as both support and protective barrier. Some of the benches contained small LED flashlights, and others had stacks of locally sourced fruit encased in mesh netting and placed in the seats. Left to rot during the course of the exhibition, the decaying fruit spoke to Lupo's engagement with process, whereby the work remains in a state of constant formation.

Scale, process, and the passage of time are recurring elements in Lupo's work, evident in the installation at Antenna and in a recent exhibition titled *All Always Already*. The show included four works sited at different locations across Los Angeles in various states of visibility. The most condensed visual experience, as Lupo describes it, was located at 3400 West Washington Boulevard, where she created a field of disposable forks woven with various types of dental floss punctuated by kitchen shelves, dog

chew toys, candies, and fruit that coalesced into sections representing the four seasons. Two of Lupo's benches (*Bench 2015* and *Bench 2016*) were placed on either side of the installation, providing seating options for viewers. *Bench 2016* was inspired, in part, by the Muscle Beach complex in Venice and had been shown previously in Lupo's 1991 Dodge Caravan parked in the Hollywood Hills. Composed primarily of wire shelving, dental floss, and millet sprays, *Bench 2016* is a functional seat and yet also potentially edible, thus providing a place for rest and nourishment. Two other works were located at Venice Beach and at De Neve Square Park in west Los Angeles, respectively. Installing works outside of the gallery has become increasingly important in Lupo's practice, allowing viewers to experience her work in nontraditional spaces, such as the beach or a city park.

For *Made in L.A. 2018*, Lupo will stage a group of the benches made during the past few years alongside a new bench. Among other works in the installation will be four 32-gallon Brute containers embellished with a range of materials. —MS

01

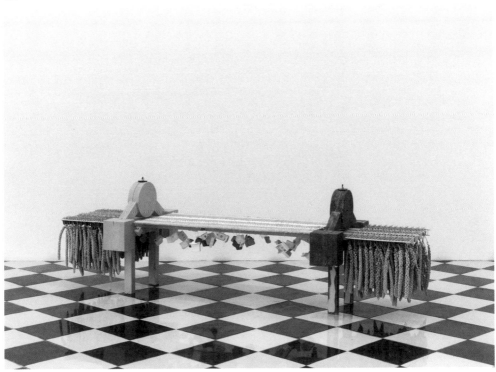

02

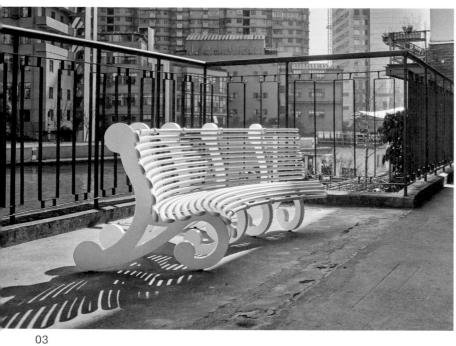

03

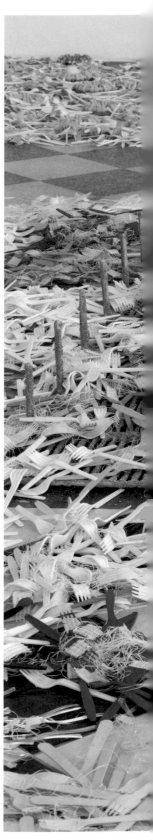

04

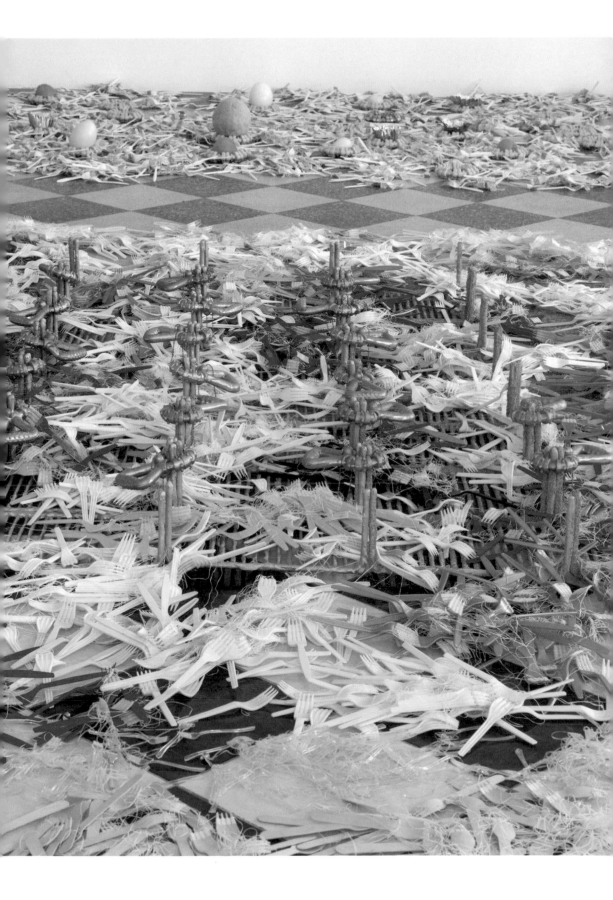

LUPO

Dancer and choreographer Flora Wiegmann looks for the spaces of intersection between the visual arts and performance. For nearly fifteen years she has located her movement-based practice within the context of visual arts institutions and public sites such as parks and beaches, rather than the proscenium or theater, in order to recall historical instances of interdisciplinary connectivity between dance and art and to search for new modes of working. Her work has clear affinities with postmodern practitioners who charted a new course for dance in the 1960s and 1970s, including Trisha Brown, Merce Cunningham, Simone Forti, Anna Halprin, and Yvonne Rainer. These pioneers had a strong foundation in classical training, but their experimentation led them to embrace quotidian movement and propose unconventional relationships between sound and choreography. Like her predecessors, Wiegmann has collaborated with visual artists on several occasions, ranging from invitations to respond to their work in a gallery setting to partnerships in which work is developed together. From the beginning of her career, Wiegmann has also been committed to creating opportunities for other artists to exhibit their work; in 2003 she and artist Drew Heitzler opened Champion Fine Art, with spaces in both Brooklyn and Los Angeles, which presented artist-curated exhibitions over a two-year period.

Wiegmann's projects often gain structure through a precise conceptual framework, which might be instigated by a site or a specific historical reference that inspires her. *Wandering (still)* (2010), for example, consisted of thirteen individual dances, each an embodiment of one of the figures in a photograph depicting German choreographer Mary Wigman's dance *Die Wanderung* from 1924. Translating the still image back into movement, Wiegmann imagined how each woman would have moved and created distinct physical characteristics for each one-hour piece. Interested in creating a space for interpretation, she did not attempt to re-create or reconstruct Wigman's actual dance but rather used it as a catalyst to create a solo work that unfolded gradually over the course of the biennial in which it was included while simultaneously drawing a connection between the contemporary moment and previous decades.

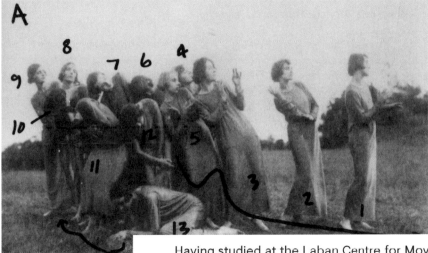

01

01. *Sketch for
 Wandering, Left
 Camera*, 2009
02. *Dyslexicon*, 2014
03. *Wandering (still),*
 2010 (still)
04. *Halo of
 Consciousness/
 L'Auréole de la
 Conscience*, 2016,
 with Rebecca Bruno

Having studied at the Laban Centre for Movement and Dance in London, Wiegmann has long had an interest in dance notation and systems for analyzing and describing movement. For *Dyslexicon* (2014), she reversed the process; rather than using a notation system like the one Laban established to document an existing choreography so that dancers could learn it in the future, she wrote notations for movements that had never been performed. During a monthlong exhibition, eight dancers (in addition to Wiegmann) were then invited to interpret her directions, which were displayed as large texts on the gallery wall, reminiscent of language-based instructional practices such as those of Yoko Ono or Lawrence Weiner. Largely avoiding specialized terms, the instructions were intended to be accessible to all, and visitors to the gallery could choose to follow them if so inclined. Indeed, *Dyslexicon* revealed the gaps between language and movement, and the pronounced space for interpretation such forms of notation provide.

For *Made in L.A. 2018*, Wiegmann has created a new piece, *Reduction Burn*—performed periodically during the run of the show—in response to a sense of vulnerability that seems to be permeating all aspects of our lives today. Pondering California's recent wildfires as a genuinely destructive force as well as a metaphor for upheaval and entropy in other arenas, such as politics and events in her personal life, the piece begins as an intact set of movements and then devolves and deteriorates. Broken up into six sections, each sequence is shown on a separate flat screen in the galleries. Each phase represents a different stage of entropy, looping around to eventually begin at a single place again. The altered movements suggest disintegration over time but also the growth and renewal that can accompany periods of concentrated, and sometimes difficult, change. —ANNE ELLEGOOD

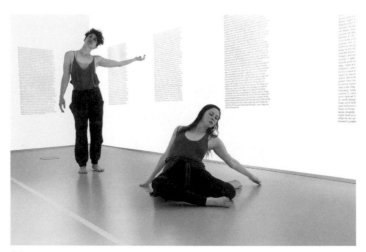

02

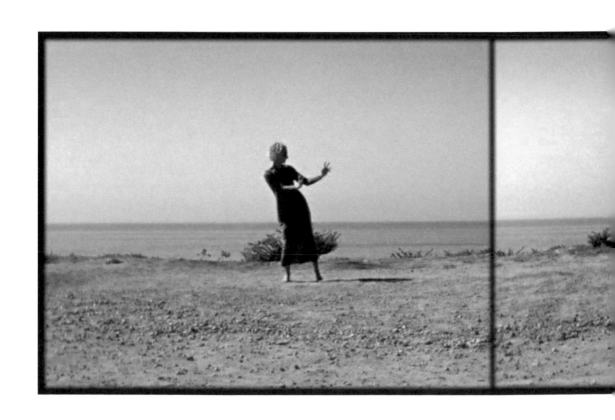

MADE IN L.A. 2018

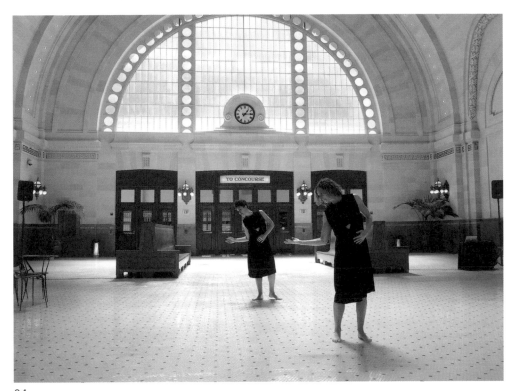

04

03

CARMEN ARGOTE

Born in Guadalajara, Carmen Argote explores ideas of place, home, and family through installation, photography, performance, and sculpture. Her personal experience as an immigrant growing up in Los Angeles is often reflected in her work. Argote's installations consider architecture and space, specifically the intimacies of home, and she frequently works with what she calls "poor materials," pointing to the beauty of everyday objects such as cardboard boxes, fabrics, and recently the ubiquitous coffeemaker. Her material choices address class, social hierarchy, and consumer culture while contending with the production and circulation of goods.

In a recent multimedia installation at Ballroom Marfa in Texas, Argote hung a curtain made of pieces of manta (an unbleached cotton with origins in Oaxaca) patterned with the familiar silhouette of standardized shipping boxes. Actual boxes were attached to one of the gallery walls and dotted the floor, metaphors for the circulation of things—goods, people, ideas—in a global context. The boxes on the floor also were reminders of the makeshift dwellings that much of the world's population calls home. Given the natural disasters that have occurred recently across the planet, the work foregrounds the fragility of the built environment and issues of inequity and privilege surrounding the idea of "home."

Curtains, capes, and other types of garments, mostly made of manta, are elemental in Argote's work. In Marfa, ponchos were painted blue and white like cloudy Texas skyscapes and installed on hangers; the garments were activated and enlivened when worn by visitors. At the Orange County Museum of Art's *2017 California-Pacific Triennial*, Argote hung long, patterned curtains in the lobby and altered them slowly over time. Every weekend she cut strips from the curtains and sewed them into capes, dresses, and skirts. The installation was in a constant state of transition, questioning the notion that an artwork can ever be finished.

Several of Argote's projects explore her family's history and her experience as an immigrant. In *720 Sq. Feet: Household Mutations* (2010), she considers the ways in which the home is a repository of memories, with traces of lived experience on the walls and ceilings and even

in the carpet. The installation is, in fact, a vestige of the Argotes' first house in Los Angeles, showing the wear and tear on the carpet. Wanting to engage further with her family's history in Guadalajara, Argote returned there for three months in 2014 to live and work in Mansion Magnolia, a neoclassical house in the city's historic district that her grandmother inherited and that now functions as an event space—home, as it were, to weddings, quinceañeras, and other social activities. Former bedrooms still contain sentimental objects such as family photographs and furnishings, and part of Argote's project was to outline each object on a thin sheet of manta. After she returned to LA, the tracings became artifacts through which she could remember and perhaps repossess this part of her history. Displayed in the gallery, *My Father's Side of Home* (2014) created a site for conversations about home, memory, and family to transpire.

For *Made in L.A. 2018*, Argote will construct a large sculpture whose form is based on an enigmatic object in the lake in Lincoln Park, which will be displayed alongside paintings made with coffee and others created from drips that accumulated over time on sheets of paper housed beneath the sculpture while it was in Argote's studio. The mound in Lincoln Park lake, as Argote has put it, is an island within an island, but in the gallery it assumes two new functions: art object and a physical record of the artist's process. —MS

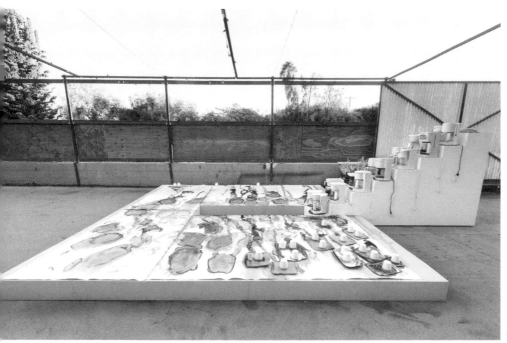

01

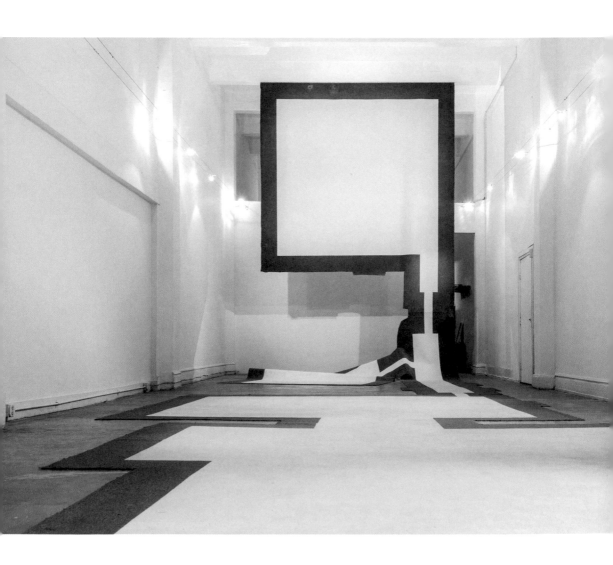

MADE IN L.A. 2018

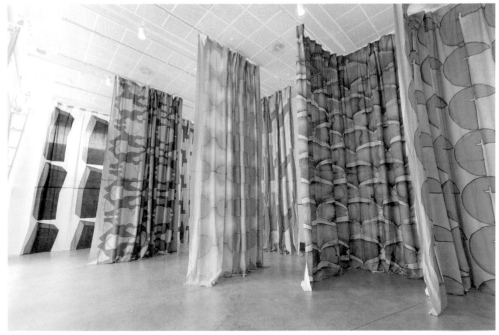

03

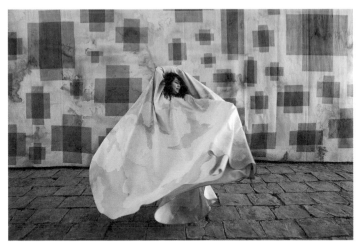

04

02

JAMES BENNING

James Benning is an independent filmmaker who has been exploring the medium for more than forty years. Through decades of experimentation and an initial allegiance to 16mm film, Benning has branched out to work with photography, archived materials, installation, and multimedia works, and has perfected the art of stillness and meditative imagery in his often landscape-oriented works. He has created more than twenty-five feature films and has been a professor and mentor to many within the field, teaching at CalArts since fall 1984.

For *Made in L.A. 2018*, Benning will construct an iteration of his multimedia installation *Found Fragments*, which features film, photography, painting, and found objects. The concept of *Found Fragments* draws from three seemingly disparate moments in US history to examine what they suggest collectively about the socio-political conditions of this country; at the same time, his own presence is somehow made implicit within or interjected into these events.

The centerpiece of the installation is a three-channel video projection installation called *Found Fragments (scorched earth, Ash 01, RED CLOUD)* (2016). The first channel features the radio transmission of a US Air Force B-52 fighter plane, which serves as documentation of the night during the Vietnam War when, within a fifteen-minute timespan, 116 B-52 planes descended upon Hanoi and Haiphong. This channel is mostly dark, with the transmission conversation highlighted through sharp, green-coded text that acts doubly to provide textual facts about the event and to further mystify the visual violence of warfare. The second channel features the slowly burning embers of a massive forest fire that occurred in 2016 in California's Sierra Nevada, which spread at a rapid rate due to the ongoing drought. Benning was one of several people directly affected by this fire and who had to evacuate. It was later discovered that the fire had been ignited when a man crashed his vehicle in the forest. Benning presents a slow-moving static shot of the furls of smoke rising from the patch of forest where the car crashed, evoking the initial scene of the fire and a melancholic anticipation of what would follow. Benning considers the implications of the drought and the aftermath of the fire as a way to interface with environmental issues and natural resource depletion.

The third and final channel features a framed drawing of a Native American man with no further context provided except for the time-lapse movement of the sun as it rises and sets over the image. The sun's presence is a glaring but gentle reminder of the loss of time in a larger discourse about the lost legacies of numerous Native American communities in this country and the lack of responsibility and action on the part of the US government in terms of providing reparations. —EC

01

02

03

04

BENNING

CELESTE DUPUY-SPENCER

Celeste Dupuy-Spencer's paintings build bridges through the intersections of sociopolitical narratives and commonalities within the human condition. Her often figurative work holds an inventory of memories and moments that, when brought to the fore, seems to enact a therapeutic release. The everyday and subtle moments of life she captures are, upon closer inspection, deeply layered, systematic, and tied to very specific historical trajectories. The artist, who grew up in rural upstate New York and then relocated to New Orleans in order to recover from addiction, paints her community: her friends, lovers, family, and favorite sports teams. Through this thoughtful focus on people in and around her life, she is able to generate a microcosm of America and its ever-evolving nature as embodied through the lived experiences of a working artist.

Love Me, Love Me, Love Me, I'm a Liberal (2017) depicts a middle-aged woman seated at a coffee table and smoking a cigarette, inhaling deeply into a neatly arranged bouquet of flowers. Dupuy-Spencer highlights the woman's contented demeanor as her gaze proves both focused yet joyfully aimless in the midst of a stack of mail and books. The carefully chosen texts that appear in the painting further bring home the intention of its title. The woman's mug boasts an "I love NPR" label, and her book is titled *The Burden of Blame: How to Convince People That It's Not Your Fault*. Dupuy-Spencer's expressionistic style underscores the satirical nature of the composition and highlights the dangers of complacency within certain political camps, something that affected the outcome of the most recent US election.

Dupuy-Spencer's 2017 painting *Durham, August 14, 2017*, depicting a doubled-over statue amid a lively crowd, makes a direct reference to recent events. Shortly after a white supremacist rally in Charlottesville, Virginia, where a group composed mainly of white men protested the desired removal of a statue of General Robert E. Lee, this monument dedicated to a confederate soldier in Durham, North Carolina, was forcefully brought down at the base of its neck by a group protesters, who pulled so hard that the statue crumpled over like a corpse. Through her handling

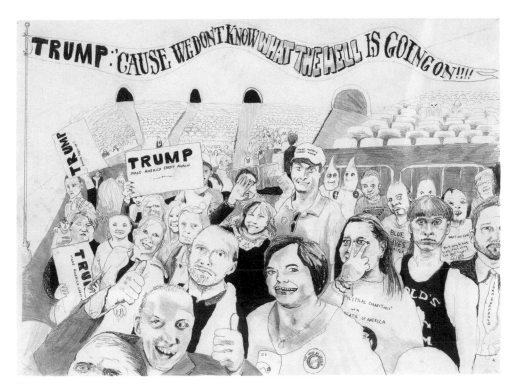

01

01. *Trump Rally (And Some of Them I Assume Are Good People)*, 2016
02. *Cajun Navy, August 2016*, 2017
03. *Durham, August 14, 2017*, 2017
04. *Sarah*, 2017

of the subject, Dupuy-Spencer illuminates the monument's fallen legacy, accentuating the contorted gestures of its figure. At the same time, the lower bodies of the people surrounding the statue evoke the diversity of those collectively advocating for the removal of monuments celebrating racially charged figures from this country's past. Perhaps the impulse to capture this moment stands as a glimmer of hope in trying and oppositional times.

For *Made in L.A. 2018*, Dupuy-Spencer will show a body of her most recent paintings and works on paper that serve as snapshots of her everyday experiences and insights. The work will range in scale and context from *Cajun Navy, August 2016* (2017), a portrait of a group of civilians who banded together to assist in rescuing people during a mass flood in Baton Rouge, Louisiana; to *Little Smoke* (2016), in which smoldering embers in a grill on the back porch of a drought-affected hillside in Los Angeles echo a furl of smoke in the distance; to *Sarah* (2017), a portrait of the artist and her girlfriend sharing a moment of solace and massaging each other's foreheads. —EC

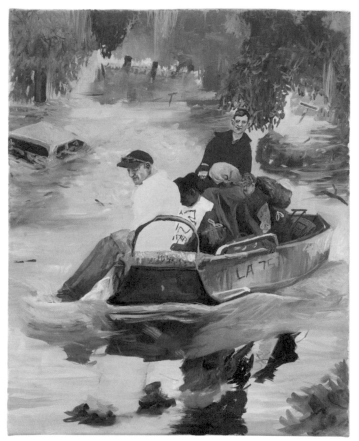

02

03

MADE IN L.A. 2018

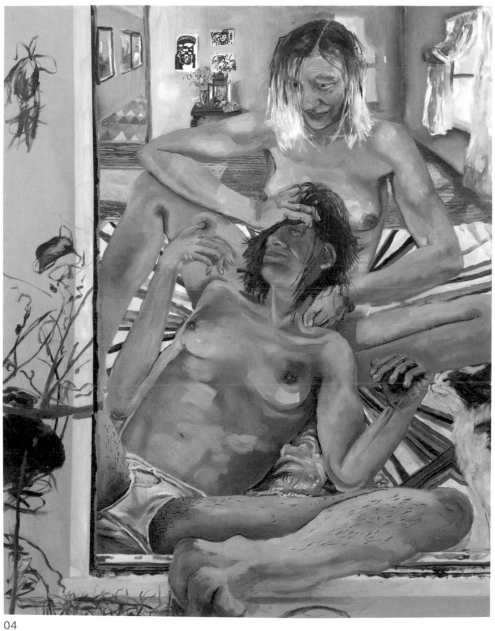

04

DUPUY-SPENCER

CHRISTINA QUARLES

Christina Quarles's deliberately ambiguous figures are hemmed in by the picture plane—pushing up against the limitation of the frame with arms and legs akimbo and pressing the surface with flexed feet. They seem to acknowledge the safety and comfort of this demarcated space while nudging it ever so gently past a point of stability. What at first seems counterintuitive soon becomes evident: Quarles's subjects find enormous freedom within these carefully articulated spaces. Although her choice of imagery is consistently limited to bodies in abstracted interior environments, her paintings are overflowing with a wide range of colors, textures, patterns, and techniques for applying acrylic to canvas in what she has called an "excess of representation." These distinct ingredients then intersect, merge, and collide across strange yet beautifully intimate scenes in which one body is nearly indecipherable from another, calling into question the very notion of a fixed or autonomous sense of subjectivity.

Often the only context for her subjects is the occasional kitchen table with a vase of flowers so stylized they could be wallpaper or a window that suggests the scene is an interior. Planes of pattern and color intersect both the space and its inhabitants, although never cleaving them violently from their site or from each other, but rather providing an opportunity to dwell in more than one space at once. Quarles has described this facet of her work as emphasizing *dislocation* over location, and one senses the ways in which this refusal, among others, becomes a site of empowerment. While playfully trafficking in visual clues of domestic space, her "dislocations" also propose otherworldly scenes, especially in how the figures seem unhinged (in the best possible sense), beyond the limitations of gravity or physical ability.

Quarles also refuses legible signifiers of subjectivity, underscoring the ways in which identity is often placed upon us and the inherent politics of representation that inflect how images are rendered and understood. A queer black woman whose fair skin often precludes her being

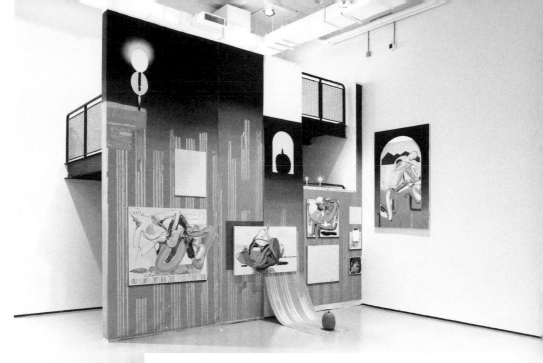

immediately categorized, Quarles has always understood her own position in the world as unstable and in transition. In her paintings, skin tones range from orangey-pink, to yellow, to shades of blue, to a washy black—at times combined in a single figure—and facial features often lack detail or are obscured from view, further challenging our ability to make assumptions about these creatures who in their complete isolation and interiority still invite our prolonged gaze. For *Made in L.A. 2018*, Quarles has returned to installation mode, creating a large-scale environment that inserts paintings into panels that cover the walls with floral patterns, like wallpaper, and trompe l'oeil renderings of her intersecting figures.

While the majority of the paintings seem to be exploring intimacy between two people, it can take a few moments to decipher how many bodies are actually present. Some suggest a larger cohort or perhaps the same figure depicted across time and space. Individual identity relayed through portraiture—such a long-standing subject in the history of painting—is thus usurped in favor of the radical potential of thinking about nonconforming relationships and about community. Even in their ambiguity, the entwined couples in Quarles's alluring works are understood as queer, a term that, like the paintings themselves, is devoted to the position that meaning should not be static or fixed and that there is power in destabilizing expectations. —AE

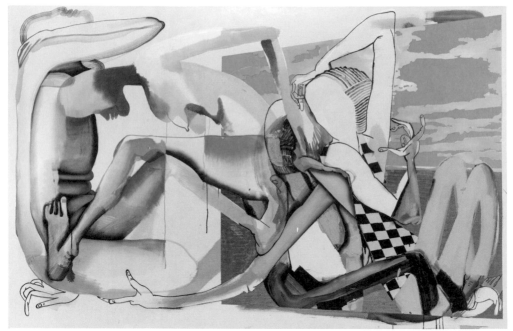

02

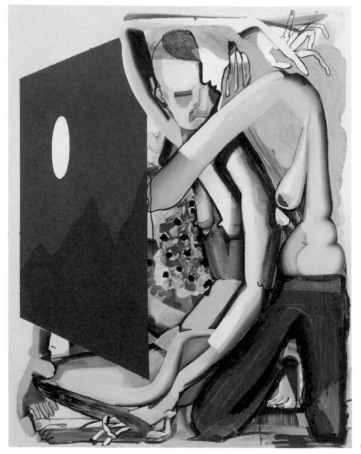

03

MADE IN L.A. 2018

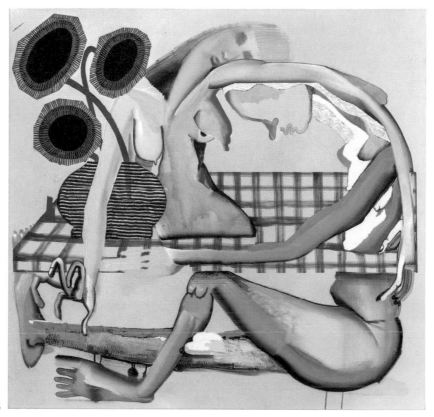

04

05

QUARLES

DIEDRICK BRACKENS

More than two hundred years ago an African American indentured servant living in the home of Mary Pickersgill assisted in creating the Star-Spangled Banner flag. Assembled in only six weeks and measuring 30 by 42 feet, it loomed over the base of Fort McHenry in Baltimore during the War of 1812. Its presence was considered to be the inspiration for the national anthem, penned by lawyer Francis Scott Key, and its iconic stars and stripes stand as the genesis of the American flag as we understand it today. Years later it was acknowledged that the servant's name was Grace Wisher, and although she participated in creating one of the most iconic signifiers of this country's liberation, her presence remained largely invisible.

Over the course of his career, Diedrick Brackens has created several abstractions of the American flag. As they intertwine with ongoing bodies of his work, their titles—*bars n' stripes* (2014), *disconnected, drown, drench* (2015), and *always look away* (2017)—invoke the weight of their pictorial relationship and ongoing tension with marginalized communities and current sociopolitical topics in the United States. Brackens thoughtfully employs the language of weaving and textile making to consider the intersections of race, class, and gender.

Brackens additionally asserts a personal and political trajectory of queerness in his work. In his ongoing series of "bandages," he creates long vertical panels of hand-woven and tea-dyed cotton that are often displayed en masse to create a collective space of visual healing. These objects, which take the shape of common store-bought bandages, reveal small, restrained bursts of rainbow

01

coloring where the center of the bandage that covers the wound typically would be. Brackens places industrial yellow cleaning gloves on a rack near the installation, which allows a broader imagining of the work: although oppression brings pain and injury, there is still space for care and purification. Brackens also frames himself within a historical lineage of what has often been considered to be "woman's work," contending with such preconceptions through the act of weaving generated by a queer man of color. He also applies this bursting technique in his piece *10-79* (2015), a rectangular tapestry that lies flat against the wall and at first glance reads as warm and inviting but upon second witness contains areas of deep red blotches that appear to seep uncontrollably through the fabric. At this juncture, the fabric seems to self-actualize to reveal itself as an abstracted figure; the blotches become gunshot wounds while faint blemishes of ghostly hands and limbs come to fore. The title, *10-79*, refers to a standard police code used internally to alert the coroner's office of a fatal exchange. Brackens leads with this notion to consider the vulnerability of the black body and its intimate relationship with death.

From a formal perspective, across his larger practice Brackens carefully hand weaves every object with calculated algorithms that stem from the cultural history of each technique. These algorithms inform the thread count, coloring, and overall patterning of the works. He often blends West African weaving and European textiles into a single piece to highlight the complexities of identity, especially as it relates to being African American, and the complicated histories and intersections that give birth to a group of people.

For *Made in L.A. 2018*, Brackens will expand upon his current body of work with a focus on familial history and childhood memories. He will introduce a new series highlighting the figure and incorporating various hand-dyed fabrics that will elicit narratives that float between reality and fantasy. —EC

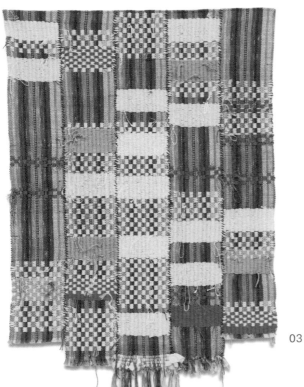

03

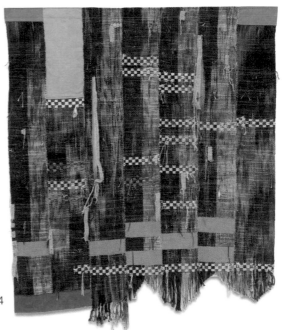

04

BRACKENS

Aaron Fowler is a painter and a collector, and his studio is filled with the odds and ends one might find in a junk shop, by the side of the road, or in a Dumpster. His mixed-media sculptural objects are composed of these carefully scavenged materials, which consist of doors, car parts, ironing boards, pieces of rope, old signage, hair weaves, and CDs. These items are incorporated into intricate, large-scale works that are often attached to the wall and resemble complex bas-reliefs or sculptural assemblage. Combining history with personal narratives—including representations of friends and family members as "the true beings they imagine themselves to be"—Fowler brings past and present into a productive dialogue that addresses American history, identity, black culture, and music.

AARON FOWLER

Fowler often appropriates imagery and compositional strategies from history paintings in order to contend with issues of race, culture, and empire. *Started from the Bottom Now We're Here* (2013) is a massive relief-like sculpture made of wooden boards, colorful textiles, pieces of cardboard, paint, and clusters of cotton balls. The focal point is a group of black men on a boat, though it is unclear if they are friends, family, important historical figures, or characters culled from the artist's imagination. Fowler provides other clues, however, for understanding the scene at hand. The cotton balls, for example, form landmasses on the blue painted background, a reminder of the slave trade and the cotton plantations that were once abundant in the South, and a nod to racial divisions in the United States. In *Family* (2015), pioneers occupy the space outside a makeshift covered wagon. A prominently placed sign in the wheel reads "Family," which may refer to the families who followed westward expansion in hopes of a better life and opportunities; Fowler's own family in Saint Louis (where he was born and raised); and the Native American families whose lives were forever altered by the waves of settlers who soon occupied their lands.

Fowler's first solo exhibition, at Diane Rosenstein gallery in 2016, included a combination of large- and small-scale mixed-media works, many of which extended beyond the composition onto the wall or the floor. The title of the show, *Blessings on Blessings*, was drawn from the lyrics of American rapper Big Sean's song "Blessings," released

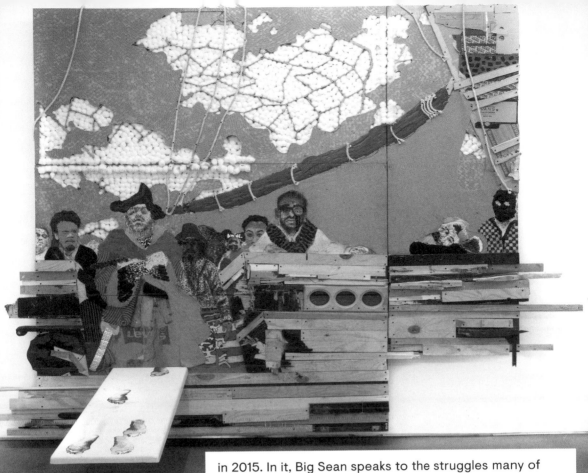

01

01. *Started from
 the Bottom Now
 We're Here,* 2013
02. *El Camino,* 2017

in 2015. In it, Big Sean speaks to the struggles many of us confront but remains hopeful and appreciative of his many blessings. Fowler shares this sensibility, and his works often carry a profound optimism while retaining a healthy skepticism.

Made in L.A. 2018 includes *El Camino*, which Fowler began to construct in 2017—a life-size hybrid of an El Camino and a covered wagon made of car parts (many of which were found on the side of the road), hair weaves, CDs, and other bric-a-brac from his studio in Inglewood. A figure representing Fowler's girlfriend sits in the driver's seat, and when the large box fan placed atop the car's hood is powered on, a tapestry of hair weaves blows in the wind. Mobility, freedom, beauty, and diversity—Fowler's car is a symbol of Southern California life and the communities that call this place home. *When Rain Is Right I'm As Right As Rain* (2018), a large-scale assemblage that combines everyday materials with pop-culture signifiers, is also included in the exhibition. In addition to hair weaves, lights, a Nike Air Force 1 shoe, Frosted Flakes cereal, Minion piñatas, and other objects, the work includes video documentation of Fowler beating a piñata until it breaks open, spraying orange paint onto the surface of the work. —MS

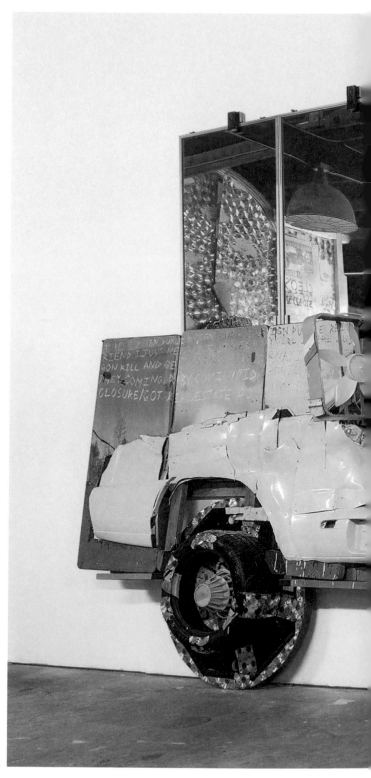

02

MADE IN L.A. 2018

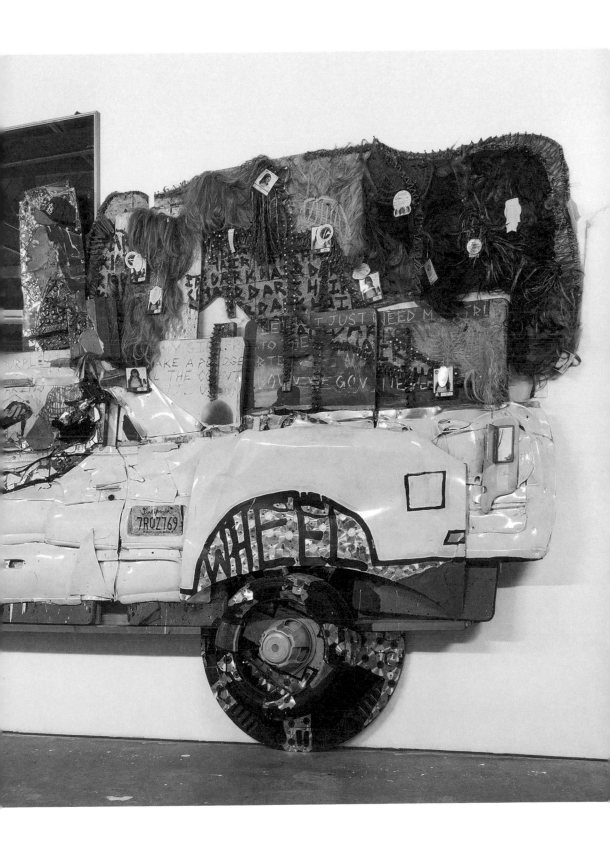

FOWLER

Nikita Gale's practice explores the idea of interpersonal relationships and how consumer products and technology-driven objects contribute to the evolution of these exchanges. Gale employs these objects in installations and sculptures in order to heighten their presence, relieve them of their societal functionality, or reveal their inner workings. Through this explicit handling, Gale also considers the term "reproduction" as a bridge to understanding how both biological and mechanical repetition work together as agents of transformation.

For her 2016 MFA thesis show at UCLA, *LOW MAINTENANCE*, Gale focused on the object that she interfaces with the most in Los Angeles: her car. Thinking about the car as a frame or space for potential experience, Gale constructed a large-scale installation that incorporated moving image and sculpture, referencing various models of the automobile and the historical underpinnings of the industry. Housed in the center of her environment was a brutalist vessel equipped with a projection screen and protruding metal bars. The viewer could sit in the semi-functional structure, and the screen featured a large-scale projection of Gale's hands on her steering wheel, scrolling through Google Maps. As she searches for directional assistance, the viewer becomes implicit in her actions, taking on the role of driver or passenger, further underscoring the ways in which mechanical objects dictate and carry out our everyday decisions.

In her 2017 show *RIFF FATIGUE*, Gale took on the iconic sensibilities of the electric guitar and its contributions to the history of rock and roll and contemporary protest. Employing materials such as upholstery foam, earplugs, XLR cables, conductive copper tape, guitar strings, and secondhand bath towels, Gale actively stripped these objects of their usual functions to home in on the complexities of silence as a sonic foundation. In her piece *FEEDBACK BAFFLER* (2017), a microphone stand is wrapped in foam where the microphone typically meets the voice. One appendage of this object is then positioned against a towel that has been stretched like a canvas and hung on the wall. This aggressive encounter, housed in various textures, elicits a tension where the two objects meet. There is something strangely figurative about the object and its posture that transforms it into a proxy for a musician laboring away in the recording studio. Gale's

carefully crafted installation, along with titles that reference songs from figures such as Michael Jackson or Tina Turner, considers the notion of riffing and how this can expand beyond a musical idea to encompass repetition in social movements, political structures, and so on.

For *Made in L.A. 2018*, Gale will continue investigating the languages of sound and the desires of protest. She will construct a large-scale wall installation featuring projected text and collaged material to further consider bodily function and performance, configurations of riots, and societal safety. —EC

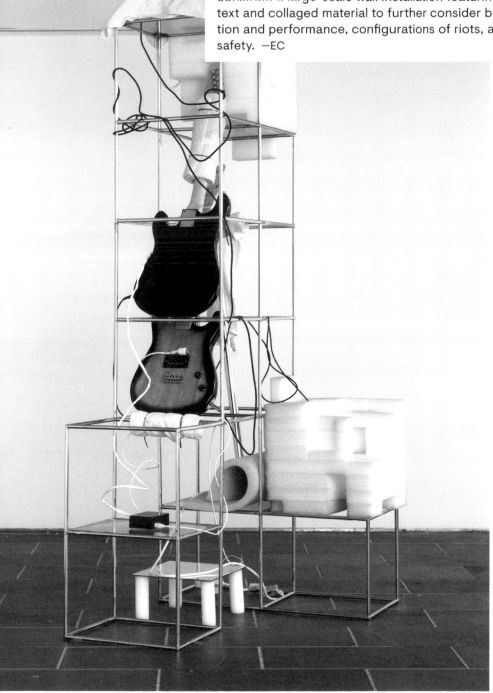

01

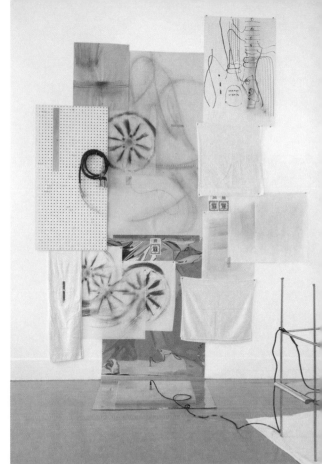

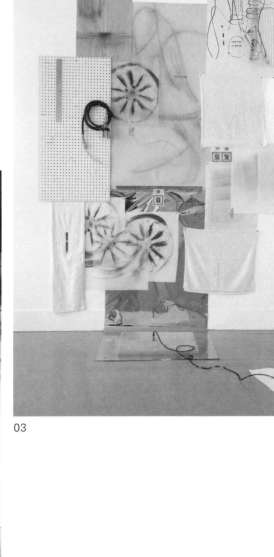

03

02

BRIDGING AND BREAKING

Participants:
Erin Christovale

IN THE SPRING AND SUMMER OF 2017, WE MET WITH
SMALL GROUPS OF PEOPLE WHO ARE INVOLVED IN
CULTURE IN LOS ANGELES—ARTISTS, CURATORS,
WRITERS—ON FIVE SEPARATE OCCASIONS. DURING
THESE INFORMAL GATHERINGS, WE TALKED ABOUT
WHAT'S HAPPENING IN THE ARTS IN OUR CITY AND
HOW IT CONNECTS TO THE WIDER WORLD IN ARENAS
OF CREATIVITY, POLITICS, AND CRITICAL THINKING.
THESE CONVERSATIONS HELPED SHAPE OUR
THINKING ABOUT *MADE IN L.A. 2018*, AND WE ARE
GRATEFUL TO ALL WHO PARTICIPATED. IN AUGUST
OF 2017 WE RECONVENED WITH A GROUP OF PEERS
WHOSE ACTIVITIES CONTRIBUTE GREATLY TO OUR
COMMUNITY AND WHOSE VOICES WE VALUE FOR
THIS ROUNDTABLE DISCUSSION.
—ANNE ELLEGOOD AND ERIN CHRISTOVALE

ANNE ELLEGOOD When the museum initiated Made
in L.A. in 2012, it was in some sense a celebration of Los
Angeles as an art center. We wanted to reinforce that there
are serious artistic practices happening here. But it seems
obvious now that LA is widely recognized as a vital and
important cultural city. Nonetheless, with any type of cele-
bration of the local, you want to make sure it doesn't come
across as too provincial, as disinterested or uninformed about
the wider world. I think past Made in L.A. biennials have made
it abundantly clear that artists here have ties far beyond the
local, in terms of both where they come from and the scope
of their interests and activities. Yet I remain interested in
examinations of the local right now. So when we talk about
what makes Los Angeles special or a place that artists and
creatives gravitate to, what exactly is the draw?

ERIN CHRISTOVALE We were interested in bringing
together this roundtable because we see you all as leaders in
your respective communities, and think the work you're doing
is innovative, both curatorially and artistically. What do you
think distinguishes LA from other art centers?

LAUREN MACKLER As someone who came here
eight years ago, I've wondered about the impulse to move
west for so many people like myself from art communities
elsewhere. There are many things about Los Angeles, but
one of the more striking for me is the leveling of generations
and disciplines—the fact that people from across different

Vaginal Davis and Manuel Vason, *Tarot*, 2009. Performance commissioned by SPILL Festival of Performance, London.

Facing: Hock E Aye Vi Edgar Heap of Birds (Cheyenne-Arapaho), *Native Hosts*, Claremont, California, 2013. Twenty steel panels. 24 × 36 in. (61 × 91.4 cm) each. Heap of Birds created twenty signs recognizing sites and landmarks in the Los Angeles basin in the indigenous Tongva language and situated them on the Pitzer College campus. *TEVA'XA'NGA* is the Tongva word for Los Cerritos.

generations, different practices, can come together and make a community or at least have creative and productive interactions. And then, of course, the sense of space, of being able to do your thing at what feels like the edge of the world.

NAIMA J. KEITH I agree. I'm a native Angeleno but spent five years in New York and then came back here, wanting to be in a thriving art community but one that has space and where you can be a part of something new and exciting. There's this idea that you can do your own thing but still participate in a larger community. You can retreat to let something manifest and grow, and then you can let it enter the public when you're ready. There's a warmth that literally and figuratively inhabits this idea of space, this idea of experimentation.

EC Thinking about LA often starts with a consideration of the wave of migrations that have brought people here. And for me, that's centered on black people who migrated here from Texas and Louisiana. The foundational neighborhoods for them were neighborhoods like West Adams, Venice, downtown. What led to those migrations? What were they desiring when they came here? It reiterates this idea of physical space,

mental space, but also natural space—the ability to have some sort of mental clarity or aesthetic value within all the natural beauty that's here. And what that means for people, especially people who historically have been oppressed. The West was the new frontier. And I think of the people who have been here longer than we can even imagine—the Tongva people and other indigenous communities—and how historically this space has shifted with the various communities that have descended upon it.

JENNIFER DOYLE I also moved here from elsewhere, in 1999. One reason I chose LA was that Vaginal Davis lived here; she was the center of a world that I was already appreciating from a distance, and I wanted to be a part of that. I wanted to spend my Sunday afternoons at her punk-rock beer-bust, Sucker.[1] That kind of space—a queer and racially mixed fusion of music and performance—has been more important to me, personally, than art-world spaces like galleries and museums. It actually took me a while to find the voice in my work for explaining why there's something that happens in performance and club spaces that really can't happen in a gallery, that can't happen in a museum. And that's okay because it also can't happen in a classroom, and that's where I work. [*laughter*] So I didn't feel like an outsider in LA. I just felt like somebody who was new to town. These spaces are so welcoming.

AE I'm interested in the idea that LA is a welcoming city, as someone who also chose to move here, now over eight years ago. If you want to engage with a community—and there are many different communities here, of course—it always feels that you're welcomed in, if you have the desire and make the effort.

LM There's a real resistance to social space in the way LA is structured, just by its sprawl and its scale. But that means that

ROUNDTABLE

you make extra effort, you create social space. So on one hand that makes Los Angeles feel welcoming, because you're going to intentional spaces. And then there's this other thing that might be a bit more flimsy and more of an illusion, which is the film industry and the ways it has depicted Los Angeles. You Angelenos might not experience it in the same way because you're from here, so you get it. But for outsiders, we have to shed this preconceived picture of Los Angeles, which plays itself in so many different situations in your life before you get here.

EC What do you think it takes to sustain a community here?

RAFA ESPARZA I'm always thinking about history. As I walk through the city, I'm always imagining the many changes the landscape has undergone and attempting to imagine what the landscape looked like before all of these different migrations happened. And it makes me want to acknowledge them—in the brilliant way that Edgar Heap of Birds does with his Native Hosts series of signs[2]—to say, "The Chumash and the Tongva are your hosts." I think this helps create a sensibility that shapes the way people can navigate the city. To acknowledge all the different layers of generations, of migrations. But also to acknowledge some really hard and difficult truths, violent truths. Because there's been a great deal of violence that has disappeared a lot of ancestors. So when I think of what the city is now, I think of what it takes to sustain a community, but also how different communities and different people have survived and thrived, and what that looks like.

NK How do you not just survive but actually *thrive* in your existent community without feeling like you're being moved out? How do you maintain the traditions and the nuances of that community when everything around you is changing?

LM Let me throw a spear in the question of what makes the community sustainable in Los Angeles—to propose, as someone who runs a micro-institution among many others and has seen many things come and go, that maybe the project is not sustainability. Maybe it's the opposite. There's something really interesting about an ecosystem in which things don't have to last. And the temporary nature allows them to be extremely risk-taking and light and passing and, in that sense, really responsive. Which is not the case with major institutions that have to hold history in a very important way.

NK But, for some reason, when something ends, it's often synonymous with the negative, with the idea that you couldn't sustain yourself.

AE Rather than the idea that you're simply moving on to something else.

Allen Ruppersberg,
Al's Room from *Al's
Grand Hotel*, 1971.
Environment/happening
first presented at
7175 Sunset Boulevard,
Hollywood, May 7–
June 12, 1971.

LM And making space.

AE This prompts me to ask: How do you each see the ecology of institutions in LA? This includes major institutions—the Getty, MOCA, LACMA, the Hammer—each with their own specific histories. What is the relationship between these museums and smaller institutions like the Underground Museum, Clockshop, Public Fiction, and HR [Human Resources], as well as the new museums that are opening, such as the Broad, the Marciano Foundation, the Main Museum, and the Santa Monica Museum moving downtown and changing its name to the ICA LA? There's a lot of apparent growth in the art industry. These institutions are quite distinct from one another, and there seems to be an important balance in this ecosystem, with the larger institutions existing alongside what are, in many cases, artist-founded smaller organizations. This allows for, as Lauren was saying, impermanence and experimentation. What else distinguishes LA at this particular moment?

LM Public Fiction has always been walking this blurry line of temporariness, the unsustainable. Is it a nonprofit? A for-profit? Is it a space? Is it an idea? [*laughter*] But in response to what you're asking, I would argue it's not a question of what distinguishes LA right now, because I think it happens

over time, in a loop. For example, I worked with Allen Ruppersberg to restage his 1971 project *Al's Grand Hotel*, which was a six-week-long temporary hotel in a house. When I think of right now, I think of Ceci Moss's gallery Gas, which presents exhibitions in an eighteen-foot truck that parks in various parts of the city. Or exhibitions being held in an elevator or vitrines or a swimming pool…

AE And in someone's car…

LM And apartments … and a walk-in refrigerator. Didn't Noah Purifoy create a space in a closet around 1980?

AE Micro-spaces.

RE I love it.

LM I think scale is interesting to think about as a counter-argument for some of the professionalizing trends in our field. Some of the newest spaces are mirroring New York or other big art capitals with their veneer and scale. And these micro-institutions or artist-run projects end up creating the opposite.

EC Also, micro-macro relationships have been evolving with different institutions. I think of MOCA and the Underground Museum. The Hammer and Art + Practice. LACMA and how they're about to open a new, smaller space in South Central. And I wonder how these partnerships came about and how the institutions benefit each other.

LM In 2015 Public Fiction left its brick-and-mortar space, and since then it's been nomadic, with a really different economic model, which is that I get hosted by larger institutions like the Hammer, MOCA, the MAK Center. Instead of seeing the small institution as temporarily sustained by the larger body economically and infrastructurally, I see it as a way to push up against the existing walls of an institution. Sometimes I can question the rules, the contract, the mind-set. I see this not as an identity crisis but as a great opportunity for small institutions to question how we frame contemporary art.

RE What I'm seeing is youth beginning to validate and create experiences for each other. There are so many great parties happening right now. I feel like this is the first of its kind, even though I agree with Lauren that there can be a loop. But right now, there are youth from South Central and East LA who are organizing parties called the Night of the Blaxican. It's strange, because it can feel like you're in a time warp and traveling back to the nineties. But you have these youth, black and brown youth, who are taking back this form that was criminalized and are completely turning it on its head and making it accessible to anyone who identifies in any way. Walking into those spaces for me is like walking into a party

NIGHT OF THE BLAXICAN
OLD ENGLISH BRAND
URBAN KINGS

WHAT
BECOMES
OF THE
BROKEN
HEARTED

LOS ANGELES
PARTY FOR
THE GHETTO

BRING YOUR VATO
YOUR RUCA
OR COME ALONE

TIME: 9-2
LOCATION -TBA

FEB 18TH

Flyer for Night
of the Blaxican,
February 18, 2017.

that I did in 1995. Yet, back then I couldn't be openly queer. It's very inspiring to see youth take the initiative to create these spaces for themselves and to validate one another outside of the kind of ecology we're describing now. And I think it's tied to the way these communities or projects are able to be sustained. There's a conversation about, Does this keep going, or does it end? Or does it get co-opted?

EC I'm also seeing spaces where people are actively saying, "Certain people are not welcome." Not welcome in this neighborhood, in this community. This is less about a desire to come together and party and more about a desire to hold on to a legacy and a community that feels like it may be threatened or in danger. In thinking about gentrification and how certain art spaces are implicit in it is, I'm wondering how certain communities are sustaining themselves while feeling the threat or the brunt of this process.

AE When we think about the growth of the art world in LA, we need to ask, "What is the tipping point?" There is a burgeoning artistic community in Los Angeles that takes many forms

and taps into many different communities, which is generally seen as positive, but is there a point where we lose something?

NK When we started this conversation, we were talking about how LA has all this space, but we are becoming more aware of the fact that it's not empty space. It's space occupied by something, or someone, else.

AE And someone's getting pushed out. There is not limitless space. Gentrification is real. Erin and I have spoken with many artists who have told us that they have to move. Some have been in their spaces for fifteen or twenty years. Some moved into a studio downtown a few years ago, and there is so much revitalization of the area that their rents are being doubled. But where do people actually go? There used to be this sense that there was a lot of space for artists here. But based on all of our visits and conversations, that is not the case anymore. And it worries me, because that's one of the primary draws for the artistic community to LA. We should discuss the fact that those who are fighting against gentrification in Boyle Heights have zeroed in on art spaces as part of the problem.

JD I don't think you can talk about art in Los Angeles without talking about gentrification and Boyle Heights. It is happening in a part of the city that has one of the richest histories of a community's politicized relationship to art making. It's a center not only for the Chicano civil rights movement but also for the student movement and for the Chicano Moratorium that protested the Vietnam War. It has this incredible history of resistance and community-based organizing. The debates about Boyle Heights were preceded by the MFA walkout at USC.[3] So there's been this turmoil around MFA degrees and also what galleries represent in terms of gentrification. I think there's a widespread feeling by people who are not wealthy that the city is not a place where they can sustain their lives. It's happening around other issues too. And the art world is really caught out ... where people imagine that their work is political but what they're often doing is mining the zone of the political and citing it in their work, and reproducing a vision of the political within an institutional space in which that work has been completely depoliticized. So you're looking at work that's *about* politics or *about* resistance, but it isn't, in and of itself, *resistant*.

EC Just because you have these markers that connote diversity doesn't necessarily mean the actual exhibition will achieve the goal of being diverse, inclusive, or political. Do biennials, more than other types of exhibitions, have the responsibility to consider the politics of the moment?

RE The invitation to participate in a biennial—or any survey like a biennial—is always a question to consider. It's never an automatic yes. One has to ask, "Why?" And then, if the

BRIDGING AND BREAKING

answer is yes, "How?" My choice in 2016 to participate in the Whitney Biennial [2017] was a combination of it being an election year and the Whitney being the kind of platform that it is. And so for me to think about what I've been working with for the last couple of years here in LA, with the land and working collectively with different people, it was a moment to be able to amplify a collective presence. But I feel like the work often gets contextualized and written about in a way that misses a lot of the really important aspects of the work—for instance, issues of colonization or the relationship between Los Angeles and New York and the lands traversed, from east to west.

AE The challenge of any group show is to find avenues to honor artists' practices more fully, in ways that allow for the complexities and nuances of how artists live and work. Because without this, there can be a reductiveness or a literalization of their ideas. Erin and I are grappling with the fact that we're drawn to artists who do much more than make objects. Not that there's anything wrong with making objects. We love objects! [*laughter*] But artists are also citizens in a very rich sense. And in many cases artists are more engaged with their communities than your average citizen, and so their practices extend beyond the studio. We're also noticing, since the election especially, with the kind of rhetoric and divisiveness that is gripping our society, there's even more desire to extend practices beyond the studio and beyond object making. How can we support that?

LM I would say we should reconsider the exhibition as a format. Not throw it out, but reconsider how the exhibition can showcase the actual impulse toward revolution, as opposed to trying to contain it for an audience. I'm a big fan of biennials, because I think the audience is equipped to understand the ideas, the culture, and the time in which artists are producing their work. Especially in the context of a local biennial. So the problem is proposing that there's one way to present an artwork: to isolate it on a white wall in a white cube. That's just not true anymore. So how can the exhibition as a medium in itself propose to showcase and foster present-day practices not only in their outcomes but also in their processes? Do institutions have to have a unified front? Can curators stake a position that complements or even conflicts with the institution's position, or the artist's position?

EC This makes me think of civil rights scholar john a. powell, who talks about the concepts of bridging and breaking.[4] Breaking is when a group of people decides to break off from the larger society to preserve their culture. Whereas bridging is when a group of people actively work with other groups with the understanding that there's a shared experience of some sort of trauma or struggle. What would it mean to accommodate both of these actions in the same space? Is there potential for equilibrium?

AE MPA is calling attention to what she calls "fault lines" as a response to the divisiveness of current political debates. Her idea is to bring people together who are on different sides of an issue to have actual dialogue. It's intriguing because it seems that spaces for discourse are really fraught right now. There is a sense that many people are speaking up, speaking out, but there aren't enough opportunities to grapple with difficult issues in meaningful ways that acknowledge difference.

JD One of the challenges is that somebody who is resistant and who is mounting a strong critique may be wary of the institution's invitation to participate in a forum at a museum or a university. People are rightfully concerned about their position, and maybe even what they embody, being conscripted and put to work in the service of the institution. And then there's a different version of this, which relates to artists whose work takes place outside of institutional structures, and the question of what happens when the institution shows interest in that work. I gave a talk once about Vaginal Davis's performances as Vanessa Beecroft, which was very much about an LA artist whose work was moving in between different institutional spaces. Somebody asked me a really good question, which was, "Your whole argument seems to hinge on the value of this work being outside the institution. What happens if Vaginal Davis is invited to show at a biennial?" I had to revise my whole take because I was arguing that what she's doing couldn't possibly be appreciated by the institution and setting up a situation where the only proper ethical position for the artist is to always wither in the shadows, which is not what she wants. That's not the proper destiny for her work, and that can't be what I want for her as a critic.

AE How do we move past the idea that the institution is "institutionalizing" for the individual?

EC It starts with the history of the museum, which was built in part by displaying and stealing objects from other cultures, with a sort of ethnographic gaze. The institution is not just the art objects on view, it's not just the curators … it's the board members and what they're tied to, their politics, and the economic structures they exist in. So, it's a layered entity.

RE Programming can elucidate a lot of complexities, and this can expand the discursiveness of the exhibition … draw people in and make the conversations accessible. I am thinking about the possibility for that to happen with subjects like race. It's always nerve-racking to send out an invitation to folks I'm really eager to work with when I explicitly state, "One of the reasons I want to work with you is because you're brown." It's not the only reason obviously, but it's an important reason because of the lack of access we have to spaces. I have a great fear of people interpreting that as

being essentialized. But once we're in this informal laboratory of being in conversation and working together, the complexities of being a brown person really come to the surface. And you see it in the work. It also expands the idea of identity. The complexities become visible. And more tangible.

NK It's interesting to think about programming as a space for debate, where you can let the audience form their own opinions about something, rather than always being in support of the exhibition.

AE In addition to institutional programming, we're interested in asking artists in *Made in L.A. 2018* to generate public programs themselves. If they want to bring people into a public space to have a particular conversation, we want the biennial to create room for that. This way the programming comes from a multitude of interests and perspectives, not just from the curators and the museum's programmers.

JD In my interactions with museums, I've found that the education and programming departments have been really open. These are the places where there are more points of entry into sharing work and being part of discussions and panels and film screenings. Through programming, museums can bring more people in to participate as makers and as agents. Event-based programming is relatively low risk in terms of the expenditure of resources, and there is a lot of opportunity to bring a heterogeneous group of people into a space where they feel welcomed and recognized, and that can be a transformative experience.

EC The idea of the town hall keeps coming up. What would it mean to have a program where people can just go up and talk about how they feel about the show and to have the curators there to answer questions?

LM I'm particularly interested right now in the idea of cultural citizenship versus authority, by which I mean an audience who is informed, involved, and for whom there are stakes. So in describing a town hall, what we're talking about is a model in which an exhibition isn't about you guys as authority figures telling us, the public, what it's about, but rather opening up the situation so that every participant, be it audience or artist, is invested in figuring out what this is about.

AE *Made in L.A. 2018* features a lot of artists whose practices will be unfamiliar to the public and primarily includes new work, which somewhat circumvents the idea of authority in the sense that this is work that may not have been written about already and many of the artists haven't had significant public exposure. So we're learning and thinking through the work as we're creating the exhibition, which makes me wonder how we could make the process more visible. This

could include not just the artists' process of making the work but also the interpretation and the thinking around it, as well as the reactions to it. Whatever opportunities we can create for deep and prolonged looking that doesn't necessarily require a curator or an educator to be the voice of the object, but rather allows the public to be that voice and to be in conversation with one another, would be quite gratifying. Also, the show will include quite a bit of performance. What can be so meaningful about performance is how it provides a type of visceral experience.

EC There's also a question of hierarchy versus impact. Performances can be very impactful. When EJ Hill was doing his *The Fence Mechanisms*, I arrived late and before I could even enter the exhibition space, I see EJ being carried out by four people, and he's passed out.[5] That was my only experience of the performance, and it was so profound to witness him in that state and have to ask different people what took place.

NK Playing devil's advocate [*laughter*], there have definitely been times when I've witnessed a performance and walked away thinking, "What the hell just happened? Why was that deemed important?" There's something about an exhibition that on some level seems democratic in that you can make your own choices about what's important and what's not. Whereas with performance, I'm made to feel as if I have to praise that performance, because we're all here together, we've all witnessed it together. It feels like we have to be unified because the museum has chosen this performance, we all have to love it.

RE It does make me think about how an institution can avoid institutionalizing its practices. And performance comes to mind right away. Thinking about my experience in the last Made in L.A., having access to the museum but also having the ability to perform outside of the Hammer felt really important. I wanted to have the opportunity to exist in both places. I think curators and artists should have a conversation about how and why the work is existing in different places. In both of my experiences with biennials, the work has existed in marginal spaces of the museum. But in both instances, it's been incredibly generative to be able to have the opportunity to perform in a museum, to have this work exist in a museum, because it brings up another set of questions. The questions and the interrogations are embodied. The performance work I do was really born out of responding to being shunned or excluded from a community. And so, creating these spaces where we could view something and experience something together has been the vehicle that inspires me to want to continue to make this work outside of museums.

Slava Mogutin
performing at
Superhuman Supertexts,
Platinum Oasis,
curated by Ron Athey
and Vaginal Davis,
Coral Sands Motel,
Los Angeles, 2002.

AE Is there a sense of intimacy that gets lost in the museum for you?

RE I think intimacy can be created anywhere. But I feel like the sets of questions that I'm faced with when performing outside of the museum are more generative. Especially when you're asking the museum to support something that is not happening already in the museum. When I've seen performance work really well inside of a space, it's structured less like a program. The schedule is not rigid. Walking into it feels like you're experiencing performance but also pieces, and there's a blurring that happens.

JD When I think of performance in LA, I think of Platinum Oasis, curated by Ron [Athey] and Vag [Vaginal Davis] in 2001 and 2002.[6] They were eighteen-hour durational performance festivals in which every room of the Coral Sands Motel was filled, with a wide range of artists participating. They chose a motel that had a particular note of an urban, gay underworld. And the closest thing I've seen to that recently was *Confusion Is Sex*, where, Rafa, you and Dorian [Wood] invited the audience to drive out to the Sepulveda Basin.[7] I don't remember there being a schedule. Just people wandering around in this park and art happening. To really enjoy it, you had to let yourself get lost; you didn't know where things were or when they began or ended.

AE This relates to a subject that has come up in a lot of the conversations Erin and I are having with artists: the vulnerability of the body and notions of self-care. There is

a heightened sense of the need for self-care in our current political moment, and we're seeing this expressed in a lot of practices, and also outside of an artist's work per se, in terms of life choices and desiring a sense of community. We're all asking ourselves what situations, what support systems, what physical settings do we need in order to care for ourselves?

LM It seems like there is an interesting cultural pivot at this moment—the idea that self-care can also be an act of resistance since the outside world and politics are in many different ways exerting an assault on our bodies. In the past, self-care seemed like something you do in private and then come back into the world. Today it can be both private and public and very potent to play out in a context like an exhibition.

EC Self-care is starting to be expressed through the media in different ways, and that is giving agency to certain people whose larger experiences have deemed self-care taboo or unimportant. I think of *Queen Sugar*, the television show that Ava DuVernay produces. One of the main characters is going through a divorce and she's very uptight and starts seeing a therapist. I'm thinking about how much impact that could have, to see this black woman going to therapy, on a viewer. A similar thing plays out on *Insecure*. These are two of the biggest shows on TV that feature a predominantly black cast, and it seems important that the main characters are doing this for themselves and how that might permeate into the world.

Teen apprentice in Simone Leigh's *The Waiting Room*, 2016. Installation view, New Museum, New York, June 22-September 18, 2016.

NK I immediately think of Simone Leigh's project *The Waiting Room*, which highlighted how, especially for women of color, there have been these unspoken, quiet survival tactics used

BRIDGING AND BREAKING

either to take time off for themselves or just to meditate.[8] But it's not something you really talk about because there's this sense that you have to keep going, keep pushing. Simone's work proposes a health-care system for people of color, and in particular, women of color. There were different rooms where you could seek treatments, like meditation, yoga, herbs. Any member of the public could participate. It was one of those times when you felt you could talk openly about this desire for therapy, or self-care, or taking time out for yourself. I agree that it's now becoming a lot more socially acceptable to talk about these things.

AE It's also become a necessity, right? I think people really do feel sick ... anxiety is palpable, it's everywhere. And we're all on edge and trying to prepare for yet another traumatic experience. I'm definitely seeing a transition away from the idea of self-care as a luxury to an awareness that, in fact, it's really critical, because our bodies are vulnerable in ways that feel even more urgent today.

LM I think we're just more aware of it now. The realization of all the ways in which women's bodies across every single culture have been oppressed, held in, tightened, and controlled makes the need or the desire to counter it very polemic.

AE We're also aware that the progress we imagined we were making toward certain social justice imperatives is fragile and fleeting, that we haven't, in fact, made the progress we thought. The simple fact that somebody like Trump, who has expressed his racism and his sexism in no uncertain terms, can get elected is a pronounced setback, a real backlash, which is psychically upsetting and debilitating. People are motivated to take action, but we also just want to crawl under the covers and never get out of bed. I think those tensions are very present, and people are trying to find some balance.[9]

JD I wanted to connect this to the breaking and bridging idea. Rafa, with each project you do, it's like you create a temporary institution. And it is a breaking away of sorts. And there is a kind of care of each other that happens in your work, in the way that it holds the work of other artists. I'm speaking as a white lady professor who works in American studies, and a lot of times I hear people express resistance to statements from people of color when they say they're going to have a conversation and don't want white people involved. But what they are really saying is, "What we need from you is to maybe step back, make room, and listen." But people hear it as a breaking, which it is in a sense. But it's also a kind of self-care. And people, when they're in a position of privilege, don't always know how much that sense of entitlement is naturalized. Self-care is relational, which is one of the reasons why, when you're in a marginalized or minoritized position,

reclaiming your time is such a political act. The challenge of self-care is that it's actually labor to get to the place where you can have the time for the self-care. You have to fight for it.

LM Rafa, I feel like so much of your performance is the opposite of self-care. It seems like it asks a lot of your body.

RE [Playwright] Virginia Grise proposed in a workshop she did a couple of years ago called *Your Healing Is Killing Me* how she feels about self-care versus collective self-defense. She was specifically responding to funding campaigns for folks who didn't have access to health care. She was looking at these forms of caring for the self as pulling away resources that could be used for some sort of collective response to something that's oppressive. At the time, I was thinking her ideas of self-care were oppositional to caring for each other. But the more I've thought about it, I see that it's radical to practice self-care. I feel like you're decolonizing when you say, "This is how I get to own my body for the first time. And this is how I get to represent it. And this is how I get to show up for myself." And it can be violent. It's a severing when you disconnect yourself from the way you're viewed, the way you're treated, the way you treat yourself because you feel you have to assimilate into this culture. I think a lot about what [queer poet and theorist] Gloria Anzaldúa meant when she wrote about "entering into the serpent," about self-realization as being like shedding skins.[10] Working collectively holds the space to allow people to talk, be vulnerable, and be listened to. If people's wellness is prioritized, then that will hopefully build a stronger collective.

LM It's an art historical paradigm shift because performance art, historically, has been a kind of violence on the individual at the service of an idea.

EC There are people who are thinking about a collective unit that is intentionally designed as an act of self-care. taisha [paggett] and her group WXPT came out of her desire to build a troupe that prioritized queer people of color but that also invited people who didn't have a traditional background in dance or movement. The conversations and the community around it were just as important as the performative aspects. Some artists want to put more of the personal into their work in response to the urgency of the political climate and how important it is to state your personal narrative in considering what's at stake. EJ [Hill] has expressed to me that a lot of his performances feel like a release of a trauma that's held in the body. He is reconsidering what violence intends to do and what's on the other side of that violence. I feel like these are spiritual spaces or movements that I'm witnessing and experiencing with the artist. In a Western sense, violence is often negative, but it can be something different: a transcendence, a bloodletting, and aligned with a higher entity.

Visiting Hours:
An installation by
Bob Flanagan in
collaboration with
Sheree Rose,
installation view,
New Museum,
New York, September
23-December 31, 1994.

AE I was recently asked to reflect on an experience that helped shape my practice, and I thought back to seeing Bob Flanagan's show *Visiting Hours*, at the New Museum in 1994. Bob, who had cystic fibrosis, used S&M as a way to cope with the pain of his illness. One of the experiences you had as a viewer, while you're looking at all this provocative imagery of him engaging in S&M—hammering into his penis and hanging from his nipples—was an awareness that, for him, this wasn't violence against his own body, but rather a survival technique. Another thing that was so radical about the show was that Bob was there, in a "hospital room" in the middle of the exhibition, and you could visit with him. When you reclaim a form of violence and enact it in a way that is cathartic for yourself, rather than having violence enacted upon you, it can be very empowering. And for the most part, culturally, those gestures are misunderstood and seen as somehow abject or perverse. In a moment when there is so much violence, it's interesting to think about some of the socially sanctioned forms of violence in which bodies are being sacrificed for some cause.

JD Yeah, for entertainment and for money. It's so naturalized. Violence is folded into our lives in so many ways that we don't even see it. And some people are reclaiming their pain, just like there's a reclaiming of a relationship to violence as

an agent. And that makes it signify differently. But I should say, too, that some performances are definitely not for everyone. You inflict harm on people by not giving them a threshold through which they can choose to pass, to say, "This is for me." Or "I'm curious." There's a huge difference between surprising people and shocking them in a bad way. And you can't always anticipate that.

LM We started to talk about quality versus community. I think there is something there, especially in terms of a biennial, which asks of you, as curators and as an institution, to propose the temperature of a time and a certain community. Or to create a community by inviting a new cohort into your space. How do you make your choices, in regards to thinking about quality versus community?

NK Now that I'm at CAAM [California African American Museum], it's been interesting to think about how spaces, particularly those committed to artists of color, are saying, "We don't want to sacrifice quality either, right?"

LM For all of us—even at my scale—the goal is to make those things one. To raise the bar community-wise, so that quality and community essentially become one, because the viewership is knowledgeable and, rightfully, demanding.

Rafa Esparza performing Eamon Ore-Giron's *Talking Shit with Quetzalcoatl/ I Like Mexico and Mexico Likes Me*, 2017, atop Esparza's *Raised Adobe Ground for Talking Shit with Quetzalcoatl*, 2017. Background: sculptures by Timo Fahler. Installation view, *Tierra. Sangre. Oro.*, Ballroom Marfa, Texas, August 25, 2017- March 18, 2018.

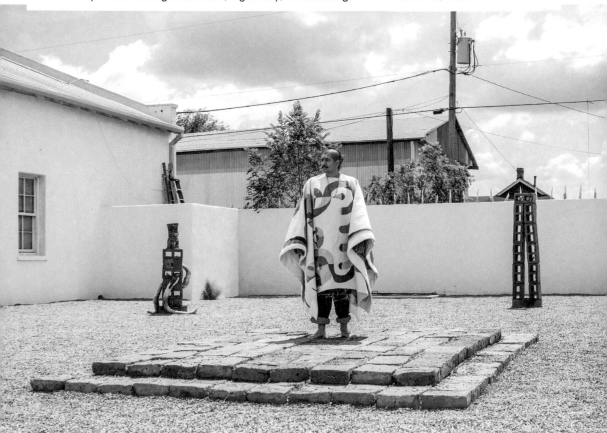

JD It's also the other way around. Look at the history of queer performance. Much of it was not considered art for a really long time, in part because it emerged in community spaces and gay bars. Spaces that were, we might say, breaking-off spaces rather than bridging spaces. You can't understand its qualities without understanding the communities from which it emerges. A lot of Chicano art from the '70s, '80s, and onward, for example, was not necessarily coming directly out of a bounded, self-appointed, politicized community space, but rather in relationship to those community spaces and in an oppositional relationship to certain art historical traditions. The trick, I think, is knowing how to support and engage those practices, which are emergent within a community, and to learn from them. But that doesn't necessarily mean that all practices are equally interesting to a contemporary art museum.

NK I agree that some performances, art objects, or shows belong in a certain context—there's a richness that comes out of seeing them and experiencing them in a particular setting. But then there's also value that's attached to being shown in a museum. There's value in thinking about diversity in terms of how work is shown.

JD There's a great book by [gender studies scholar] Miranda Joseph called *Against the Romance of Community*, which looks at the ways in which communities can only articulate themselves in relation to what community doesn't do, and who doesn't belong. That's a big part of community-based conversations ... it's the definition of the community. There are quite painful parts of community formation, the exclusionary moment.

EC At the beginning of our research for this biennial, I really wanted to make space for some older artists of color who have been in the city and who have important legacies. But one of the issues we kept running into was quality of life and access to resources that some of these artists don't seem to have anymore. They made an amazing body of work at some point, but now because of certain factors, they can't make work anymore, or their work has shifted into something different. Or sometimes their health isn't good. It was heartbreaking to see that these people don't have a system to ensure that their legacy and archives exist.

AE For some artists, what needs to happen first is a lot of archival work. It's very difficult to take that on in the context of Made in L.A. But you hope that somebody will and that there will be an opportunity later. You end up with a list of artists to return to in some capacity in the future.

RE I'm thinking back to what we were saying about how to showcase a process, as opposed to a piece, or an object. It is an interesting opportunity to think about how an institution can acknowledge a kind of failure. Part of what I love about doing performance is inherently why it's so difficult to sustain, I imagine, for a lifetime. Does a practice sort of die, or does it transform?

JD There are people who are easier to work with because their path to the institution has been easier. Every class-room is a history of exclusion. There's a world of people who could be there and who aren't because they are lacking some of what it takes—in terms of finances, life stability, having a car, and just practical stuff like that. It means they can't even be in the room. And the longer you live in LA, the more geniuses you know. Really amazing people who have contributed so much to the city. And in some cases, they have assistants and archivists, and in some cases, every day is a hustle. Never mind figuring out how to be an art historical force.

1. The weekly gathering Club Sucker ran for five years at the Parlour Club in West Hollywood (ending in December 1999).
2. Hock E Aye Vi Edgar Heap of Birds began his Native Hosts series in 1987 in New York's City Hall Park and has since made them in numerous locations. Installed outdoors in public spaces, the simple metal, text-based signs, reminiscent of street signs or institutional markers, identify the tribes that inhabited the land prior to colonization, naming them as "hosts" to remind visitors they are on indigenous land and printing the names of the site backward so that NEW YORK, for example, becomes KROY WEN, to disrupt legibility.
3. In 2016 seven students in the MFA program at USC's Roski School of Art and Design dropped out to protest the lack of promised financial support and the departure of key faculty.
4. john a. powell, "Bridging and Breaking," Haas Institute for a Fair and Inclusive Society, http://haasinstitute.berkeley .edu/bridgingandbreaking.
5. On October 25, 2014, Hill tied a jump rope to a fence that he'd installed at Commonwealth and Council gallery in Los Angeles and jumped rope for approximately two hours before he collapsed.
6. Platinum Oasis was part of the gay and lesbian film festival Outfest each year.
7. *Confusion Is Sex* was an event on August 3, 2013, that Rafa Esparza participated in with artist and composer Dorian Wood; it was organized by Dawn Kasper, Dino Dinco, and Oscar Santos at the Sepulveda Basin Wildlife Area. The area was bulldozed by the US Army Corps of Engineers in 2012, which displaced animals that had occupied the area.
8. Simone Leigh's *The Waiting Room* took place at the New Museum, New York, June 22-September 18, 2016. It was curated by Johanna Burton, Shaun Leonardo, and Emily Mello.
9. Since these conversations took place, revelations about the widespread and systemic sexual harassment and assault in Hollywood gave rise to a social reckoning in which the perpetuation of abhorrent behavior and rampant sexism in many industries, including the art world, has come to light, and movements to end the oppression and empower women, such as #metoo and #notsurprised, have taken hold.
10. Gloria Anzaldúa, "Entering into the Serpent," in *Borderlands/La Frontera: The New Mestiza* (San Francisco: Aunt Lute Books, 1987).

ARTISTS

NEHA CHOKSI

CHARLES LONG

ALISON O'DANIEL

DANIEL JOSEPH MARTINEZ

MICHAEL QUEENLAND

ROSHA YAGHMAI

LINDA STARK

JOHN HOUCK

TAISHA PAGGETT

PATRICK STAFF

Through considerations of consciousness, memory, and mortality, Neha Choksi centers her practice on the materialization of time. She is drawn to dislocation and erasure, processes that are made visible in her performance-based videos but also within her sculptures, photography, and works on paper. Temporality and transformation are foregrounded over the desire for permanence or the efforts toward preservation that are often presumed to be the impulse behind the making, display, and collecting of art. Choksi's work explores the fragility of life, how we process loss, and the productive possibilities in confronting, head-on, manifestations of absence.

Choksi has quoted the poet Zbigniew Herbert's phrase "The most beautiful is the object / which does not exist," and several of her works have set out to dismantle or destroy, sometimes with an absurdist sense of obsessive playfulness, an object or an image. An early video, *Leaf Fall* (2007–8), for example, features a group of people denuding a peepul tree, sacred to Hindus and Buddhists, until only one leaf is left. The slow and meticulous process of removal allowed for a heightened sense of presence for the single remaining sprig. Born into a Jain family and

steeped in their values (although herself an atheist), Choksi does not consider the process destructive but rather an act of prolonged care and attentiveness meant to acknowledge the inevitable entropy that attends simply being alive, while also foretelling the possibility for renewal. More recently, in *Dust to Mountain* (2016), the artist is seen kicking stone in a variety of forms, from dust and pebbles to a large hill at the end of the video, on the grounds of a landscape-supply company. In this environment that is natural yet exists because of human interventions into the topography, Choksi energetically lashes out at matter she knows will hardly be affected by her efforts. Despite the futility on display, the work recognizes the enormous potential of stone to be transformed, while her actions also serve as a metaphor for disempowerment in the face of political turmoil and dislocation so prevalent in societies around the world.

The sun has been a recurring motif for Choksi. For her 2007–10 video installation *The Weather Inside Me (Bombay Sunset)*, she filmed a single sunset from the site of a crematorium in Mumbai and then manipulated the footage and display to show slightly altered versions of the same event

on eight monitors. For her project *The Sun's Rehearsal* at the 2016 Biennale of Sydney, she created a billboard-size image of sunsets on a freestanding wall that included eight layers of wallpaper and a large cutout void where the sun was located. Throughout the run of the show, dancer Alice Cummins slowly tore at the layers of imagery to suggest the loss and decay that time enacts, including the possibility of a "final fatal sunset," as described by the artist.

For *Made in L.A. 2018*, Choksi has created *Every Kind of Sun* (2018), a multichannel video installation that includes footage from earlier solar works but transforms them by adding imagery shot in Dhaka, Bangladesh; a solar observatory in India; the dry landscapes of the Los Angeles basin; and her studio. In Dhaka, the artist worked with eleven children who were asked to make drawings of the sun. Ranging in age from seven to twelve, the children were paired with adult professionals—a climate scientist, a folk singer, and a psychiatrist, among others—and made drawings over the course of four hours. One video channel draws largely on the daily notations of the sun's activity made by solar scientists in India during the forty weeks the artist was in her mother's womb. Connecting the daily solar cycles with the temporality of human life, the works strike a poetic tone that balances the optimism we feel with the sun's arrival each day and the haunting sense of the transience that accompanies the erasure and darkness we associate with the setting sun and, indeed, our very mortality. —AE

01

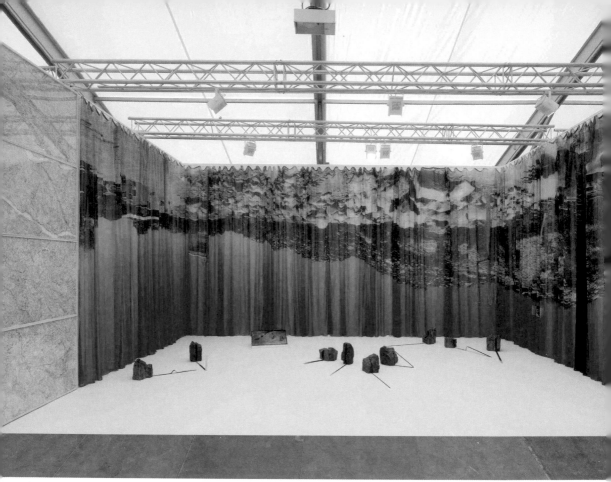

02

03

MADE IN L.A. 2018

04

CHOKSI

CHARLES LONG

For more than twenty-five years, Charles Long has examined the legacies of modernist sculpture in an effort to absorb its lessons while also pushing the medium into unexplored territories. He has the obsessive and patient disposition of a scientist seeking to uncover a hidden truth, evident in his voracious curiosity and his desire to understand all facets of his chosen materials. Compelled equally by his inner voice and by the glut of information and activities in the world around him, Long believes in sculpture's enormous capacity to elucidate how human subjectivity is informed by evolving systems of knowledge as well as the simplicity of everyday experience. His works often take up the language of abstraction while acknowledging its inextricable ties to the real, with references to music, literature, science, the environment, the figure, death and dying, capitalism, and politics. Nagged by the feeling that as sentient beings our experiences are almost indescribable, Long uses sculpture as a platform to work through these existential conundrums.

In the 1990s in New York City, Long was focused primarily on the relationship of the body to the sculptural object. His sometimes interactive works sought to engage the senses beyond the optical by, for example, incorporating sound or music or allowing the public to touch the work. Often biomorphic and brightly colored, these sculptures embraced the possibilities for pleasure in art. After the artist moved to Los Angeles in the early 2000s, his work took a rather dramatic turn. Using the natural habitat and urban detritus of the Los Angeles River as inspiration and source material, he created a number of sculptures out of papier-mâché, clay, and plaster combined with an assortment of scavenged materials that seemed to be on the verge of falling apart. Through an acceptance of vulnerability, Long mined feelings of loss and mourning, resulting in forms of pronounced beauty and mystery. His engagement with the strange abundance of the river reached its climax in a body of work that located fragility and a certain tenderness within depictions of bird shit. Struck by how the droppings of blue herons and white egrets slid down the concrete banks of the river, he

found their remarkably long, skeletal contours curiously absorbing. The slender forms of Long's sculptures, some as tall as twelve feet, are composed of papier-mâché and plaster embedded with everything from cigarette butts to bird feathers to plastic bags and managed to be at once life-affirming and abject.

These works established a formal approach that Long has returned to in subsequent groups of sculptures. Usually human scale, the works incorporate some type of base made of durable and stable materials such as steel or wood. Although fully integral to the sculpture, through its geometric shape or precise construction the base acts as a physical support for another element with which it is put into dialogue. That second component is often a kind of antidote to the base—soft-edged, handmade, and multifaceted in its shape, and experimental in its materiality. A recent group of sculptures, for example, combined pig-mented skin-like silicone rubber forms atop shiny stainless-steel bases, suggesting alien figures equally informed by nature and the newest technologies for rendering images.

For *Made in L.A. 2018*, Long has made an ambitious new group of sculptures that collectively create an immer-sive environment that is both otherworldly and grounded in present-day conflicts, fantastical and disturbingly forensic. Inspired by recent political events, the installation humor-ously yet insistently calls for an end to patriarchy and male aggression. Connecting recent cultural shifts with climate change, he has created a large scroll depicting a field of tree stumps and a large sculptural relief more than twelve feet in diameter and hanging on the wall like a fossilized relic whose surface pattern is taken from scientific illustra-tions of the cross section of a penis. Long also irreverently but with great affection interprets iconic works by male artists such as Alberto Giacometti, Salvador Dalí, Edvard Munch, and Philip Guston using this penis imagery. Despite the violence of the severed penis, the installation seeks to locate a space for quietness amid our anger and pain in order to break free of a cycle of pathos and start to find a way forward. —AE

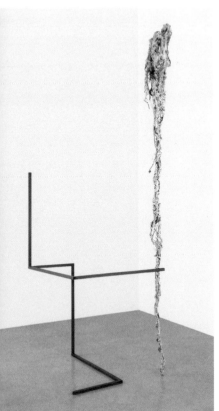

01

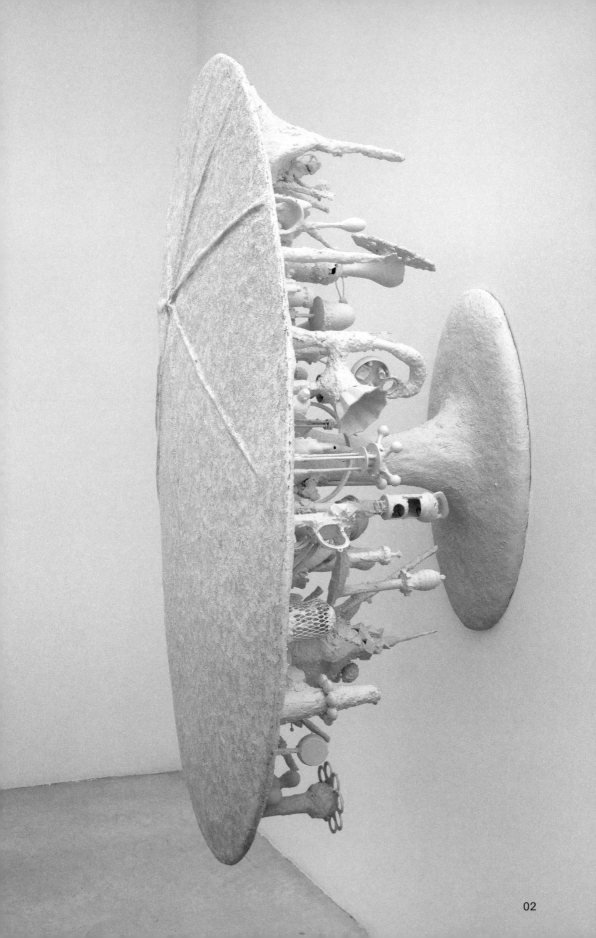

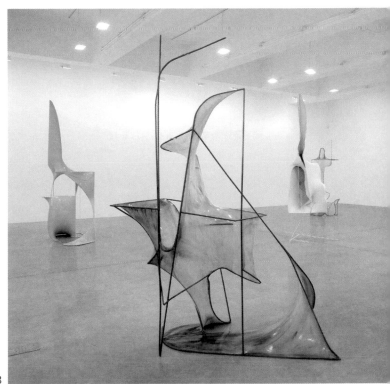

03

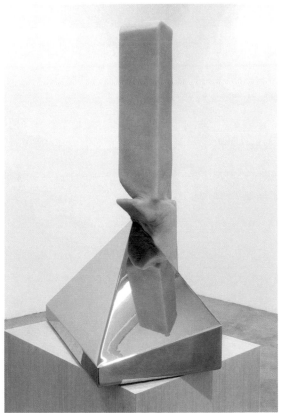

04

Alison O'Daniel's *The Tuba Thieves* was inspired by an unlikely crime: a spate of tuba thefts from a number of high school marching bands in Los Angeles. A slowly unfolding feature-length film she has been shooting scene by scene since 2013 (collaborating whenever possible with cast and crew who are deaf, hard of hearing, or sensitive to sound), it is a portrait of music and silence built around events both historic and mundane. O'Daniel, who has binaural hearing loss, saw the removal of this tonally rich instrument from the collective sound of the band as analogous to her daily experience of missing parts of conversations and having to fill in the gaps. Constantly confronting what she has described as "a hypersensitivity to a lack of information," O'Daniel is highly attuned to differences in how we each perceive our surroundings, and how this in turn impacts the way the world perceives us.

A recurring image in O'Daniel's mind of tuba players stripped of their instruments who now can only sit and listen became the catalyst to start writing the script. Switching between scenes that refer to the original thefts, with the participation of a band director and student musicians from one of the schools, and several fictionalized narratives featuring deaf drummer and performer Nyke Prince, the film also revisits two historically significant concerts: the premiere of John Cage's highly influential composition *4'33"* in Woodstock, New York, in 1952 and a punk concert at San Francisco's now defunct Deaf Club in 1979. These two events function like interludes along a trajectory from intentional silence to the fast-paced pounding and insistent screaming of punk, from the relative political and social calm of 1950s America to the post-Vietnam countercultural imperatives of the next generation. *The Tuba*

01

02

Thieves offers an alternative to a typical linear narrative by anachronistically depicting a range of spaces and events that highlights acts of listening and aural transformation.

O'Daniel is invested in collaboration and has described her work as a type of call-and-response in which interactions with and contributions of composers, actors, musicians, and technicians inform her decisions. Her working method often revolves around the translation of one medium into another, calling attention to the loss of information that occurs and the great potential for originality and new ways of both seeing and hearing. She has created several sculptures in response to music or sound, for example, so that an aural experience is manifest as form, color, and materials. This disruption of the conventions of different mediums and disciplines is evident in almost all aspects of *The Tuba Thieves*. Rather than applying musical scores to the film footage after it was shot to provide emotion and narrative thrust, she inverted the process by commissioning scores beforehand. She enlisted one deaf and two hearing composers—Christine Sun Kim, Steve Roden, and Ethan Frederick Greene—to write music based on news accounts of the tuba thefts, poems, and images, ranging from the notoriously dark and smoky eyelashes of the late sculptor Louise Nevelson to the patterns a Zamboni makes when resurfacing an ice rink. The artist then used these scores as inspiration for the screenplay and the accompanying images and objects.

For *Made in L.A. 2018*, O'Daniel produced additional scenes of *The Tuba Thieves* and presents the most ambitious and multifaceted version of the project to date. The diverse scenes and objects function at times like an atonal avant-garde composition, clashing and bumping into each other. At other times they come together to form an exquisite balance of tactile, aural, and visual perceptions. Two of the sculptures—*There Is No Mathematical Logic; We Unfold Somehow* and *Second Personage and Her Eyelashes*—return to the earlier musings on Nevelson's sculpture and eyelashes and the Zamboni pattern. Materials include acoustic foam and carpet so that the sculptures themselves interact with the video, reflecting and absorbing sound. O'Daniel makes us cognizant of the many nuances of sound and how it interfaces with our other senses, while also revealing the often hidden politics inscribed within a culture that takes hearing for granted and elevates the visual over the aural. —AE

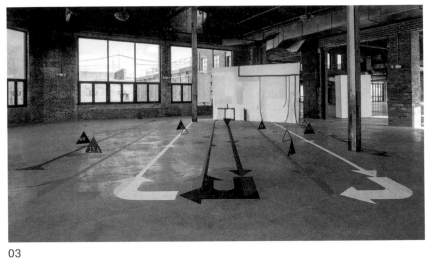

03

04

05

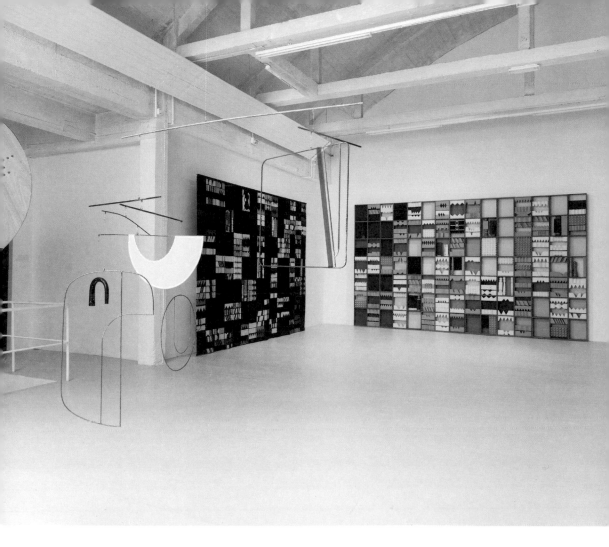

06

O'DANIEL

DANIEL JOSEPH MARTINEZ

Born and raised in Los Angeles, Daniel Joseph Martinez has been an integral participant in the ecology of the art world here. In a four-decade-long career, he has exhibited widely internationally, while closer to home he has been fundamental to the establishment of UC Irvine, where he has taught for more than thirty years, as one of the most highly regarded art schools in the country. Moreover, Martinez was a cofounder of two important nonprofit spaces, Deep River (which operated from 1997 to 2001) and the extant LAXART. He is an unrelenting social critic whose work takes up such topics as the relationship between individual and collective identity, socially prescribed categories that serve to oppress the most vulnerable in our society, and state-sanctioned forms of violence. Spanning different mediums, the affective temperature of Martinez's work oscillates between a cool remove, expressed through sleekness and elegance, and an almost alarming embrace of the visceral.

The House America Built (2004) is a full-scale reproduction of "Unabomber" Ted Kaczynski's cabin, sliced down the middle in a nod to Gordon Matta-Clark's split structures of the 1970s. It is painted in deceptively cheerful colors from Martha Stewart's Signature paint collection. Martinez thus draws parallels between the economic damage inflicted by extreme capitalism and domestic terrorism in the United States. In *Divine Violence* (2007), he again took up the relationship between capitalism and power but expanded his purview to other parts of the world, invoking a range of perpetrators of violence in the name of ideology, sovereignty, or freedom. The installation consists of 125 gold-painted panels, each with the name of a political organization, including the CIA, Hezbollah, and the Irish Republican Army. His use of automotive paint to give the panels a flawless metallic surface embodies Theodor Adorno's contention that artists must maintain an aesthetic distance from their subject of critique.

Over the years Martinez has abused and violated representations of his own body in an effort both to examine the psychology of violence and to call attention to the way brutal episodes from the past are idealized through the discipline of history and the capitalist mechanisms of the media. In *IF YOU DRINK HEMLOCK, I SHALL DRINK IT WITH YOU or A BEAUTIFUL DEATH; player to player,*

pimp to pimp. (As performed by the inmates of the Asylum of Charenton under the direction of the Marquis de Sade)* (2016), a gruesome sculptural interpretation of Jacques-Louis David's famous 1793 painting *The Death of Marat*, Martinez plays both victim and perpetrator as well as menacing accomplice. The installation questions how history painting aestheticizes cruelty and human suffering while comparing the conditions that led to the French Revolution to the levels of inequality present in our society today.

Made in L.A. 2018 features a number of photographs from a recent body of work titled *I am Ulrike Meinhof or (someone once told me time is a flat circle)* (2016). For this series Martinez visited numerous sites along the 103-mile border between the former East and West Berlin where the Berlin Wall once stood, both physically and metaphorically dividing the country. In each location—some urban settings replete with Brutalist architecture or state-sanctioned memorials, and others landscapes filled with trees and grass—he holds up a banner featuring a portrait of Ulrike Marie Meinhof, the German left-wing militant and cofounder of the Red Army Faction, at different stages in her life. The images complicate Meinhof's legacy, asking probing questions about the role of women in revolutionary politics, the status of the individual within social structures, and why violence is sometimes deemed necessary by those who embrace civil disobedience as a means of civic reform. Returning to this pivotal moment in post-1968 Europe is a reminder to heed the lessons of the past at an unprecedented time in American history in which threats to democracy loom large. —AE

01

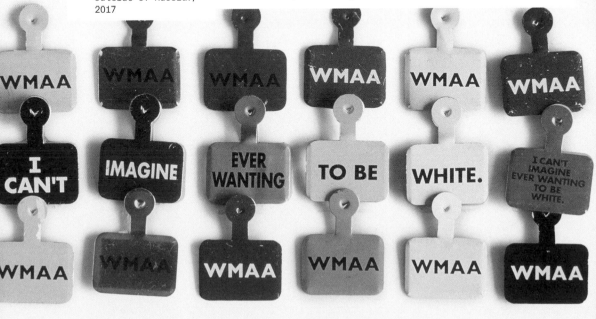

02

03

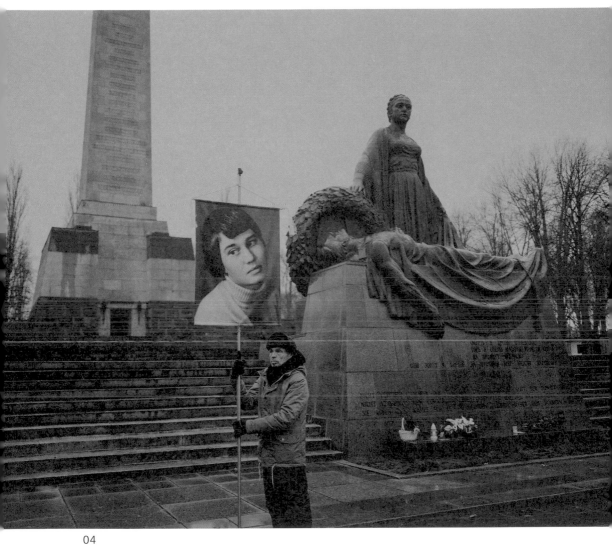

04

MICHAEL QUEENLAND

Michael Queenland is interested in the redistribution and configuration of everyday objects or familiar architectural elements, especially the point at which they become illegible and/or form new functionalities.

For his sprawling 2012 exhibition called *Rudy's Ramp of Remainders*, presented at the Santa Monica Museum of Art (now the Institute of Contemporary Art, Los Angeles), Queenland created a site-specific sculptural installation composed of handmade balloon sculptures and various cultural goods such as newspapers, Afghan war rugs, US brand cereals, plumbing pipes, and perishable foodstuffs. Through various groupings and points of intersection, this unfixed assemblage of utilitarian and cultural objects asked viewers to consider the diverse aesthetic, formal, social and political associations inherent in everyday cultural material, as well as the nature of consumption and the imperceptible means of distributing resources, information, and propaganda. The title comes from a discount surplus store Queenland would often pass by while he was living in Berlin called Rudis Resterampe, which roughly translates to Rudy's Pile of Leftovers.

The balloons, which he has used often in his work, are made through a process of injecting them internally with plastic resin, allowing him to carve and fill them to mimic abstracted bodies, vessels, bowling balls, or the iconic image of a bomb with a wick in its center made popular by cartoons and other pop culture references. These spherical objects were carefully placed throughout the space, some upon various Afghan rugs on the floor in the direction of Mecca, evoking prayer mats, while others were placed inside large hand-quilted trash bags evoking body bags. Considering the World Trade Center attacks in New York City that took place some eleven years earlier, Queenland's visual cues, including the incorporation of several Afghan war rugs commemorating 9/11, mark a critique of the implicit biases in how the American media views otherness, terrorism, and the racial tensions attached to that context, often moving seamlessly between the construction of facts and fantasy.

For *Made in L.A. 2018*, Queenland will revisit his interest in cereal boxes, employing several cereals from various companies. He will align them on the walls via a shelving unit and will rebox them with a hard, transparent plastic that will then be adorned with various appliqués and ornaments. —EC

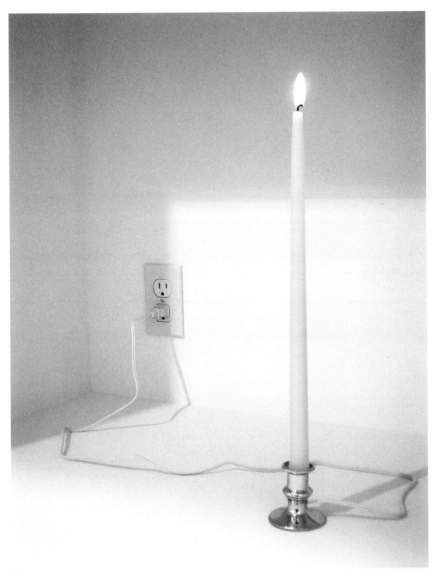

01

02

MADE IN L.A. 2018

03

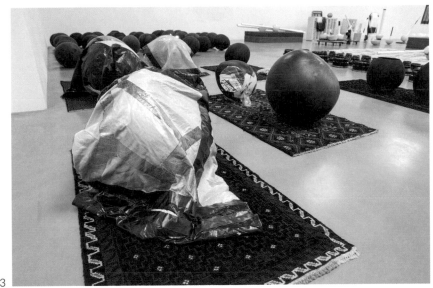

04

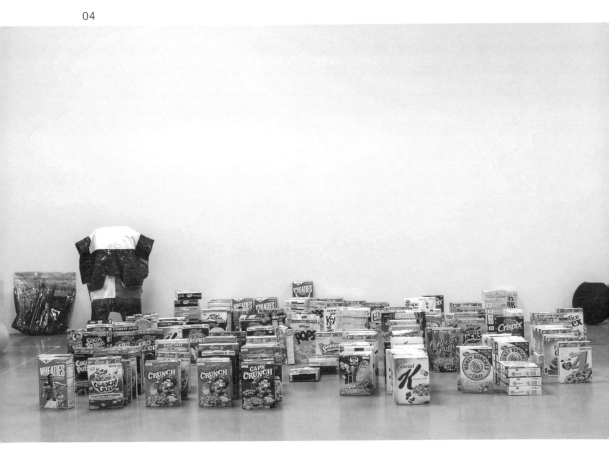

QUEENLAND

ROSHA YAGHMAI

Rosha Yaghmai's sculptures are striking in their incredible stillness. Deeply rooted in the history of sculptural practice in Southern California, her works vacillate in their makeup between natural materials mined from beneath the earth or found in the air we breathe—iron, aluminum, copper, nickel, clay, neon—and industrially manufactured or common commercial products such as silicone, fiberglass, plastic bags, and eyeglass lenses. By using materials that are familiar yet may be deployed in ways that call attention to their uncanny qualities, her installations evoke feelings of estrangement or foreignness.

Yaghmai's sensibility brings to mind the Light and Space artists of the 1960s—for example, the optically flighty surfaces of a Mary Corse painting or Craig Kauffman's hanging sheets of lacquered acrylic—and her objects invite a similar quiet contemplation. But her work notably diverges from these precedents in that her objects are inflected with a pronounced degree of storytelling. She is equally influenced by the disaffected performances of Mike Kelley or the lonely abandoned landscape of a John Divola photograph. In Yaghmai's world, abstract, geometric forms are transformed into glowing park benches or portals to another dimension and installed as components of a moody urban setting, replete with forms reminiscent of rusted street lamps or metal rolling gates that protect commercial storefronts.

Having grown up and studied art in Los Angeles, Yaghmai has been informed by West Coast conceptual art and the history of various counterculture movements such as the student antiwar and feminist movements or those spearheaded by charismatic (and sometimes deadly) cult leaders or initiated by those drawn to California for its tolerance of alternative lifestyles. Yaghmai's 2015 exhibition *Easy Journey to Other Planets* portrayed an LA weathered by the ravages of time while also being optimistically oriented toward the psychedelic imagination and potentialities of outer space. It included casts of rocks from Topanga Canyon, a rusted pool chair, and a series of Gates made to resemble the doorway to the Griffith Observatory. This sense of an open-ended narrative was expanded upon in the haunting environment of her 2017 show *The Courtyard*, which felt at once private and public, cohesive and fragmented, familiar and strange. Her modified approximations

01

01. *Optometer, Door,*
 2016 (detail)
02. *Cave by Fire (black
 awning)*, 2016
03. *Pipe #4*, 2017
 (detail)
04. *The Courtyard*, 2017
 (installation view)

of the real, in fact, allow visitors to become attuned to difference and to embrace the unknown.

Yaghmai's father immigrated to the United States from Tehran to study architecture at UC Berkeley and met her mother, who is American, while she was a student at Mills College. Though Yaghmai's work has not addressed explicitly her identity as a mixed-race person, her environments conjure a sense of otherness, feelings of alienation, and even a mild paranoia that the artist associates with the need, often experienced by first-generation children, to continuously scrutinize one's sense of belonging. Going through a box of family slides her father gave her, she found a number of abstract images of material and light that seemed curiously like something she could have created herself. When asked about them, her father relayed that the works were his, made when he first arrived in Northern California and used photography as a way to explore his new culture, taking chunks of glass from a nearby Coca-Cola factory and creating colorful reflections through available sources of light. For *Made in L.A. 2018*, Yaghmai has incorporated some of her father's imagery into an environment of objects and projections, locating her work in her family's past while imagining the possibility for an integrated and inclusive future. —AE

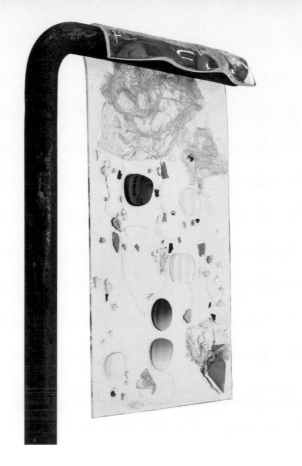

03

04

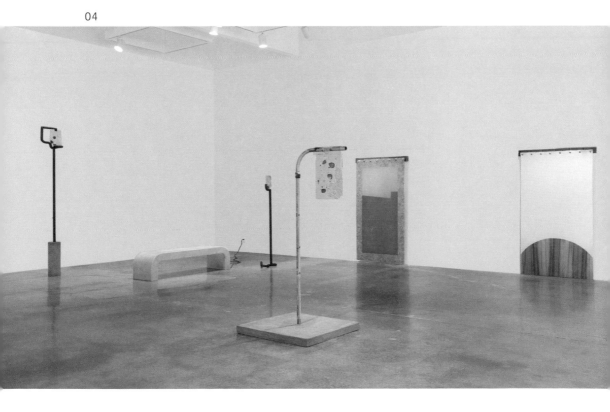

LINDA STARK

Linda Stark explores through painting the tropes and stereotypes of the feminine in its relationship to myth making, spirituality, and transcendence. Her manner of working is wholly unique, and it will sometimes take her more than a year to finish a small but intricate painting. Stark has developed her own technique of mark making that allows her to achieve a three-dimensional quality through precise grooves and textures that linger throughout the work. She is interested in breaking open traditional ideas of femininity by creating abstracted portraits of objects and images that society usually associates with women, such as hearts, jewelry, and dresses, at times reconsidering their usual implications by aligning them with female genitalia or ancient symbology. Her works are cartoonish in nature and surprisingly eerie, and through their groupings, coloring, and shapes, Stark gives new life to these everyday notions.

In her Potions series, Stark creates her own potions and spells based on found objects that she attaches to the canvas with oil paint. Taking on the role of witch or sorcerer, the artist breaks down preconceived notions about

01

spellbinding and ceremonial iconography while suggesting that anyone has the capacity to mix the ingredients necessary to manifest a new desire or mode of being. Her Potion paintings are small and intimate in scale, and though they comprise a range of coloration and embedded objects, all are defined by a spiral swoop that envelops the canvas. The process involves layering varying amounts of oil paint on the canvas while simultaneously rotating it and allowing it to dry over time, creating a glazed set of strips that seem to hover just above the flat surface. She then inserts the various objects that are ingredients for the potion at hand. All of the works have telling names, such as *Passion Potion* (2007), which brings together more than a dozen ingredients, including blood root, myrtle, and patchouli, or *Purple Protection Potion* (2007), which comprises such botanical materials as sage, periwinkle flower, and sweet basil. Each painting is also accompanied by a drawing that details the ingredients and where they are placed within the painting, functioning as a directional map. The materials Stark uses were found and procured from botanical shops or supermarkets within the Los Angeles area and from her kitchen, neighborhood, or backyard.

Made in L.A. 2018 will feature a collection of Stark's older works and her most recent body of paintings, in which she continues to explore the boundaries and abstractions of the familiar and the feminine: a set of portraits of numerous cats that have played a role in her life. The paintings, which vary in scale, serve as memorials to the now deceased animals, which she took care of and supported at some point—either her own long-term companions or ones belonging to her neighbors. The felines offer an interesting way to think about community and alternative familial structures. These animals are what allowed Stark, over time, to build closer relationships with her neighbors. —EC

03

02

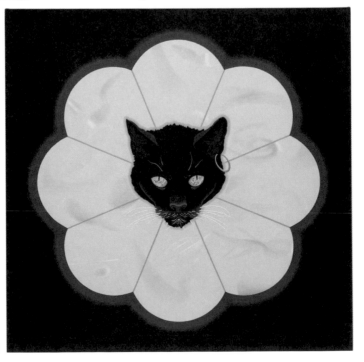

04

MADE IN L.A. 2018

05

STARK

Folds, creases, and grids are some of the defining features of John Houck's early photographs. Within the past few years, folds and creases have been replaced by groupings of objects and, more recently, the inclusion of painted passages. All of Houck's photographs are highly worked, the result of a laborious process of composing, layering, photographing, printing, and rephotographing. The traces of his manipulations—the seams, edges, and layers—are intentionally left visible; in fact, they are integral parts of a practice that is focused on navigating and interrogating photography's conceptual and philosophical underpinnings as well as the very materiality of the medium.

Houck came to photography by way of architecture and computer programming, and his early work conveys his deep knowledge of coding, computation, and computer languages. From 2012 to 2014 he produced a series of prints, titled Aggregates, by creating a computer program that would generate every possible variation within a set number of colors on a grid. The works consisted of gridded sheets altered by diagonal folds that cut across them, transforming each sheet of paper, at least momentarily, into a three-dimensional object. The creased prints were then photographed and flattened out—a return, as it were, to their original state as two-dimensional objects. Art historian Rosalind Krauss, in her canonical essay "Grids," from 1979, considered the grid to be the marker of modernity, as its geometricized form excluded nature and narrative. Even as Houck's works speak to this discourse, the folds disrupt the consistency or regulatory aspects of the mathematical grid; instead, he calls attention to the irregularity of his grids, to the process of their making, and to the materiality of the paper support.

In 2013 Houck started to incorporate mundane objects into his photographic compositions, resulting in beautiful, if somewhat bewitching, still lifes. This new direction was prompted by weekly psychoanalysis sessions. As a therapeutic method, analysis offers a means for understanding the contours of our personalities by peeling back the layers of our lives, beginning with childhood. For A History of Graph Paper (2013–17), Houck applied this process to his art, producing still lifes that contain objects from his childhood bedroom, such as baseball cards, baby shoes, stamps, and drafting triangles. Within the final photograph, these objects float against colored or patterned

backgrounds, sometimes placed slightly askew, indicators of Houck's process of photographing multiple layers of prints to achieve a collage-like effect. Deconstructing the layers within the composition can be all-consuming, but the obvious care with which the objects were selected and arranged is also significant, leaving the viewer to conclude that these items are quite special. In his influential text *Camera Lucida*, the philosopher Roland Barthes noted photography's unique ability to conjure the past and, as such, to move us. Houck's photographs conjure his childhood, and displayed together they become a sort of visual compendium of his memories.

Houck recently began exploring painting, first by incorporating painted passages into his photographs and, more recently, by installing paintings and photographs on opposite sides of suspended walls, resulting in objects with a distinct recto and verso. These works engage the viewer in a kind of memory game: one has the image of the painting or the photograph (whichever is encountered first) in one's mind while looking at the opposite side. The act of remembering and considerations of how memory functions are important to Houck, and his contribution to *Made in L.A. 2018* includes a selection of photographs that articulate his interest in perception, memory, and the relationship between viewer, maker, and object. —MS

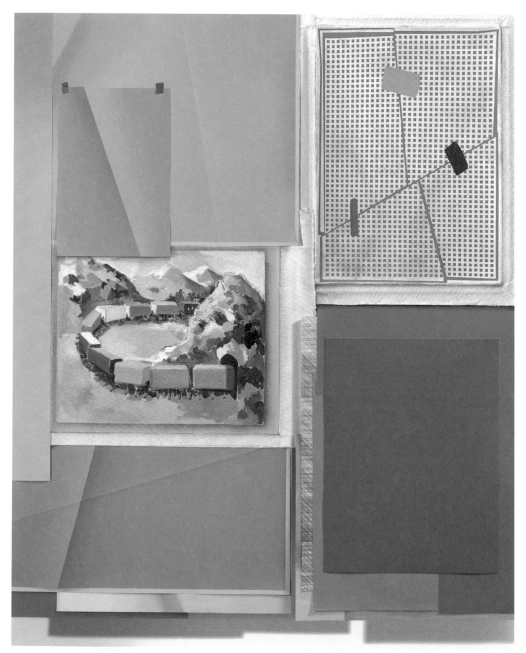

02

03

04

05

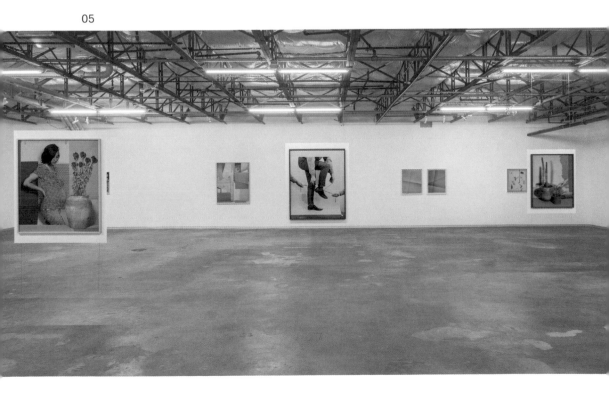

HOUCK

taisha paggett

taisha paggett is interested in what bodies do: how they rise, how they fall, and, more important, how they rise again. Her practice explores the depths of embodied movement and how healing gestures, both individual and collective, can be the conduits of transcendence. Coming from a traditional dance background, paggett draws upon the trajectories of postmodernism, yet the language of her movement continues to evolve beyond any set form, as desires for inclusion and experimentation propel her forward.

paggett is interested in the power of practice and how the rehearsal space houses the heavy lifting, idea shifting, and overexertion of the body that often is underrecognized during the performance. Through this interest, and inspired by a "school for colored youth" rumored to have been founded by a member of her family in eastern Texas in the early twentieth century, paggett formed the School for the Movement of the Technicolor People, an extension of WXPT (We Are the Paper, We Are the Trees), paggett's temporary dance company composed of "a community of queer people of color and allies, dancers and nondancers alike." The School for the Movement of the Technicolor People, a collaboration with Ashley Hunt and Kim Zumpfe, was initiated in 2015 at Los Angeles Contemporary Exhibitions (LACE) in response to the question "What is a black dance curriculum today?" Through a program of workshops, weekly classes, and microperformances, the space became an activated "meadow"—a term paggett uses as a metaphor for a landscape installation that contains the entwined actions and thoughts of the company members. These smaller convenings and interactions then formed a language of choreography, which was executed in a culminating performance.

paggett's site-specific project *Mountain, Fire, Holding Still* (2016) is a meditation on the cycles of life and death. In the gardens of the Getty Villa, in Malibu, paggett completed a ten-hour durational performance that served as a vigil to honor the often underappreciated contributions of black labor and cultural production. Draped in an astral black tunic, paggett orbited the grounds of the gardens, while attaching to and then releasing herself from a body-size bag filled with personal ephemera and memory objects. This relational action served to highlight the historical weight that bodies hold and how trauma should be

acknowledged, worked through, and relegated to the past. paggett's tunic served to visually connect blackness with antiquity while simultaneously breaking that notion through the very contemporary motions of her gesturing body. At sunset, paggett stepped into the darkness with her hands raised, a doubled action of resistance and acknowledgment of a higher power.

For *Made in L.A. 2018*, paggett will expand upon an ongoing piece with WXPT collaborator Meena Murugesan, *counts orchestrate, a meadow (our weekly practice with breath)*. Drawing on the notion of breathing as a fundamental activator of the body, an ensemble of dancers will generate sonic breathing-scapes solicited from artists and friends that will inform the collective actions, which, as they grow and coalesce, will be documented from rehearsal spaces outside of the dance studio and materialized in the gallery through video. That documentation will then be enacted upon and responded to through physical intervening and will generate a space to create a contemplative environment for considering the nuances of life and death. —EC

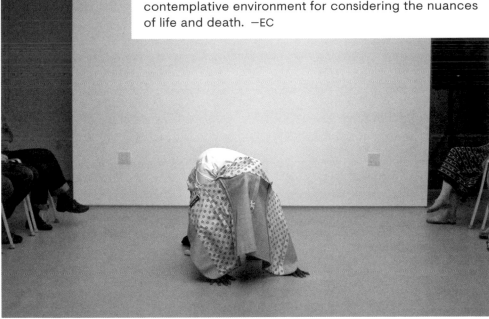

01

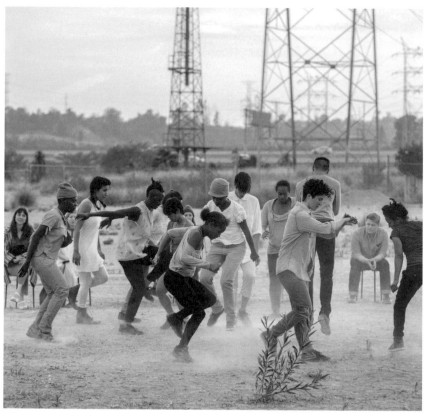

02

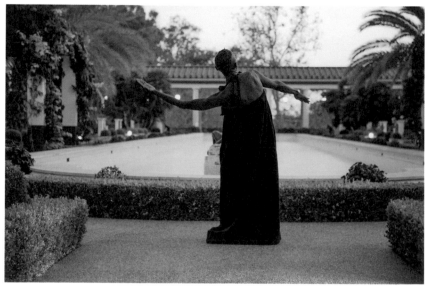

03

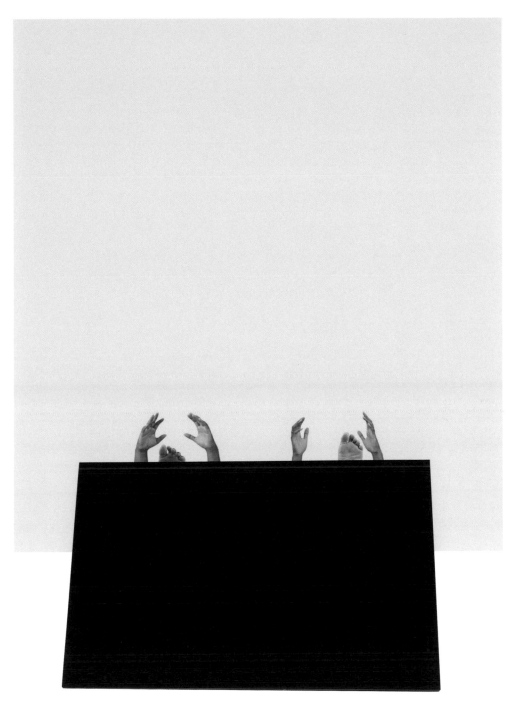

04

PAGGETT

In film installations, performances, and new-media works, Patrick Staff cites the various ways in which the queer body is regulated, embodied, and interpreted. Staff recalls a trip to Los Angeles in 2012 when, in anticipation of a new project, a friend recommended visiting the former home of Finnish erotic artist Tom of Finland. Embedded in the hills of Echo Park and now known as the Tom of Finland Foundation, the space functions as an activated archive that also hosts social events and holiday potlucks. Upon frequenting the house, Staff discovered that it was not only an archive but also an important communal space for an eclectic group of gay men and queer folks who lived in or around the site and who, in some cases, established lifelong relationships. The foundation became an important space for Staff in navigating the nuances of Los Angeles as the artist came to know the people living there and, even more, negotiated the difficulties of Staff's trans-feminine identity within this community.

Inspired by these newfound relationships and interactions, Staff created *The Foundation* (2015), a film installation that considers the home as an activated space for an ongoing, intergenerational dialogue on the importance of support systems, unconventional relationships, and alternative familial structures within queer communities. Staff intersperses interviews and everyday happenings in the home with a choreographed dance featuring the artist and an older, burlier man, both of whom are adorned in BDSM wear that was typical of the figures that solidified Tom of Finland's oeuvre. Both Staff and the older gentleman immerse their bodies in syncopated gestures—elements of the Japanese Noh theater tradition in which the father teaches the son the family legacy through embodied storytelling. Staff considers the importance of upholding legacies that are often deemed insignificant in larger historical frameworks but also complicates them in thinking about how these structures of inheritance can be fraught or lean toward heteronormative values.

Staff's recent piece *Weed Killer* (2017) is a visual response to Catherine Lord's 2004 memoir *A Summer of Her Baldness: A Cancer Improvisation*. Lord, who lived in Los Angeles for several years and is a pioneering voice of

queer theory and feminism, wrote this memoir shortly after her experience with cancer. In it, Lord reflects on her very personal experience with the disease, notably the idea of the contaminated body and how it affects and interfaces with intimacy, external relationships, and gender identity. Staff takes this notion further to think about how a trans body and a lesbian female body unravel each other through similar but individual experiences and negotiations within society.

For *Made in L.A. 2018*, Staff has created a video exploring the body through performance and dance called *Bathing* (2018). In it, a single dancer is immersed in a shallow pool of water while generating small actions and gestures that allow for an eventual overextendedness of the body. Through this durational action, the pool will start to become "contaminated," further exploring how bodies dictate the excretions, chemicals, and hormones that are released and stored and how cleanliness and illness can potentially intertwine. This accumulation of bodily waste acts both to decenter the notion of the body as an independent entity and to address its scientific and biological implications. Staff uses this action metaphorically in considering a space in which experimentation under the guise of queerness can be an ongoing exploration of biopolitics and intoxication. —EC

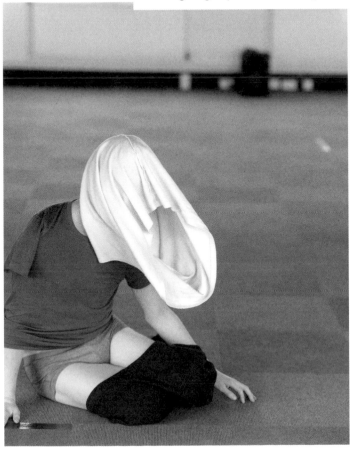

01

02

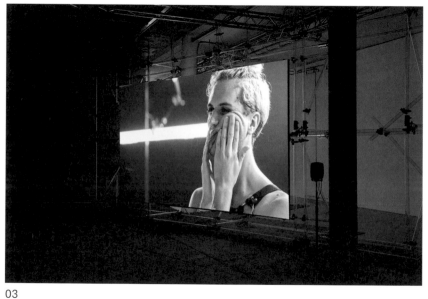

03

04

05

STAFF

CONFLUENCE: MADE IN L.A.

Tisa Bryant

THE NOTION OF IMAGINATION HELPS US TO REMEMBER THE SCOPE AND BREADTH OF THE INTERIOR, FOR ALTHOUGH THE INTERIOR IS, TAUTOLOGICALLY, INTERIOR, IT IS NOT SMALL; LIKE IMAGINATION, THE INTERIOR IS BOUNDLESS.

—Kevin Quashie, *The Sovereignty of Quiet: Beyond Resistance in Black Culture*

It seems to me that when a person searches for creative force in a city, what she is really looking for is its interior. Where do artists make sanctuary for their thinking, trying, and collaborations? Whom do they call late at night, borrow money from, sex up, revel and commiserate with? What chronicles from their sketchbooks and studios might be retained only in the ephemeral archive of gossip, intimacy, memory? Sometimes the most evident sites of imagination—the "scenes"—are shining surfaces that attract, obscure, bridge, or even protect the quiet flows of vitality running beneath. The energy of art making is about labor: physical, intellectual, spiritual; the connections among artists are both deliberately focused and serendipitous. Ambition and commitment fuse and make not just a happening place but something like a phenomenon, ambient and subterranean, generative, rhizomatic: a practice.

On our way to Los Angeles for the College Art Association conference in February 1999, Wura-Natasha Ogunji and I visited Noah Purifoy at his desert compound in Joshua Tree. In my mind this visit is the fulcrum of much transformative thinking: the recalibration of my views on art, community, and career; the manifestation of a desire to learn about Black art and activism in Los Angeles; and a shift in my attitude about LA itself, which had been East Coast–centric, bathed in Bay Area Funk, and wholly negative, based on my previous visits to a cousin who worked in the entertainment industry and lived a very different life in Burbank, far from the queer colored squad of artist-activists we called "The Village," and I called family. On the cusp of the new millennium, everybody was trying to level up. As we drove south on the I-5 in Wura's adorable Datsun pickup, we speculated about the future. But we were already in it.

Noah's sculptures evoked a vast city of specters, totems of experience and protest. They commented on Black life, aesthetics, politics, and futures; the failings of culture and of law; the enduring promise of technology; and the oppressive force of white supremacy, strangely apt within a desert clime often described as alien. We wandered through an outpost of deferral, dreams subjected to entropy, reanimated by the wind. This was the work of uprising and a study in contrasts—collective and singular, known and remote, devastating and humorous—built from the waste, casualties, and castoffs of our lives into tableaus that are both archival and prophetic. When I met Noah, I didn't have a full grasp of his practice, of the assemblage art born of

the frustration, pain, and char of the Watts rebellion, itself the ground for the "LA Rebellion" in Black filmmaking and myriad conceptual art and performance practices to come. I had no idea in 1999 that Wura would soon move to Los Angeles herself, that I was standing in the desert with the first Black student at Chouinard Art Institute, now CalArts, or that I would be teaching at that same school ten years later. It may be too woo-woo to say that some powerful, transformative energy got tapped during that visit, but I'm saying it anyway. I understand now that Noah's visible work at Joshua Tree is syncretic, the outer expression of a hidden cosmology of artists, aesthetics, and spirit encompassing decades, emanating from Los Angeles.

Noah spoke frankly about his disenchantment with the professional art world, and the fervor in his voice resonated with us. As culture workers in our community, we constantly grappled with questions of love for our people and our personal ambitions, of conceptual and experimental practices and Black liberation, of how to get over, how not to sell out, how to just be and do and thrive, what was required, ethically, on our own terms. Wura, months from finishing her visual arts degree, was to have her portfolio reviewed by someone at CAA. Noah was silent about this, then he said, "I had a studio, gallery, made that kind of stuff." It was our turn to be quiet. "It's all in there," he said, gesturing broadly toward a Quonset hut in the near distance, a chain and padlock clearly securing the handles of the door. I stared at the hut for a beat, trying to imagine his sculptures confined by white walls, then let my gaze wander back up at the works he offered up to the sky.

In a photograph I have from that trip, Wura stands on a platform facing a wood tower at the top of the stairs leading to one of Noah's sculptures, listening, observing. Noah is in profile and in shadow, his body nearly flush with the edge of a newel at the top of the stairs, his head seeming to top the post. Noah's position seems emblematic of his 1963 statement, "I do not wish to be an artist, I only wish that art enables me to be."[1] He appears almost fused with one of his sculptures.

I admit to being prone to romantic notions of artistic life, and the image of Noah against a cloud-swept desert landscape standing firm in his beliefs fed right into that. The next day, at the College Art Association conference at the LA Convention Center, Wura and I would by chance meet then Metropolitan Museum of Art curator Lowery Stokes Sims, who would celebrate her birthday by introducing us to her bestie from childhood, Maryland Institute College of Art curator Leslie King Hammond, and taking us out for sushi. Lowery's elegant demeanor would undergo the subtlest of shifts upon hearing Noah Purifoy's name. As she spoke, I heard concern about him as well as about his departure from his studio practice. This was love, not just for him but for all of us. This was the difficulty of acknowledging an "us" at all, the politics of our collective endeavor as Black people, versus the impact on the continuum that singular choices like Noah's can have on our opportunities to be artists on our own terms. Did Noah's withdrawal cause a rupture in the network? Did it close a crucial portal that only he could hold open to the future, or only obscure it? If so, what attention could reopen or reveal it? At Joshua Tree, I too was concerned for Noah's well-being. He assured me he was looked after, so I chin-checked myself about his seeming loneliness, drinking and smoking alone in the desert, immersed in a sprawling world built by his own hand that mirrored in all its complex tableaus of racial segregation, technological obsolescence, and innovative repurposing the one he left behind.

What happens to the energy that makes a place conducive to art making in communities over time? Consider the planned obsolescence of a collaboration, a project. The organized dispersal of matter through sweat, stress, and vision. What trace does this leave? Who feels it, knows it?

During that 1999 visit, our friend Patrick "Pato" Hebert took Wura, Laurette Hamilton, and me to the collectively run art gallery Deep River (1997–2001), on the aptly named Traction Avenue, to visit his friend and mentor at UC Irvine, Daniel Joseph Martinez, who cofounded the gallery with Rolo Castillo, Glenn Kaino, and Tracey Shiffman as a space for exhibiting new work, with a specific focus on artists of color. The site is now a trendy bakery, but back then it was significant to my shift in attitude toward Los Angeles. I was beginning to see what was particular about the city. It was asphalt and buses, dense with people in spots,

Facing: Wura-Natasha Ogunji (right) and Noah Purifoy at Joshua Tree, February 1999.

Left: Leslie King Hammond (left) and Lowery Stokes Sims, February 1999.

isolated industrial stretches in others, but also kind of country, with massive hills and dirt roads, backstreets and unincorporated territories, seemingly identical streets teeming with low-rise stucco buildings and palm trees opening onto mountain vistas or concealing enclaves of working artists. Roughneck, laid-back, and bourgie, it spoke in many registers at once, like my friends, like my writing. Like life.

Like the show at Deep River: *Download* by Vince Golveo. Hundreds of portraits of young men, sketched on lined paper from a small spiral-bound notebook, in ballpoint or felt-tip pen. Multiples don't create sameness but insist on a finer way of seeing. *Download* created a sense of intimacy with an unseen city, created the city itself through the men portrayed: here, wisps of hair inked as if caught in a sudden breeze, there a pensive face, as of a commuter stalled in traffic, each small portrait an invitation to slow down, get close, and observe the specificity of these seemingly similar human moments Golveo rendered in time. In that moment of contemplation, Deep River became a kind of microcosm of the city I had been trying to feel for so long. I considered Deep River's expansive gesture toward a critic-free space for non-conforming arts, and thought again of Noah Purifoy, his Los Angeles in the desert, his locked Quonset hut, the Download show manifesting alongside it, how it all might converge, as a freeway to a vista, a vision quintessentially LA.

I stood outside the gallery and watched people stream by on the street. I may have seen in passing then someone I know well now, or who made a scene what it was, who left, or died, long ago. While writing this, I came across a 2010 essay, "The Magician," by Connie Samaras, whom I would meet upon moving to Los Angeles, not long after she wrote it. "The Magician" is a meditation on haunting and ghosts written in elegy to her friend Santiago Bose. About him she says, "Unlike the other dearly departed, he seems to reside outside the corrosive forces of memory and appears instead to occupy his own external plane of energy due, perhaps, to the legacy of magnificent work he left behind."[2] This is precisely the trace that intrigues me, how cities are palimpsests of creative force, how we mark a place with our living, how those markings connect afresh, across time and space, to other people and practices. The care and attention to friendship are part of this trace, as Bose coaxed Connie to break through a common

Above: Patrick "Pato" Hebert (right) and Daniel Joseph Martinez at Deep River, February 1999.

Facing: Vince Golveo, *Download*, installation view, Deep River, Los Angeles, 1999.

kind of career-related inertia and pick up the jewels of opportunity gathering at her feet. She had first met Bose at a 1996 show of contemporary Filipino art, *Memories of Overdevelopment*, curated by her UC Irvine colleague Yong Soon Min (whom I would later meet in an art salon for women of color in 2015), that included Bose and Golveo, whose *Download* show I stood before at Deep River, connecting my present, their past, and our future.

I consider the confluence of thought gathering around me then: how one balanced aesthetics and integrity with ambition; "the game" of professionalization in the arts; curation and friendship as ecologies of care evidenced by the unforeseen networks of artists I entered by crossing a threshold on Traction Avenue. All of these concerns flow into what curator Erin Christovale told me about the studio visits she made in preparation for *Made in L.A. 2018*: "So many of these artists might not even be here by the time the show goes up; I heard over and over again about rent increases, displacement." We are reckoning with the economic forces negatively impacting people's lives. Yet life under duress often results in radical subversions, underground currencies. As Martinez put it, "We have the freedom to be an autonomous center for the presentation of work."[3] If curation is a social action, one of organization and care, then exhibitions of art, the archives of memory and relation they represent, can continue to fortify and affirm the interior of the city, making a way out of no way.

1. Noah Purifoy Foundation, http://www.noahpurifoy.com /about-noah/.
2. Connie Samaras, "The Magician," http://www.conniesamaras.com /DOCs_current/WEB_Writings_ pdfs.5.11/01_MAGICIAN-fnl.pdf.
3. Irit Krygier, "Report from L.A.," *Artnet*, http://www.artnet.com /magazine_pre2000/reviews /krygier/krygier6-3-99.asp.

ARTISTS

CANDICE LIN
EAMON ORE-GIRON
GELARE KHOSHGOZARAN
CAROLINA CAYCEDO
BEATRIZ CORTEZ
EJ HILL
LAUREN HALSEY
MPA

Candice Lin's work draws from multiple disciplines to unearth histories that have largely been forgotten or disregarded. She engages in practices that have been marginalized or discredited through established hierarchies of value or biased determinations of what constitutes expertise. With an array of mediums to match her curiosity with wide-ranging subject matter, since the beginning of her career Lin has created objects and imagery that unflinchingly, and often with refreshing candor, question the legitimacy of social categories that define race and gender. Her interest in the legacies of colonization and the attendant fictions relating to authenticity, purity, and birth-right has led her to explore how specific natural materials and goods are given value and how they circulate through global trade routes.

For her 2015 exhibition *You are a spacious fluid sac*, Lin examined the well-established propensity in science to classify the natural world through systems that can be so delimiting as to undermine its remarkable heterogeneity. Several collages composed of plant life, found text, and images call attention to beings that fall outside the narrow conventions of biological taxonomies and provide evidence that contradicts our belief in binaries, such as female barklice, which have a penis, and a lactating man said to have breast-fed numerous children. Highlighting the distinction between biological sex and the construction of gender, the works include references to figures such as

Jeanne Baret, who was the first woman to travel around the world, but did so dressed as a man. In this show Lin started to incorporate fluids into works that suggested homegrown experiments or ancient forms of fermentation or medicine, such as Chinese herbalism. A glass jar containing dead animal specimens immersed in tea-colored liquid was inspired by an eighteenth-century technique for spontaneous generation that claimed that wrapping wheat in cloth for twenty-one days would produce baby mice.

Lin has since built elaborate systems in which fluid drawn from an exposed tub flows through tubes connecting an assortment of glass, copper, and ceramic vessels or is diverted to a surface where it pools into large stains. While still reminiscent of a DIY

experiment, here fluid becomes less a means to preserve specimens and more a process for the integration of biological matter and a commentary on contamination. Fear of contamination is often deployed to justify the policing of bodies, and Lin calls attention to how these efforts to control are linked explicitly to identity—to race, gender, class, and ability. For Lin, contamination is a space for possibility, where distinct bodies come together and coexist. She has combined fermented tea (kombucha) and human urine collected from friend volunteers, which was distilled and used to humidify and grow edible mushrooms. In *System for a Stain* (2016), fluids colored with red dye created from the cochineal insect (a colonial commodity used to dye textiles once commonly exported from Central America) deliberately called to mind the human circulatory system. Stains produced on a stark white floor looked like the site of a bloody confrontation or a visceral ritual. Containing other coveted merchandise such as tea and sugar, the evolving installation functioned like a thought experiment on the materials' relationship to the occupation of lands, slave labor, and capital expansion.

In a 2017 installation created with Patrick Staff, *Lesbian Gulls, Dead Zones, Sweat and T.*, fraught histories of subjugation were transformed into something both speculative and aspirational. The room-size sculpture used numerous common household items such as fans, hot plates, and roasting pans to function as a machine emitting an herbal tincture that filled the gallery with a visible fog. Drawing on ancient herbal knowledge associated with healers and witches, the artists vaporized a botanical con-coction containing natural antiandrogens such as licorice and black cohosh that suppress testosterone production in humans. Visitors were made more aware of how porous our bodies are and, perhaps unwittingly, were exposed to an environment that reconfigured their hormone levels, calling into question the very notion of gender. For *Made in L.A. 2018*, Lin continues her investigation into the relationship between the body and valued materials, tracing their links to slave labor, immigration, industrialized farming, and military technology. Titled *Chinese Charade*, the installation comprises an earthen bed containing poppy seeds and guano fertilizer with an impression of the Charada China figure used in a gambling game, and explores the diaspora in the nineteenth century of Chinese indentured laborers in the United States, the Caribbean, and Peru. —AE

01

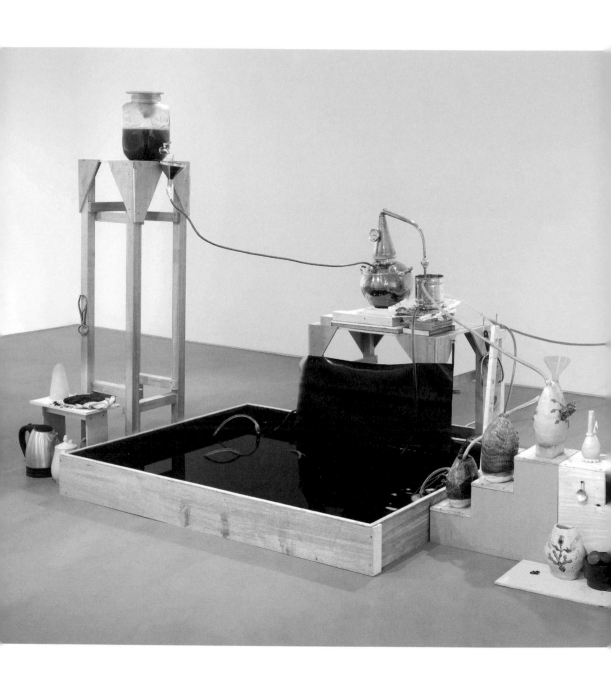

02

03

04

Eamon Ore-Giron's interdisciplinary practice contends with history and cross-cultural exchange. His paintings are in dialogue with hard-edge abstraction, Russian suprematism, and South American neo-concretism, yet, like many of his contemporaries, he is committed to destabilizing modernism's hierarchy, which prioritizes conceptions of knowledge that are Western in origin. He questions modernism's discourses by reinterpreting and repurposing its strategies, and by citing sources that are geographically diverse and extend into the ancient past. As such, Ore-Giron's paintings are informed by a rich visual lexicon drawn from Western European and indigenous cultural sources as well as music.

Ore-Giron's Infinite Regress series comprises more than fifty paintings, containing the geometric forms for which he has become well known. Each painting is a variation on an arrangement of geometric patterns, resulting in an iterative chain that refers simultaneously to the work that preceded it and to the work that will eventually follow. The paintings typically include combinations of elemental shapes—circles, triangles, rectangles, and squares—rendered in bright colors with golden, luminous forms that interlock, overlap, and often coalesce into pyramid-shaped structures. The inclusion of a clear vanishing point in many of the paintings creates the illusion of spatial recession on the picture plane. Infinite regress—as a philosophical concept—is based in skepticism, whereby the notion of fixed knowledge or facts is problematized and interrogated. The Infinite Regress series assumes a critical vitality because of its very relentlessness. Ore-Giron's specific visual vocabulary is reinvented with each iteration, and thus, like the circularity of a philosophical proof, each of the Infinite Regress paintings is reformulated again and again without end.

Recently, Ore-Giron has begun working with new kinds of materials and techniques, such as loom-woven textiles produced in partnership with the Taller Mexicano de Gobelinos tapestry workshop in Guadalajara, Mexico. His painting *Talking Shit with Quetzalcoatl/I Like Mexico and Mexico Likes Me* (2017) was reproduced as a tapestry at the workshop and then incorporated into a group exhibition organized by Rafa Esparza at Ballroom Marfa in Texas that year. *Talking Shit* was placed atop a two-layer mound of adobe bricks created by Esparza—part plinth,

01

part altar—that served as both a physical and a metaphorical support for the large textile. Presented in this way, Ore-Giron's work was transformed into a ritual object or offering to Quetzalcoatl, the Aztec god, here abstracted into a swirling snake composed of greens, blues, and reds. Ore-Giron designed the piece as a poncho meant to be worn by Esparza—a vehicle for "talking shit" with each other, referring to the two artists' ongoing critical conversations— and allowing Esparza to momentarily assume the role of a sacred spirit.

For *Made in L.A. 2018*, Ore-Giron will produce a mural painting, *Angelitos Negros*, extending across the entire span of the Hammer's lobby walls. The painting is inspired by the poem "Píntame Angelitos Negros" (Paint me black angels), written by the Venezuelan poet and politician Andrés Eloy Blanco in 1943. Described as a hymn against racial discrimination, the poem implores "the painter"—native to the country but having "a foreign paintbrush"—to include *angelitos negros* (little black angels) in his religious works. The poem is a lamentation on exclusion and racism as well as a commentary on erasure and racial hierarchy. It was adapted into a song soon after it was published, and has been performed since the 1950s by artists throughout Latin America and North America, including Pedro Infante, Los Pasteles Verdes, Celia Cruz, Eartha Kitt, Roberta Flack, and Cat Power. For Ore-Giron, the song, which has become a kind of Pan-American anthem, is an elegy for African and indigenous cultures that were oppressed or erased by the colonialist enterprise. The song is a poignant example of the ways in which music, cultural artifacts, and ideas assume new and potent meanings in different contexts.

Drawing on a rich tradition of muralism within Mexico and throughout Latin America, as well as European, North American, and Latin American modernist traditions of abstraction, indigenous imagery, and patterning, *Angelitos Negros* remixes seemingly disparate visual histories, offering the viewer a monument that resists omission and hierarchy and instead foregrounds multiplicity and simultaneity. —MS

02

03

04

05

ORE-GIRON

GELARE KHOSHGOZARAN

Gelare Khoshgozaran explores the personal and political effects of displacement and the potential for transnational intimacy through video, performance, installation, and writing. The artist, who moved to Los Angeles in 2009 for graduate school, was born and raised in Tehran.

Khoshgozaran's work addresses the impersonal formalities and invasive actions that those who are seeking citizenship or are considered "alien" have to negotiate on a daily basis. Her piece *eye five eight nine: application for asylum and for withholding of removal* (2016) utilizes the technique of blind embossing to depict the artist's own twelve-page application for asylum in the United States submitted to the US Citizenship and Immigration Services in 2012. Form I-589, Application for Asylum and for the Withholding of Removal, allows a person who is living in the United States but not a US citizen to apply for asylum. The work integrates the historical impact of embossing, which stemmed from the rise of printing processes in the fifteenth century, allowing people to personalize their legal documents. In this way, Khoshgozaran illuminates the urgency of her personal needs against the backdrop of a formulaic document and further highlights her own status as a queer political subject.

For her recent solo show, *Rocket Rain/*باران کشوم, at Human Resources in Los Angeles, Khoshgozaran created several installations that were housed within the historical timeline of the Iran-Iraq War (1980–88), during which she was born. *Cosmos* (2016) highlights an ongoing action that she carries out with her parents, who still live in Tehran. As it has become increasingly difficult for her family to visit the United States due to heightened restrictions around certain Middle Eastern countries, Khoshgozaran has started asking that items from her childhood be sent to her via postal service as an alternative way of communication. These items vary in personal and political significance as they circle back to her youthful and imaginative memories of violent wartime. A component of the installation features several crossword puzzles from a local Iranian newspaper called *Kayhan* (Cosmos) that her mother completed during the nine months she was carrying Khoshgozaran in her womb. The puzzles, floating in Plexiglas in the chronological

order of publication, serve to bridge civic conflict and the highly personal nuances of childbearing.

For *Made in L.A. 2018*, Khoshgozaran will premiere her quasi-documentary film *Medina Wasl, Connecting Town*. Medina Wasl is a small desert town housed within a military base in Southern California that is designed to mimic the desert landscape of Iraq or Afghanistan, countries also known for their palm trees and sprawling terrain. On this base are active battlefields and spaces that are set in place to simulate various parts of the Middle East. Public tours are given a few times a year, and Khoshgozaran will document her experience on one of these tours, dressed in an Iranian uniform designed for men and sent from her parents during the time of the Iran-Iraq War. The piece will be accompanied by a stop-motion 16mm animation of declassified National Security Agency documents regarding the events of the Iran-Iraq War. She will further explore, including through interviews with US war veterans, the simulacrum of the "Middle East" in the Southern California desert, used as a training site to conquer and colonize, as well as other cultural references in the area such as the Riverside County Fair & National Date Festival. —EC

01

02

MADE IN L.A. 2018

03

04

KHOSHGOZARAN

CAROLINA CAYCEDO

Even as recent rainy spells have helped quench the five-year drought in California, such episodes have made it clear that in the coming years water will be our most coveted, scarce, and politicized natural resource. Access to clean water, rights to the bounty contained within, and control over the lands that rivers run through have been at the heart of recent political protests and civic outrage in the United States, such as those related to the Dakota Access Pipeline—for which the slogan "Water Is Life" was emphasized by activists who dubbed themselves "water protectors" in solidarity with those fighting for water rights around the world—and the scandal around the highly contaminated drinking water in Flint, Michigan.

Since 2012 Carolina Caycedo has examined the ecological, economic, and psychological impacts of dams built along waterways, particularly in relationship to development in Latin American countries such as Colombia (where she grew up), Brazil, Guatemala, and Mexico. Her ongoing *Be Dammed* project—which includes the group of sculptures from her Cosmotarrayas series shown in *Made in L.A. 2018*— recognizes water as a living entity, a public resource, and a human right. Reflecting Caycedo's belief that art can play a vital role in political activism, civic discourse, and public awareness, the project brings to light the impact of large dams on both natural and social landscapes. *Be Dammed* has taken a number of different forms, including sculptures, portraits of rivers printed on textile panels, video installations, drawings, group performances called "geochoreographies" that straddle protest and art, and handmade books with drawings and texts relaying indigenous rituals and mythology, as well as workshops, acts of civil disobedience, pedagogy, and everyday gestures.

Caycedo's works involve much research and fieldwork, and she often collaborates with people living along rivers in bioregions, documenting their stories, forming friendships, and participating in their grassroots efforts to maintain their way of life. The Cosmotarrayas sculptures take as their primary structure handwoven fishing nets given to the artist by friends or acquaintances in the

sites she visits or purchased in local markets; the nets are then adorned or filled with a variety of objects Caycedo acquires during her fieldwork or from her personal archive. Some sculptures become portraits of sorts, but all suggest, through their precise balance of porousness and the stability and strength that comes from the rhizomatic structure of the net, an inherent connectivity among beings. These sculptures also honor the wisdom of cultures whose artisanal practices, in their very structure, embrace food sovereignty, equality, and justice.

Caycedo's work argues that we must reimagine and reorient our relationship to water, to resist notions of the river as a resource to be exploited and instead understand it as an active agent that has an almost endless capacity for giving and sustaining when cared for. *Be Dammed* takes one of the most conventional subjects of art history—the landscape—and not only makes it relevant to the urgencies of our day but also brings the landscape to life, unveiling the affinities between the interconnectivity of the world's waterways and the blood that flows through our veins. Caycedo recognizes and makes visible the relationships between environmental degradation and the mistreatment and oppression of people. Seeing dams as a kind of tumor that blocks the natural flow of energy and life, she calls for "the conjuring of water for the common good." —AE

01

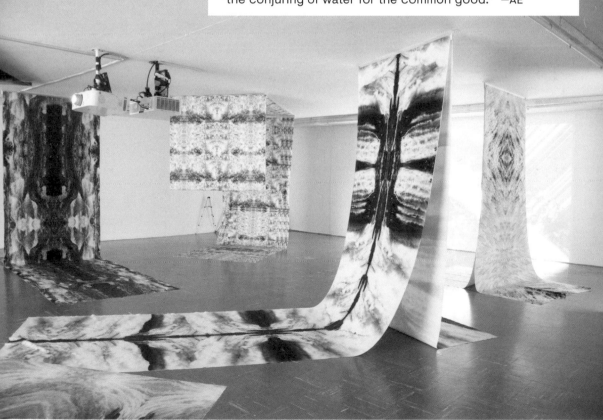

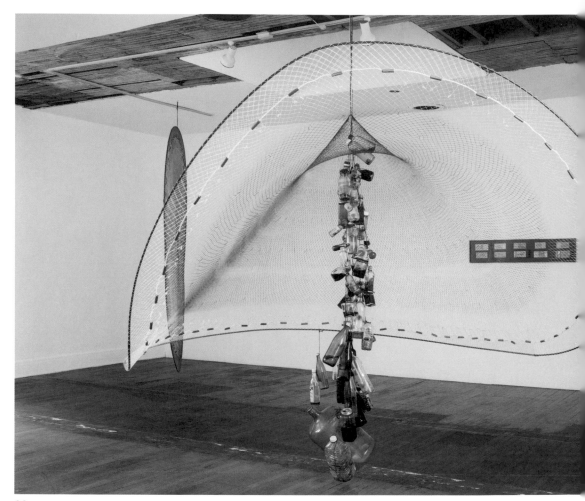

02

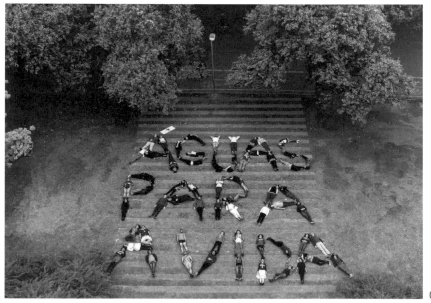

03

MADE IN L.A. 2018

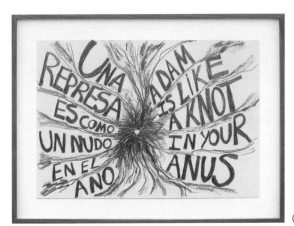

04

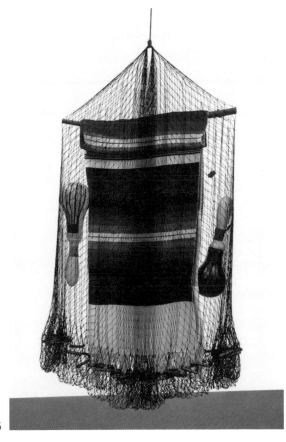

05

CORTEZ
BEATRIZ

Like all good science fiction, Beatriz Cortez's works dream of a different future but remain firmly rooted in the past. Simultaneously holding two different frames of reference—the temporal and the spatial—comes easily to Cortez, who immigrated to the United States from El Salvador at the age of eighteen when the war in her native country made it too dangerous to remain. She feels oriented to both San Salvador and Los Angeles and is committed to examining the historical and contemporary routes of cultural, commercial, and human exchange that occur along the axis connecting sites within the Americas. Working primarily with sculpture, Cortez for the past several years has been building machines that bring together different histories, acknowledge global and cosmic nomadism, and imagine the potential for divergent entities to coexist. She has stated of her work, "I build memory in order to imagine possible futures."

Cortez's *Los Angeles Vernacular: Space Capsule Interior* (2016) consists, in part, of one half of a geodesic dome, of the type advocated by the influential architect Buckminster Fuller, made of welded sheet metal. In addition to the potential social gains resulting from innovative architecture, it calls up an array of idealistic movements aimed at creating a better life. Housed within the arc of the dome is a welded steel replica of a type of fireplace originally built from river rocks and granite inspired by the work of the stone builder George Harris, who was part of the Little Landers, a community of cooperative farms established in Tujunga, north of downtown Los Angeles, in the early twentieth century. The work is also indebted to the handmade domestic architecture of the early Craftsman movement, with a particular interest in construction techniques that bring together knowledge and working methods from a range of cultures.

Los Angeles Vernacular, as well as *The Lakota Porch: A Time Traveler* (2017), makes specific reference to the Mescalero Apache master stonemason Dan Montelongo, who built many homes in Southern California a century ago. Informed by the back-to-the-land belief in working with locally sourced materials, Montelongo's stonework also evokes pre-Columbian architecture such as the Templo

01

01. *The Lakota Porch: A Time Traveler,* 2017
02. *Nomad 13,* 2017, with Rafa Esparza
03. *The Fortune Teller (Migrant Edition),* 2015
04. *The Untimely Conversation Box,* 2015

Mayor built by the Aztecs in Mexico City and the Maya's Chichén Itzá in the Yucatán. For Cortez these works are a type of time travel, conjuring the ancient, the industrial, and the modern, and proposing a future in which differences are celebrated. *Nomad 13* (2017), made in collaboration with Rafa Esparza, is conceived as a space capsule to house indigenous plants from the Americas. Interested in how the migration of plants mimics the movement of people across borders and boundaries, the work also speaks to the ways in which ancient civilizations used plants for various purposes, including nutrition and healing, spirituality and ceremony, and as a commodity for trade and negotiation.

For *Made in L.A. 2018,* Cortez has built a new kind of machine, *Tzolk'in* (2018), based on the Maya's 260-day agricultural calendar and what came to be known as hypocycloid motion, which is also found in planetary movements, the industrial design of steam engines, and even microbes inside the human body. At its core is a set of gears that move in opposite directions, generating movement that is both circular and linear. Literally enacting a temporality and a spatiality that embrace forces often considered to be in opposition—the spherical and the straight—the work argues for more nuanced understandings of time and an incorporation of both labor and play. Made of welded steel and constantly in motion through its kinetic system, *Tzolk'in* is at once a modern machine and an ancient calendar. —AE

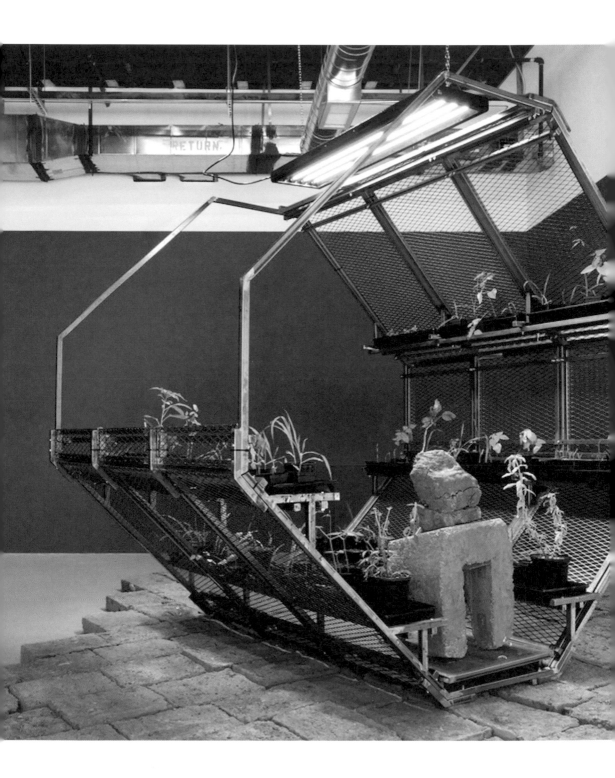

MADE IN L.A. 2018

03

04

02

CORTEZ

There is a vulnerability to EJ Hill's work that is at once touching and devastating. His willingness—most directly through his performance and writing but also embedded in his built structures, neon phrases, and ethereal paintings—to expose both his physical body and his psychic states feels like a defiant act of bravery. His uncompromising honesty is a gift offered to those who have experienced alienation or marginalization, who have felt either invisible or as though a single physical characteristic has reduced their subjectivity to a handful of assumptions. Hill insists

that we look—really look—at how our society's deeply held prejudices and systemic inequalities continue to render black, brown, and queer bodies the targets of violence, and his work can be as painful to contend with as it is essential to witness.

Hill doesn't shy away from the tension engendered when different energies seek to inhabit a shared space. What might be experienced as humanizing and heartfelt by some may be interpreted as alienating or discomforting to others. His frustrations are present and visceral: a thirty-day vow of silence ended in a scream that must have been as jarring to the artist as it was to those observing it. Yet there is hopefulness, for it is in the collision of these two energetic forces that the possibility for increased understanding resides. Drawing upon the legacies of artists from earlier generations—notably feminists and artists of color such as Carolee Schneemann, Linda Montano, Marina Abramović, Tehching Hsieh, and William Pope.L—Hill has embraced a form of durational performance that reflects both the hardships that certain bodies are forced to endure and their enormous resilience. For *The Fence Mechanisms* (2014), he attached himself to a chain-link fence and then skipped rope until he collapsed. During *O Captor, My Captor* that same year, he and collaborator David Bell sparred, managing to land painful punches despite being blindfolded. Hill has explored being policed, assaulted, unwelcomed, misunderstood, and confused. Yet he believes in the power of representation and the possibility of healing. He is committed to making visible, to retelling the story, to affirming experience.

His recent solo show, *The Necessary Reconditioning of the Highly Deserving* (2017), suggests a type of ascension, an ability to rise above it all, at least temporarily, through imagery of open spaces—clouds and mountains—and sculptural sites for viewers to inhabit. Visitors are invited to swing so their feet reach for the peak of a mountaintop and to climb stairs to a platform and view the phrase "We deserve to see ourselves elevated" in neon across

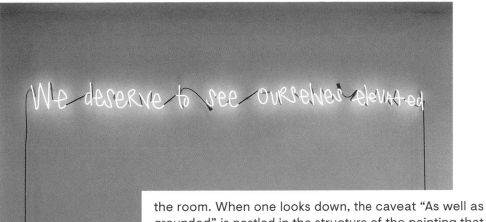

01

the room. When one looks down, the caveat "As well as grounded" is nestled in the structure of the painting that forms the facade.

For *Made in L.A. 2018*, Hill reprises durational performance, but in a process that suggests endurance as a form of meditation, a life-affirming temporality, and a revisiting of the past. For *Excellentia, Mollitia, Victoria* (2018), he visited every school he ever attended in Los Angeles—from kindergarten to UCLA—and ran around them, charting a course along the streets that circumscribe each campus. Each victory lap might be seen as an act of enveloping time and space, a reinsertion of his body into places regarded as foundational to his development. Cumulatively, the documentation of these actions might suggest Hill has been running in circles his entire life. But what is the essence of running if not the simple act of breathing? This crucial concern with breathing runs through all of Hill's practice: the right to breathe without obstruction, without interruption, and without contamination, and to conclude an inhale with a loud primal scream when needed. —AE

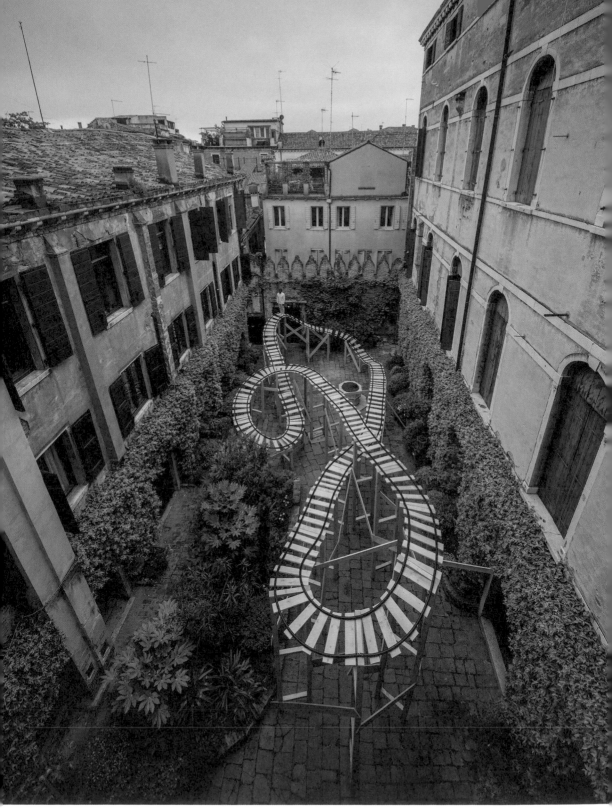

02

MADE IN L.A. 2018

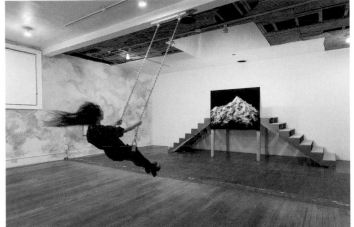

03

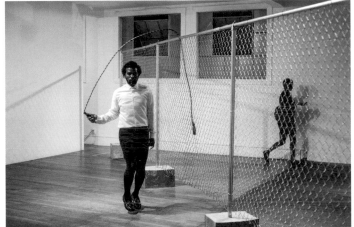

04

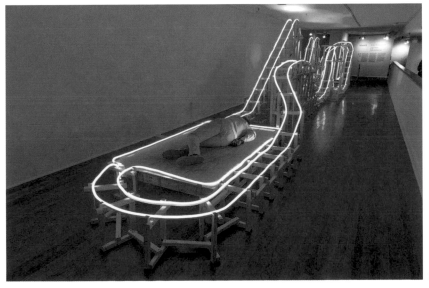

05

LAUREN HALSEY

Born and raised in Los Angeles, Lauren Halsey recounts that her first serious consideration of art making took place in the twelfth grade, after creating a project on hieroglyphs. She would go on to study art and architecture at El Camino Community College and CalArts, eventually landing in the sculpture department at Yale University.

In *The Crenshaw District Hieroglyph Project*, Halsey, who has always been strongly committed to her family's neighborhood and the larger narrative of South Central, returns to this practice of hiero-glyphy and a consideration of the power of the pictorial to house and share history.

The Crenshaw District Hieroglyph Project is Halsey's most ambitious to date, centering on the legacy and preservation of her community in South Central. Halsey finds a particular urgency in examining the various ways in which new development is cur-rently driving the redistribution of neighborhoods and shifting the local landscape. The project will function as a kind of activated archive that will also be a des-ignated space for public engage-ment and cultural place making.

Halsey is working with large panels of drywall that will be applied to plywood to create the main structures of this space. The drywall with gypsum, a mineral that was used in building ancient Egyptian pyramids, will then serve as a surface for inscriptions, similar to the writing system of hieroglyphs; community members will be invited to create imagery and contribute texts to, she says, express personal narratives, share important news, honor com-munity leaders, celebrate events, or leave memorials. Those inscriptions will be permanent within the framework of the structures to function as a larger metaphor for belonging and stability. The main structure will be an atrium with hieroglyphs inscribed both on and within the space, allowing passersby to step inside and interact with the images. Halsey will erect this project on Crenshaw Boulevard in an area that historically has been utilized as an African bazaar, one that she would often visit as a child.

Halsey will construct the first prototype of the main space of this project and several floor-to-ceiling columns for *Made in L.A. 2018*. She has gathered various images of friends, family, local storefronts, and the iconography

that defines her neighborhood, which she will inscribe on the structure. Her stake in space—how it is inhabited, constructed, and disseminated—allows the notion to hold a twoness in its implications for societal and cultural shifts, especially as it relates to Los Angeles. Not only does space define the environments we call home but it is also the celestial body that governs the universe. As the experimental jazz musician Sun Ra boldly asserted, "Space is the place." —EC

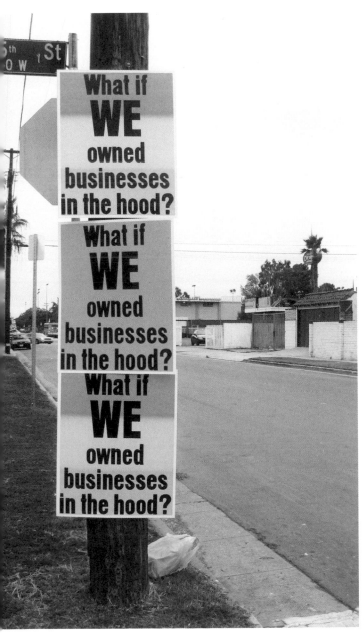

01

02

04

03

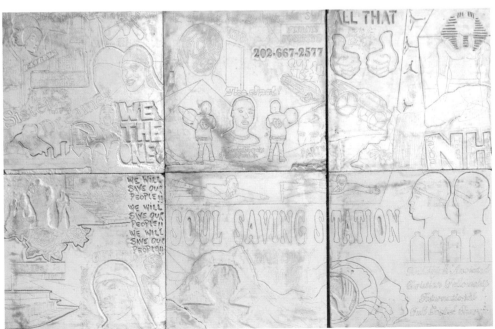

05

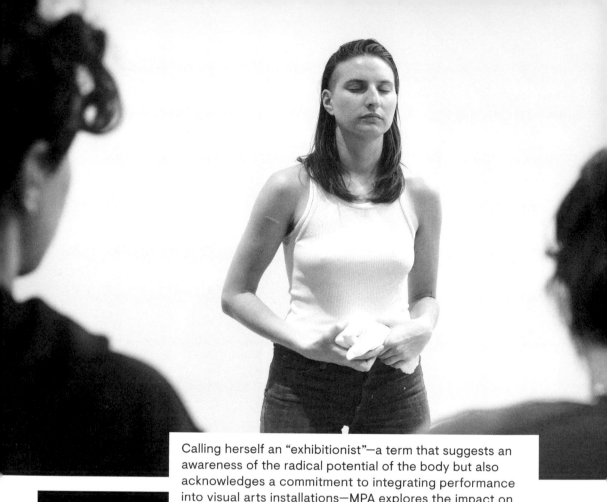

MPA

Calling herself an "exhibitionist"—a term that suggests an awareness of the radical potential of the body but also acknowledges a commitment to integrating performance into visual arts installations—MPA explores the impact on the body of the social and political realities that govern our existence. She understands that art always operates within a political framework, and her works examine how power is articulated through particular human behaviors. Also dedicated to the idea that the body and the psyche can be empowered through action, MPA strives for performances that are corporeal in their presence, affective in their tenor, and energetic in their progression over time.

For *Initiation*, the first chapter of her three-part *Directing Light onto Fist of Father* (2011), MPA stood silently for two and a half hours holding a white plaster cast of her father's clenched fist in the middle of a gallery full of people. An act of meditation and protest, the work was an overt contemplation of patriarchy in terms both personal and social. In her 2015 performance *Nothing to You*, MPA reversed the usual hierarchy between artist and viewer by placing the audience in the middle of the gallery as the performers moved around the outer boundaries. While the artist spoke of the interconnectivity of capitalism, violence, and white supremacy, the five performers enacted further "collisions" by inserting themselves physically into fissures she had imposed upon the architecture.

01

After moving in 2013 to Twentynine Palms, on the edge of a US military base in the desert east of Los Angeles, she became increasingly preoccupied by efforts geared toward the colonization of Mars. In ancient Roman mythology, Mars is the god of war and in astrological terms is often associated with calls to action motivated by an aggressive survival instinct. With this historical backdrop in mind, MPA began talking to NASA scientists, aerospace engineers, and UFO investigative journalists in an attempt to understand the correlations between our urge to colonize another planet and the role of militarization in claims to land throughout human history. Her installation *THE INTERVIEW: Red, Red Future* (2016) included photography, sculpture, and performance in the form of conversations, shifting the discourse to include the public. Next to a crimson red lawn chair and on a folding metal table was a telephone receiver that connected visitors to an interviewer who engaged them in a discussion about the effects of colonizing behavior, instigated by questions about whether they've ever thought about living on Mars. These intimate conversations became windows into the overlaps between science and the imagination and how the unknown can become a site upon which to project speculative ideas about the relationship between the materiality of the body and the illusory notion of the soul. MPA was struck by the sense of vulnerability and even pain that permeated these conversations. She wondered whether the countless sites of conflict and protracted states of war that have shaped life on earth have resulted in a condition of grieving for humanity that is somehow heightened by the possibility that we may eventually escape its confines.

For *Made in L.A. 2018*, she has created a bright red sculptural line running through her gallery and out onto the terrace of the Hammer. As its title—*Faultline*—indicates, the piece responds to the proximity of Los Angeles to fault lines such as the San Andreas, which portend massive earthquakes in the future; it is also inspired by an item that is almost synonymous with Southern California: sunglasses. Positioned half inside the galleries and half outside on one of the large stucco terrace walls is an enormous pair of sunglasses, split in two and connected to the fault line. A perfect metaphor for the current state of political affairs, *Faultline* creates a site for differences to coexist. Rather than fear the eruptions brought on by divisive partisanship, MPA argues for the need to honor a multiplicity of perspectives by allowing ourselves to walk on both sides of a divide. —AE

02

03

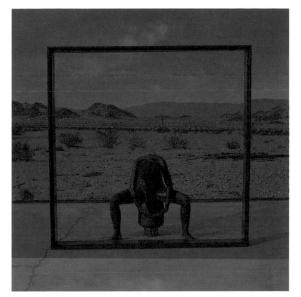

04

05

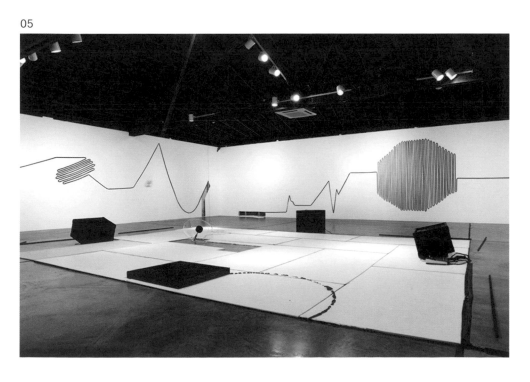

MPA

ARTIST BIOGRAPHIES

CARMEN ARGOTE

(b. 1981, Guadalajara, Mexico) works in the Lincoln Heights neighborhood of Los Angeles. She received her BA in 2004 and MFA in 2007 from University of California, Los Angeles. Her work has been exhibited at various institutions, including Ballroom Marfa, Texas (2017); Los Angeles County Museum of Art (2017); Denver Art Museum (2017); Orange County Museum of Art, Newport Beach, California (2017); National Museum of Mexican Art, Chicago (2015); MAK Center, Los Angeles (2015); and Vincent Price Art Museum, Los Angeles (2013). She is a recipient of the Rema Hort Mann Foundation YoYoYo Artist Grant (2015) and California Community Foundation Emerging Artist Grant (2013).

JAMES BENNING (b. 1942,

Milwaukee, Wisconsin) works in Val Verde, in northwestern Los Angeles County. Benning received his MFA from University of Wisconsin, Madison, in 1975. He has had solo exhibitions at neugerriemschneider, Berlin (2018, 2016, 2012, 2011); Museum of Natural History, Vienna (2014); VOX Centre de l'image contemporaine, Montreal (2014); and Kunsthaus Graz, Austria (2014), among numerous others. His work has been included in group exhibitions and screened at Akademie der Künste, Berlin (2017); neugerriemschneider, Berlin (2016, 2014, 2010); Kunsthalle Wien, Vienna (2016); Centre d'art de l'Onde, Vélizy-Villacoublay, France (2016); MAK Center, Los Angeles (2015); De Cordova Sculpture Park and Museum, Lincoln, Massachusetts (2014); Kunstverein, Hamburg (2014); Whitney Museum of American Art, New York (2014, 2006, 1981, 1979); and Walker Art Center, Minneapolis (2013, 2003, 1979, 1978), among others.

DIEDRICK BRACKENS

(b. 1989, Mexia, Texas) works in the Leimert Park neighborhood of Los Angeles. Brackens received his BFA from University of North Texas in 2011, and MFA in textiles from California College of the Arts in 2014. His work has been shown in solo exhibitions at Ulrich Museum of Art, Wichita (2017); Steve Turner Gallery, Los Angeles (2016); and Johansson Projects, Oakland (2015). Group exhibitions include those at SOMArts, San Francisco (2014); Berkeley Art Museum (2014); 3rd Ghetto Biennale, Port-au-Prince, Haiti (2013); and Museum of Geometric Art, Dallas (2011). Brackens is a recipient of the Barclay Simpson Award from the California College of the Arts (2014) and Clare Hart DeGolyer Memorial Fund Award (2011).

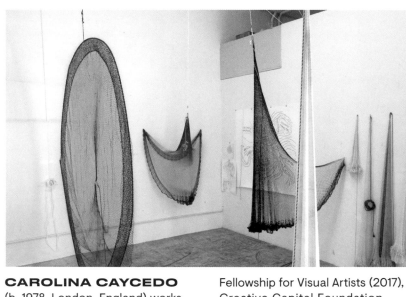

CAROLINA CAYCEDO

(b. 1978, London, England) works in the Chinatown neighborhood of Los Angeles. Caycedo received her BFA from Los Andes University, Bogotá, Colombia, in 1999, and MFA from University of Southern California in 2014. She has exhibited at Commonwealth and Council, Los Angeles (2017); 32nd São Paulo Biennial (2016); Human Resources, Los Angeles (2016); LAXART, Los Angeles (2016); Museo de Arte Universidad Nacional, Medellín, Colombia (2016); Museum of Contemporary Art, Santa Barbara, California (2016); 9th Shanghai Biennale (2012); San Francisco Museum of Modern Art (2012); X Havana Biennial (2009); Wattis Institute for Contemporary Art, San Francisco (2009); New Museum, New York (2009); Queens Museum, New York (2007); Whitney Biennial, New York (2006); Los Angeles Contemporary Exhibitions (2005); Museo de Arte Contemporáneo, Santo Domingo, Dominican Republic (2003); and 50th Venice Biennale (2003). She has completed artist residencies at the Main Museum of Los Angeles (2017), São Paulo Biennial (2016), and 18th Street Arts Center (2013). She is the recipient of numerous awards, including California Community Foundation Fellowship for Visual Artists (2017), Creative Capital Foundation Visual Artist Grant (2015), and Harpo Foundation Visual Artist Grant (2015).

NEHA CHOKSI

(b. 1973, Belleville, New Jersey) works in Inglewood, California, and Bombay. Choksi received her BA in art and Greek from University of California, Los Angeles, in 1997, and MA in classics from Columbia University in 2000. She has exhibited or performed at Dhaka Art Summit, Bangladesh (2018, 2016); Manchester Art Gallery (2017); LAMOA at Occidental College, Los Angeles (2017); Commonwealth and Council, Los Angeles (2017); Los Angeles Municipal Art Gallery (2017); Project 88, Mumbai (2016, 2013, 2010, 2009, 2007); 20th Biennale of Sydney (2016); Hayward Gallery Project Space, London (2015); Kochi-Muziris Biennale, India (2014); Armory Center for the Arts, Pasadena, California (2013); Whitechapel Gallery, London (2013); John Hansard Gallery, Southampton, UK (2012); 9th Shanghai Biennale (2012); and Asia Pacific Triennial 7, QAGOMA, Australia (2012), among others.

BEATRIZ CORTEZ

(b. 1970, San Salvador, El Salvador) works in

San Fernando, California. Cortez received her BA (1994) in Latin American history, her MA (1996) in Spanish, and her PhD (1999) in Latin American literature from Arizona State University, Tempe; MA in visual arts from California State University, Northridge, in 2013; and MFA from California Institute of the Arts in 2015. She has had solo exhibitions at Vincent Price Art Museum, Los Angeles (2016); Monte Vista Projects, Los Angeles (2016); Cerritos College Art Gallery, Norwalk, California (2016); and Grand Central Arts Center, Santa Ana, California (2013), among others. Group exhibitions include those at UCR ARTSblock, Riverside, California (2017); Torrance Art Museum, California (2017); Orange County Museum of Art, Newport Beach, California (2017); Centro Cultural Metropolitano, Quito, Ecuador (2016); Sala Nacional de Exposiciones Salarrué, San Salvador (2016); Los Angeles Contemporary Exhibitions (2016); and Centro Cultural de España, Guatemala City (2015). She is a recipient of

the Rema Hort Mann Foundation Emerging Artist Grant (2018) and California Community Foundation Fellowship for Visual Artists (2016).

MERCEDES DORAME

(b. 1980, Los Angeles, California) works in Malibu. Dorame received her BA from University of California, Los Angeles, in 2003, and MFA from San Francisco Art Institute in 2010. Her work has been exhibited at the Fine Arts Gallery at San Francisco State University (2016); Thatcher Gallery, San Francisco (2015); Armory Center for the Arts, Pasadena, California (2014); Phoebe A. Hearst Museum, Berkeley (2012); California Indian Conference, Chico (2011); and Diego Rivera Gallery, San Francisco (2010), among others. She is a recipient of the James D. Phelan Award in the Visual Arts from the San Francisco Foundation (2017), En Foco's New Works Photography Fellowship (2012), and Harpo Foundation Fellowship (2011).

CELESTE DUPUY-SPENCER (b. 1979, New York, New York) works in downtown Los Angeles. She (almost) received her BFA from Bard College in 2007. Her work has been exhibited at the Whitney Biennial, New York (2017); Marlborough Contemporary, New York (2017); Max Hetzler, Berlin (2017); Mier Gallery, Los Angeles (2016); Mitchell-Innes & Nash, New York (2012); Museum 52, New York (2011); Museo Tamayo Arte Contemporáneo, Mexico City (2010); San Francisco Museum of Modern Art (2010); MoMA PS1, New York (2009); and Bronx Museum, New York (2008).

AARON FOWLER (b. 1988, Saint Louis, Missouri) currently works in the Harlem neighborhood of New York City, Los Angeles, and Saint Louis. Fowler received his BFA from Pennsylvania Academy of the Fine Arts in 2011, and MFA from Yale

University in 2014. His work has been exhibited at New Museum, New York (2018); Savannah College of Art and Design Museum of Art, Georgia (2017); Saatchi Gallery, London (2017); Beeler Gallery, Columbus College of Art and Design, Ohio (2016); Diane Rosenstein Gallery, Los Angeles (2016); Rubell Family Collection, Miami (2016); Studio Museum in Harlem, New York (2015); Flanders Gallery, Raleigh, North Carolina (2015); Thierry Goldberg Gallery, New York (2013); and Sophia Wanamaker Gallery, San José, Costa Rica (2012). He is a recipient of the Rema Hort Mann Foundation Emerging Artist Grant (2015) and was an artist in residence at the Skowhegan School of Painting and Sculpture (2014).

NIKITA GALE (b. 1983, Anchorage, Alaska) works in Inglewood, California. Gale received her BA in anthropology at Yale University in 2006, and MFA in new genres at University of California, Los Angeles, in 2016. Her work has been exhibited at Artist Curated Projects, Los Angeles (2017); Studio Museum in Harlem, New York (2017); LAXART, Los Angeles (2016); Zuckerman Museum of Art, Kennesaw, Georgia (2015, 2014); Samuel Dorsky Museum of Art, New Paltz, New York (2014); Center for Photography at Woodstock, New York (2012); School of Visual Arts, New York (2012); and Atlanta Contemporary Art Center (2012), among others. She is a recipient of the Rema Hort Mann Foundation Emerging Artist Grant (2017) and National Endowment for the Arts Southern Constellations Fellowship (2013). She has been an artist in residence at Vermont Studio Center (2013) and Center for Photography at Woodstock (2011).

JADE GORDON (b. 1975, Santa Rosa, California) works in the Glassell Park neighborhood of Los Angeles. Gordon is a founding member of the Los Angeles collective My Barbarian with Malik Gaines and Alexandro Segade. She received her BA in theater in 2008, and MA in applied theater in 2011 from University of Southern California. My Barbarian has exhibited and performed at numerous institutions, including the New Museum, New York (2016); Los Angeles County Museum of Art (2015); Whitney Museum of American Art, New York (2014); San Francisco Museum of Modern Art (2012); Museum of Modern Art, New York (2012); Hirshhorn Museum and Sculpture Garden, Washington, DC (2012); and Hammer Museum, Los Angeles (2011). The collective has also received awards from the United States Artists Fellowship (2018), Foundation for Contemporary Arts (2013), Creative Capital Grant (2012), City of Los Angeles, Department of Cultural Affairs (2009), and Art Matters (2008). Gordon also collaborates with Megan Whitmarsh, and the two have performed and exhibited at Human Resources, Los Angeles (2017).

LAUREN HALSEY (b. 1987, Los Angeles, California) works in Los Angeles. Halsey received her BFA from California Institute of the Arts in 2012, and MFA from Yale University in 2014. She has exhibited her work at the Museum of Contemporary Art, Los Angeles (2018); Armory Center for the Arts, Pasadena, California (2016); Museum of Modern Art, New York (2016); Recess, New York (2016); and Studio Museum in Harlem, New York (2015). She is the recipient of the Rema Hort Mann Foundation Emerging Artist Grant (2015), Alice Kimball English Travelling Fellowship (2013), and Beutner Family Award

for Excellence in the Arts, California Institute of the Arts (2011). Halsey was an artist in residence at the Main Museum of Los Angeles (2017), Studio Museum in Harlem (2014–15), and Skowhegan School of Painting and Sculpture (2014). She received the William H. Johnson Prize in 2017.

EJ HILL (b. 1985, Los Angeles, California) works in the Manchester Square neighborhood of south Los Angeles. Hill received his BFA from Columbia College Chicago in 2011, and MFA from University of California, Los Angeles, in 2013. He has exhibited or performed at Institut d'art contemporain, Villeurbanne/Rhône-Alpes, France (2017); Underground Museum, Los Angeles (2017); Future Generation Art Prize at the 57th Venice Biennale (2017); Human Resources, Los Angeles (2017); Commonwealth and Council, Los Angeles (2017); and Studio Museum in Harlem, New York (2016), among others. He was an artist in residence at Praxis Studio, California State University, Dominguez Hills (2017), Studio Museum in Harlem (2015), and Artists' Cooperative Residency and Exhibitions (2010). He was nominated for the Victor Pinchuk

Foundation Future Generation Art Prize (2017) and is the recipient of a Foundation for Contemporary Arts Grants to Artists Award (2018), Art Matters Foundation Award (2017), William H. Johnson Prize (2016), and American Austrian Foundation Prize for Fine Arts, Salzburg (2012).

NAOTAKA HIRO (b. 1972, Osaka, Japan) works in Pasadena, California. Hiro received his BA from University of California, Los Angeles, in 1997, and MFA from California Institute of the Arts in 2000. His work has been exhibited at Brennan & Griffin, New York (2017, 2016, 2013); Armory Center for the Arts, Pasadena, California (2016, 2010); Los Angeles Contemporary Exhibitions (2016), LAXART, Los Angeles (2016); The Box, Los Angeles (2016, 2015, 2014, 2008); Centre d'art contemporain, La Ferme du Buisson, France (2015); and Misako & Rosen, Tokyo (2015, 2011, 2009, 2008, 2007), among others. He is the recipient of grants and awards from the Art Matters Foundation (2014) and the Asian and Pacific Islander Artist Presenting Initiative (2006).

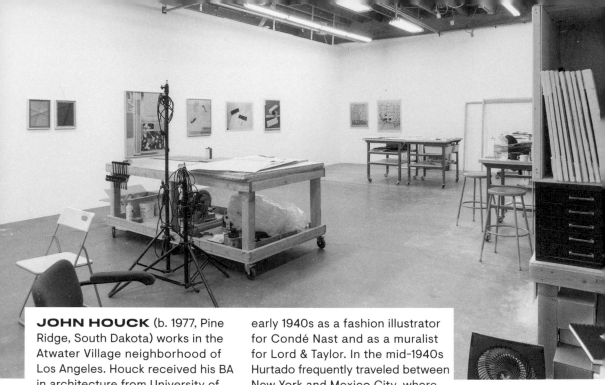

JOHN HOUCK (b. 1977, Pine Ridge, South Dakota) works in the Atwater Village neighborhood of Los Angeles. Houck received his BA in architecture from University of Colorado Boulder in 2000, and MFA from University of California, Los Angeles, in 2007. He also studied at the Whitney Independent Study Program in 2010 and the Skowhegan School of Painting and Sculpture in 2008. His work has been exhibited at Dallas Contemporary (2017); The Mistake Room, Los Angeles (2017); International Center of Photography, New York (2016); Museum of Modern Art, New York (2015); Museo de Arte Moderno de Medellín, Colombia (2015); Museum of Contemporary Canadian Art, Toronto (2015); Jewish Museum, New York (2015); Los Angeles County Museum of Art (2014); Palm Springs Art Museum, California (2014), and others. He is the recipient of the National Endowment for the Arts Anderson Ranch Residency (2008).

LUCHITA HURTADO

(b. 1920, Caracas, Venezuela) works in Santa Monica. In 1928 Hurtado immigrated to New York City, where she studied at Washington Irving High School and the Art Students League. She began her career in the early 1940s as a fashion illustrator for Condé Nast and as a muralist for Lord & Taylor. In the mid-1940s Hurtado frequently traveled between New York and Mexico City, where she worked within an international group of artists and writers who were part of the World War II diaspora. In the late 1940s Hurtado moved to Mill Valley, California, where she associated with the Dynaton Group. In 1951 she moved to Los Angeles, where she has resided ever since. Recent solo exhibitions include the Annenberg Community Beach House, Santa Monica (2017), and Park View Gallery, Los Angeles (2016). Prior to these, her last solo exhibition was held at the Woman's Building, Los Angeles (1974). Hurtado has exhibited sporadically from the 1950s until the present, including at Night Club Gallery, Chicago (2016); Carnegie Art Museum, Oxnard, California (1994); Tally Richards Gallery, Taos, New Mexico (1970); and Paul Kantor Gallery, Los Angeles (1953).

GELARE KHOSHGOZARAN

(b. 1986, Tehran, Iran) works in the Mount Washington neighborhood of Los Angeles. Khoshgozaran received her BA in photography from University of Arts in Tehran in

2009, and MFA from University of Southern California in 2011. Recent solo exhibitions and performances include those at Los Angeles Contemporary Exhibitions (2017); Human Resources, Los Angeles (2016); Los Angeles Municipal Art Gallery (2016); and Queens Museum, New York (2016). Her work has been included in group exhibitions and screenings at LAXART, Los Angeles (2017); Pori Art Museum, Finland (2015); and Galeri Nasional Indonesia, Jakarta (2013). She has had residencies at the Museum of Contemporary Art in Tucson (2017), Echo Park Film Center (2017), Krannert Art Museum (2016), and Santa Fe Art Institute (2016). She is the recipient of an Art Matters Award (2017), a Rema Hort Mann Foundation Emerging Artist Grant (2016), The Andy Warhol Foundation Creative Capital Arts Writers Grant (2015), and a California Community Foundation Fellowship for Visual Arts, Emerging Artist Fellowship (2015).

CANDICE LIN (b. 1979, Concord, Massachusetts) works in Altadena, California. She received her BA in both visual arts and semiotics from Brown University in 2001, and MFA in new genres from San Francisco Art Institute in 2004. Her work has been exhibited at Portikus, Frankfurt (2018); Moderna Museet, Stockholm (2017); Bétonsalon—Center for Art and Research, Paris (2017); Human Resources, Los Angeles (2017); New Museum, New

York (2017); SculptureCenter, Long Island City, New York (2017); Los Angeles Contemporary Exhibitions (2016); and Vincent Price Art Museum, Los Angeles (2013), among others. She is the recipient of several residencies, grants, and fellowships, including a California Community Foundation Award (2014), Fine Arts Work Center Residency (2012), Frankfurter Kunstverein Deutsche Börse Residency (2010), and Smithsonian Artist Research Fellowship (2009).

CHARLES LONG (b. 1958, Long Branch, New Jersey) works in Mount Baldy, California. He received his BFA from Philadelphia College of Art in 1981, and MFA from Yale University in 1988. Recent solo exhibitions or projects include those at Tanya Bonakdar Gallery, New York (2017, 2014); The Contemporary Austin, Texas (2014); Madison Square Park Project, New York (2012); and Orange County Museum of Art, Newport Beach, California (2010, 2002). He has shown in numerous group exhibitions, including at the Philadelphia Museum of Art (2015); Carnegie Museum of Art, Pittsburgh (2013); Nasher Sculpture Center, Dallas (2013); Armory Center for the Arts, Pasadena, California (2012); SculptureCenter, Long Island City, New York (2012); Hammer Museum, Los Angeles (2011); Orange County Museum of Art, Newport Beach, California (2010); Santa Barbara Museum of Art, California (2009); Whitney Biennial, New York (2008); Museum of Contemporary Art, Miami (2007); and Hirshhorn Museum and Sculpture Garden, Washington, DC (2006).

NANCY LUPO (b. 1983, Flagstaff, Arizona) works in Los Angeles. She received her BFA from the Cooper Union in 2007, and MFA from Yale University in 2011. She has had solo exhibitions

at Antenna Space, Shanghai (2018); Kristina Kite Gallery, Los Angeles (2017); Musée d'art contemporain de Lyon, France (2017); Astrup Fearnley Museet, Oslo (2016); Swiss Institute, New York (2016); 1857, Oslo (2015); WALLSPACE, New York (2015); and LAXART, Los Angeles (2014), among others. Her work has been included in group exhibitions at Museum of Contemporary Art, Los Angeles (2016); Atlanta Contemporary (2016); MoMA PS1, Long Island City, New York (2014); Hammer Museum, Los Angeles (2013); and Night Gallery, Los Angeles (2013), among others. She is a recipient of numerous awards, including the Rema Hort Mann Foundation Emerging Artist Grant (2015), Foundation for Contemporary Arts Emergency Grant (2013), and Virginia Commonwealth University's Fountainhead Fellowship (2012).

DANIEL JOSEPH MARTINEZ (b. 1957, Los

Angeles, California) works in South Los Angeles. Martinez received his BFA from California Institute of the Arts in 1979. His work has been featured in numerous exhibitions, including at Los Angeles County Museum of Art (2017); Museum of Contemporary Art, Detroit (2017); Whitney Museum of American Art, New York (2017); Museum of Fine Arts, Houston (2017); Museo de Arte Moderno, Medellín, Colombia (2016); Jewish Museum, New York (2016); and Museum of Modern Art, New York (2012). Martinez has represented the United States in eleven biennials worldwide, including SITE Santa Fe Biennial (2014); Istanbul Biennial (2011); Berlin Biennial (2010); California Biennial (2008); Quebec Biennial (2010); Venice Biennale (1993); and Whitney Biennial (1993, 2008); he represented the United States in the American Pavilion at the Cairo Biennial (2006). He is the recipient of the Rockefeller Foundation Bellagio Residency, Italy (2018); American Academy Fellowship, Berlin (2016); Herb Alpert Award in the Arts (2014); United States Artists Fellowship (2007); ArtPace Foundation Fellowship and Residency (2005); California Arts Council Individual Artists

Fellowship (2003); Pollock-Krasner Foundation Grant (2001); Getty Center Foundation Individual Artist Fellowship (1997), and National Endowment for the Arts Individual Artist Fellowships (1991, 1995). Martinez cofounded Deep River and LAXART, both in Los Angeles. He is Donald Bren Distinguished Professor of Art at University of California, Irvine.

MPA (b. 1980, Redding, California) works in Twentynine Palms, California. MPA completed the La MaMa Performing Arts Program at Trinity College in 2002, and received her BA in liberal arts from Hampshire College in 2004. She has had solo exhibitions at the Whitney Museum of American Art, New York (2016), and the Contemporary Arts Museum, Houston (2016). She has exhibited and performed at Los Angeles Contemporary Exhibitions (2016); TBA Festival, Portland, Oregon (2015); Paço das Artes, São Paulo (2014); Museum of Art and Design, New York (2012); Stedelijk Museum, Amsterdam (2012); Swiss Institute, New York (2012); and Center for Performance Research, Brooklyn (2010), among others. MPA has had residencies in Woodridge, New York (2010); Stockholm, Sweden (2010); Nottingham, England (2007); and

Oaxaca, Mexico (2006). She is a recipient of the Grants to Artists Award from the Foundation for Contemporary Arts (2012).

ALISON O'DANIEL
(b. 1979, Miami, Florida) works in Los Angeles. She received her BFA from Cleveland Institute of Art in 2003, and MFA from University of California, Irvine, in 2010. She has exhibited, screened, or performed at the Ford Theater with FLAX French Los Angeles Exchange (2018); Los Angeles Municipal Art Gallery (2017); Art in General, New York (2016); Hammer Museum, Los Angeles (2016); The Drawing Center, New York (2016); Top-kino, Vienna (2016); Passerelle Centre d'art contemporain, Brest, France (2015); Aspen Art Museum (2016); LA Louver, Los Angeles (2013); and Samuel Freeman Gallery, Los Angeles (2013). She has completed artist residencies at Wexner Center for the Arts (2014), Fine Arts Work Center (2012–13), Skowhegan School of Painting and Sculpture (2007), and others. She has received several awards and honors, including a Rema Hort Mann Foundation Emerging Artist Grant (2014), Center for Cultural Innovation Grant (2013), Art Matters Grant (2012), Franklin Furnace Fund Fellowship (2012), and California

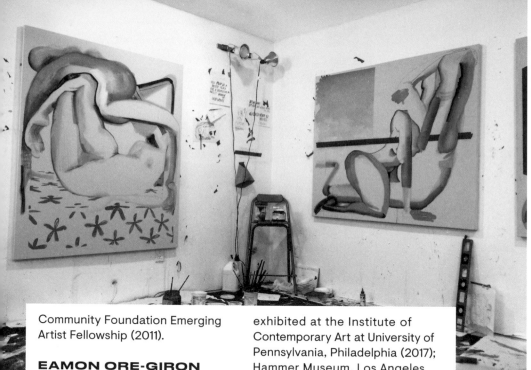

Community Foundation Emerging Artist Fellowship (2011).

EAMON ORE-GIRON

(b. 1973, Tucson, Arizona) works in the Angelino Heights neighborhood of Los Angeles. Ore-Giron received his BFA at San Francisco Art Institute in 1996, and MFA from University of California, Los Angeles, in 2006. He was a member of the collective OJO, which was active from 2004 to 2013, with artists Brenna Youngblood, Joshua Aster, Justin Cole, and several others. He has exhibited or performed at the Whitney Biennial, New York (2017); Ballroom Marfa, Texas (2017); LAXART, Los Angeles (2015); Prospect 3, New Orleans (2014); Perez Art Museum, Miami (2013); Museo Rufino Tamayo, Mexico City (2009); Museum of Contemporary Art, Los Angeles (2008); and Los Angeles County Museum of Art (2008), among others.

TAISHA PAGGETT (b. 1976,

Fresno, California) works in Riverside County, California. She received her BA in art history from University of California, Santa Cruz, in 2002, and MFA in choreography from University of California, Los Angeles, in 2008. She has performed or

exhibited at the Institute of Contemporary Art at University of Pennsylvania, Philadelphia (2017); Hammer Museum, Los Angeles (2017); Getty Villa, Malibu (2016); Diverseworks, Houston (2016); the Cooper Union, New York (2016); Los Angeles Contemporary Exhibitions (2015); Clockshop, Los Angeles (2015); University of Toronto, Scarborough (2015); Whitney Museum of American Art, New York (2014); REDCAT, Los Angeles (2013); Studio Museum in Harlem, New York (2012); and Torrance Art Museum, California (2010), among others. She has had residencies at the Headlands Center for the Arts (2015), ACRE (2014), Hothouse Residency, University of California, Los Angeles (2013), and Hyde Park Art Center (2012). She is the recipient of grants from University of California Institute for Research in the Arts (2014), Multi-Arts Production Fund with Los Angeles Contemporary Exhibitions (2014), and Choreographers in Mentorship Exchange (2013).

CHRISTINA QUARLES

(b. 1985, Chicago, Illinois) works in the El Sereno neighborhood of Los Angeles. She received her BA in studio arts and philosophy

from Hampshire College, Amherst, in 2007, and MFA in painting and printmaking from Yale University in 2016. Her work has been exhibited at the University of California Berkeley Art Museum & Pacific Film Archive (2018); Jessica Silverman Gallery, San Francisco (2018); New Museum, New York (2017); Studio Museum in Harlem, New York (2017); David Castillo Gallery, Miami (2017); Skibum MacArthur, Los Angeles (2017); LAXART, Los Angeles (2017); Rubell Family Collection, Miami (2017); and Armory Center for the Arts, Pasadena, California (2016). She is a recipient of the Rema Hort Mann Foundation Emerging Artist Grant (2017) and J. Paul Getty Foundation Grant (2006, 2005), and has completed residencies at Fountainhead (2017) and Skowhegan School of Painting and Sculpture (2016).

MICHAEL QUEENLAND

(b. 1970, Pasadena, California) works in the East Hollywood neighborhood of Los Angeles. Queenland earned his BA in English literature and MFA at University of California, Los Angeles, in 1992 and 2002, respectively. His work has been shown in solo and group exhibitions at Kristina Kite Gallery, Los

Angeles (2017); Hammer Museum, Los Angeles (2017); Santa Monica Museum of Art, California (2012); Whitney Biennial, New York (2008); LAXART, Los Angeles (2007); Harris Lieberman, New York (2007); Institute of Contemporary Art at the Maine College of Art, Portland (2005); and Massachusetts College of Art and Design, Boston (2005), among others. He is a recipient of numerous awards, including the Rome Prize (2016–17), American Academy in Berlin Fellowship (2009), United States Artist Fellowship (2006), and Helena Rubenstein Foundation Fellowship award for Studio Museum in Harlem (2004–5). He was assistant professor of sculpture at Yale School of Art from 2010 to 2016.

PATRICK STAFF

(b. 1987, Bognor Regis, England) works in the Silver Lake neighborhood of Los Angeles. Staff received their BA in fine art and contemporary critical studies from Goldsmiths University of London in 2009. They completed the LUX Associate Artists Programme and the Cunningham Method Contemporary Dance course at The Place in London in 2011. Their work has been exhibited at the Museum of Contemporary

Art, Los Angeles (2017); New Museum, New York (2017); Los Angeles Contemporary Exhibitions (2016); Contemporary Art Gallery, Vancouver (2016); Serpentine Galleries, London (2015); Chisenhale Gallery, London (2015); Tate Liverpool, England (2014); Monte Vista Projects, Los Angeles (2012); Tate Modern, London (2012), and Whitstable Biennale, England (2012), among others. They have received the Paul Hamlyn Award for Visual Artists (2015) and the David and Margot Kitchen International Artist Fund (2010). Staff has had residencies at FD13 Residency for the Arts (2018), LUX (2014), The Showroom (2014), Fogo Island Arts (2012), and Banff Centre (2010).

LINDA STARK (b. 1956, San Diego, California) works in Los Angeles. Stark received her BA from University of California, Davis, in 1978, and MFA from University of California, Irvine, in 1985. She has had solo exhibitions at Jenny's, Los Angeles (2017); University of California Berkeley Art Museum & Pacific Film Archive (2013); Angles Gallery, Los Angeles (2011, 2007, 2006, 1999, 1998); and Santa Barbara Contemporary Arts Forum, California (2002), among others. She has been included in group exhibitions at Los Angeles Municipal

Art Gallery (2017); Orange County Museum of Art, Newport Beach, California (2017); ArtCenter College of Design, Pasadena, California (2016); Kayne Griffin Corcoran, Los Angeles (2016); Vincent Price Art Museum, Los Angeles (2013); Otis College of Art & Design, Los Angeles (2013, 2012); and Harris Lieberman, New York (2012), among others. She is a recipient of California Community Foundation Artist Fellowship (2008), City of Los Angeles Visual Artist Fellowship (2001), California Arts Council Visual Artist Fellowship (1998), and NEA Visual Artist Fellowship (1995, 1992).

MEGAN WHITMARSH (b. 1972, Cambridge, Massachusetts) works in the Highland Park neighborhood of Los Angeles. Whitmarsh received her BFA from Kansas City Art Institute in 1993, and MFA from University of New Orleans in 1997. She also attended the Yale Summer School of Art in 1992. Her work has been exhibited at Human Resources, Los Angeles (2015); New Image Art, Los Angeles (2012, 2009); Museum of Design, Zurich (2011); Elaine Levy Project, Brussels (2011, 2006); Riverside Art Museum, California (2009); and Ulrich Museum of Art, Wichita (2006), among others. She has had residencies at The Watermill Center (2011) and Kling & Bang (2005).

FLORA WIEGMANN (b. 1976, Lincoln, Nebraska) is a dancer and choreographer who works in Venice, California. She studied at Laban Centre for Movement and Dance in London before earning her BA in dance from Columbia College Chicago in 1998, and MFA from University of California, Los Angeles, in 2007. She has performed at Midway Contemporary, Minneapolis (2018); Aspen Art Museum (2016); Union Station in the Seattle Art Fair (2016); Occidental College, Los Angeles (2016); Camden Arts Centre, London (2014); Banff Art Centre, Alberta (2009); Whitney Museum of American Art, New York (2008); and the Kitchen, New York (2006). Her film and installation work has been shown in exhibitions at C. Nichols Project, Los Angeles (2014); LAXART, Los Angeles (2013); Université Rennes, France (2013); California Biennial, Orange County Museum of Art, Newport Beach (2010); Contemporary Arts Museum, Houston (2010); and Institute of Contemporary Art, Philadelphia (2009), among others. She has been an artist in residence at El Segundo Museum (2017), Montalvo Arts Center (2016), and Headlands Center for the Arts (2009).

SUNÉ WOODS (b. 1976, Montreal, Canada) works in the Mid-Wilshire neighborhood of Los Angeles. Woods received her BFA from University of Miami in 1997, and MFA from California College of the Arts in 2010. Her work has been included in exhibitions at Light Work, Syracuse, New York (2017); Everson Museum of Art, Syracuse, New York (2017); Urban Video Project, Syracuse, New York (2017); Papillion Art, Los Angeles (2015, 2014); Commonwealth and Council, Los Angeles (2015); 18th Street Arts Center, Santa Monica (2012); Center for the Arts Eagle Rock, Los Angeles (2012); Performance

Art Institute, San Francisco (2011); and Arts Commission Gallery, San Francisco (2009), among others. She has had residencies at Light Work (2016), Center for Photography at Woodstock (2015), Vermont Studio Center (2014), and Headlands Center for the Arts (2012). She is a recipient of a John Gutmann Photography Fellowship Award from the San Francisco Foundation (2015), Visions from the New California Award from the James Irvine Foundation (2012), and Murphy and Cadagon Fellowship (2009).

ROSHA YAGHMAI (b. 1979, Santa Monica, California) works in the West Adams neighborhood of Los Angeles. Yaghmai received her BFA in visual arts from School of Visual Arts, New York, in 2001, and MFA from California Institute of the Arts in 2007. Her work has been exhibited at Tate St. Ives, England (2018); Marlborough Contemporary, New York (2017); Kayne Griffin Corcoran, Los Angeles (2017); Cleopatra's, New York (2016); Central Park, Los Angeles (2016); Weiss Berlin, Germany (2016); Human Resources, Los Angeles (2016); Commonwealth and Council, Los Angeles (2013); Public Fiction, Los Angeles (2013); Tiff's Desk, Los Angeles (2012); Thomas Solomon Gallery, Los Angeles (2011); Terra Foundation for American Art, Giverny, France (2009); GBK, Sydney (2008); Estacion Tijuana, Mexico (2008); Riverside Art Museum, California (2007); and Transmission Gallery, Glasgow (2007), among others. Yaghmai is a recipient of the Villa Aurora Berlin Fellowship (2016) and Terra Foundation Fellowship (2009).

STAFF ACKNOWLEDGMENTS

Organizing Made in L.A. is a multifaceted and time-consuming process, and this exhibition, its catalogue, and its accompanying programs required and benefited enormously from the Hammer's remarkable staff. None of our collective efforts would have been possible without the steadfast support and trust of the Hammer Museum's director, Ann Philbin, whose leadership and vision continue to shape the museum as a site for challenging art, new ideas, and civic responsibility. Her profound commitment to local audiences and the wide-ranging communities that make up our city is something our entire staff embraces as a shared responsibility, and, indeed, is at the very heart of the biennial. We are indebted to curatorial associate MacKenzie Stevens and project coordinator Vanessa Arizmendi, who tirelessly supported our efforts throughout this process and dedicated themselves to the exhibition completely. We also thank Tara Burns for always being willing to lend a hand to provide additional assistance when needed. Our curatorial colleagues at the Hammer, including Cynthia Burlingham, Connie Butler, Aram Moshayedi, Ikechukwu Onyewuenyi, Allegra Pesenti, and Matthieu Vahanian, are an invaluable resource and source of support. Melanie Crader, director of exhibition and project management, provided vital guidance during every aspect of planning for this exhibition and publication, and we are grateful for her professionalism and patience throughout. And Courtney Smith's adept project management of this catalogue was instrumental to its realization.

An exhibition of this scale is truly a collaborative effort and involves the participation of all museum departments and the entire Hammer staff. We have received extensive support from colleagues in Academic Programs, Administration and Operations, Communications, Development, the Director's Office, the Hammer Store, Public Engagement, Public Programs, Registration and Preparation, Security, Technology, and Visitor Experience. The expertise of Peter Gould, assistant director of exhibition design and production, with assistance from Evelia Magallon, in the design of exhibition spaces and oversight of many facets of construction and fabrication was essential to *Made in L.A. 2018*. Portland McCormick, director of registration and collection management, and her fellow registration staff, including Haley Di Pressi, Susan Chin, Jean-ha Park, Victoria Itaya, and Sheryl Nakano, were integral to securing loans for the exhibition and safely delivering works of art into the building. Chief preparator Jason Pugh, with assistant preparators Luke Whitlatch and Michael Terzano and their team of art handlers, worked with the artists on the installation of the artworks with great dexterity and care. Claudia Bestor, director of public programs, with Janani Subramanian and Alison Lambert, have worked closely with us to craft a rich variety of programs and events to accompany the exhibition. Justin Glasson, chief advancement officer, Veridiana Pontes, director of development, Curt Shepard, chief of donor relations and special projects, and the entire development team, including Laura Hyatt, whose excellent oversight of the Hammer Circle patron group has been critical, Hannah Howe, Julia Howe, Ariel Sehr, Shelby Ulisse, and Sara Friedman, provided essential support

through their wide-ranging fund-raising efforts. The communications department, overseen in the interim by senior communications and marketing manager Mitch Marr, followed by our new chief communications officer, Scott Tennent, implemented an extensive marketing and press outreach campaign; the full team, including Susan Edwards, Nancy Lee, Chisa Hughes, and Arielle Feldman, have done an outstanding job developing engaging promotional materials for the exhibition and overseeing all the press. Senior graphic designer Patrick O'Rourke and his design and production team, including Tara Morris and Lauren Graycar, developed a suite of creative and dynamic exhibition graphics and advertisements. Lindsay Martin worked closely with our store buying manager Brooke Berlin and store operating manager Sara Beattie to develop a truly special line of products designed by artists in the exhibition for our store. Jeff Williams, associate director of technology, Jim Fetterley, Tim Ferris, Brian Springer, Robert Loveless, Phon Tran, and the rest of the AV and IT staff oversaw the many complex audiovisual needs for the exhibition. Associate director of academic programs Theresa Sotto and her team, including Zoe Silverman and Olivia Fales, organized wonderful activities for families. Daniel Munoz, assistant director of security, with our entire security staff, diligently safeguard the works, while Lauren Coryell and Brittany Buchanan, with the visitor experience and gallery operations teams, manage the front-line staff and interface with the public on a daily basis. Henry Clancy, director of operations, oversaw the renovation of Gallery 6 and the Annex space to stage performances and programs, both reopening in time for the exhibition. We would also like to recognize the commitments of time and effort from our finance and administrative department, overseen by Michael Harrison, deputy director of finance, operations, and administration; Hilary Fahlsing, Jared Hammond, and Margot Stokol were always ready and willing to assistant with whatever needs came up. Additional organizational support was provided by Lisa Aubry, Breanne Bradley, Kelly Connors, Carlos Diaz, Shelby Drabman, Sarah Gnirs, Jorge Gomez, Margie Hill, Jen Ho, Dylan King, Ryan Lenhardt, Miriana Llamas-Cardenas, Libby O'Kane, and Nicholas Stevens. —AE and EC

Nancy Lainer
Shari Leinwand
Burt Levitch
Arthur Lewis and Hau Nguyen
Richard Massey
Delia and Jonathan Matz
Sarah and Joel McHale
Marla and Jeffrey Michaels
Marcy Miller
Angella and David Nazarian
Dr. Marina Ochakoff
Kelsey Lee Offield and
 Cole Sternberg
Phillips
Lee Ramer
David Regan and
 Edgar Cervantes
Lance Renner
Ellen and Edward Schwarzman
Susan and Kent Seelig
Alexandra Shabtai and
 Brent Bolthouse
The Shifting Foundation
Diane and Michael Silver
Julie Simpson
Sotheby's
Thaddeus Stauber
Rachel Tabori
Laila and Mehran Taslimi
Mimi and Warren Techentin
Pamela West
Lily Johnson White and
 Alexander White
Orna and Keenan Wolens
Ann Soh Woods and Mel Woods
Sonya Yu and Zachary Lara
Alissa and Jordan Zachary

LENDERS
The Box, Los Angeles
Alberto Chehebar
Commonwealth and Council,
 Los Angeles
David Castillo Gallery, Miami
Jeffrey Deitch
Mike De Paola
Allie Furlotti
Brett Green and Martha Jackson
Greg Hodes and Heidi Hertel
Heather and Theodore Karatz
Wanda Kownacki
Kristina Kite Gallery, Los Angeles

Joel Lubin and Marija Karan
Marianne Boesky Gallery,
 New York and Aspen
Frank Maurer and David Kobosa
Arty Nelson and Naomi Despres
neugerriemschneider, Berlin
Nino Mier Gallery, Los Angeles
Eileen Harris Norton
Park View/Paul Soto, Los Angeles
 and Brussels
Roberts Projects, Los Angeles
Johnny Roux
Carole Server and Oliver Frankel
Michael and Carrie Sherman
Sam Sparro
Roeg Sutherland
Tanya Bonakdar Gallery, New York
University of California, Berkeley Art
 Museum and Pacific Film Archive
Dean Valentine and Amy Adelson
Jessica Witkin
and private collections

SPECIAL THANKS
The Box, Los Angeles
Clockshop, Los Angeles
Commonwealth and Council,
 Los Angeles
Wendy Cromwell
David Castillo Gallery, Miami
Eve Fowler/Artist Curated Projects
Ghebaly Gallery, Los Angeles
Ryan Good
Kayne Griffin Corcoran, Los Angeles
Kristina Kite Gallery, Los Angeles
Thomas Lax
Marianne Boesky Gallery,
 New York and Aspen
Montblanc Cultural Foundation
John Morace and Tom Kennedy
John Mullican
Liz Munsell
neugerriemschneider, Berlin
Nino Mier Gallery, Los Angeles
Panel LA, Los Angeles
Park View/Paul Soto, Los Angeles
 and Brussels
Pilar Corrias, London
Pilar Tompkins Rivas
Roberts Projects, Los Angeles
Cole Root
Tanya Bonakdar Gallery, New York

REPRODUCTION AND GALLERY CREDITS

Every reasonable effort has been made to identify, contact, and acknowledge rights holders. If there are errors or omissions, please contact the Hammer Museum so that they can be addressed in subsequent editions.

All works are © the artist(s); most photographs are reproduced courtesy of the artist(s) and the owners or lenders of the materials depicted. The following list applies to those for which additional acknowledgments are due for facilitation of artwork loans (indicated by "Work") and/or supplying of photography (indicated by "Image"), as well as photographer credits.

11: Artwork © Jenny Holzer, member of Artists Rights Society (ARS), New York. Photo © Lisa Kahane, New York. Model: Lady Pink
13: Photo: Library of Congress/ Corbis/VCG via Getty Images
14: Video: Andrew Mutzabaugh
39: Photo: Aaron Farley
41, 42 (top right): Work: Courtesy the artist and Park View/Paul Soto, Los Angeles and Brussels. Photo: Jeff Mclane
42 (top left): Photo: Jeff Mclane
42 (bottom): Work: Courtesy the artist and Park View/Paul Soto, Los Angeles and Brussels. Photo: Brian Forrest
43 (top): Work: Courtesy the artist and Park View/Paul Soto, Los Angeles and Brussels. Photo: Cole Root
43 (bottom): Photo: Brian Forrest
44, 45: Work and image: Courtesy the artist; The Box, Los Angeles; and Brennan & Griffin, New York. Photo: Fredrik Nilsen
46 (top): Work and image: Courtesy the artist; The Box, Los Angeles; and Brennan & Griffin, New York. Photo: Naotaka Hiro

46 (bottom), 47: Work and image: Courtesy the artist and Brennan & Griffin, New York. Photo: Charles Benton
49: Photo: Mercedes Dorame
53: Photo: Allen Hansen
57, 59: Work and image: Courtesy the artist and Kristina Kite Gallery, Los Angeles
58: Work and image: Courtesy the artist and Antenna Space, Shanghai
62 (top): Work and image: Courtesy the artist and c. nichols project, Los Angeles. Photo: David Koizumi
63 (top): Photo: Trinie Dalton
65: Work and image: Courtesy the artist and Panel LA
67 (top): Photo: Craig Kirk
67 (bottom), 110, 170 (bottom): Work and image: Courtesy the artists and Ballroom Marfa, Texas. Photo: Alex Marks
69, 70: Work and image: Courtesy the artist and neugerriemschneider, Berlin
73: Work and image: Courtesy the artist and Nino Mier Gallery, Los Angeles
74, 75: Work: Courtesy the artist and Nino Mier Gallery, Los Angeles. Image: Courtesy Marlborough Contemporary, New York
78 (top), 79 (top): Image: Courtesy David Castillo Gallery, Miami
78 (bottom), 79 (bottom): Work and image: Courtesy David Castillo Gallery, Miami
80, 82: Photo © Phillip Maisel
83: Work and image: Courtesy the artist and Steve Turner Gallery, Los Angeles
85: Work and image: Courtesy the artist and Thierry Goldberg Gallery, New York
89: Work and image: Courtesy the artist and 56 Henry, New York
91: Work: Courtesy Artist Curated Projects, Los Angeles
94: Photo: Manuel Vason

95: Image: Courtesy Pitzer College.
Photo © Edgar Heap of Birds
105: Photo: Duane Cramer; courtesy
Slava Mogutin
106: Work: Courtesy the artist and
Luhring Augustine, New York. Image:
Courtesy New Museum, New York.
Photo © Simone Leigh
109: Image: Courtesy the artists
and New Museum, New York.
Photo: Fred Scruton
117: Work and image: Courtesy
the artist and Project 88, Mumbai.
Photo: Zan Wimberley
118 (top): Work and image: Courtesy
the artist and Project 88, Mumbai.
Photo: Andy Keate
118 (bottom), 119: Work and image:
Courtesy the artist and Project 88,
Mumbai
121, 122: Image: Courtesy Tanya
Bonakdar Gallery, New York
123 (top): Image: Courtesy the
artist and Tanya Bonakdar Gallery,
New York. Photo: Jean Vong
123 (bottom): Work and image:
Courtesy the artist and Tanya
Bonakdar Gallery, New York
126 (top): Photo: Charles Benton
127 (top): Photo: Aurelien Mole
129, 130 (top), 131: Work and image:
Courtesy the artist and Roberts
Projects, Los Angeles
130 (bottom): Photo © Museum
Associates/LACMA. Courtesy
the artist and Roberts Projects,
Los Angeles
134: Work and image: Courtesy
Kristina Kite Gallery, Los Angeles.
Photo: Brian Forrest
145, 146, 147 (top): Work and image:
Courtesy the artist and Marianne
Boesky Gallery, New York and Aspen
147 (bottom): Photo: Kevin Todora;
courtesy Dallas Contemporary
150 (top), 199 (top): Photo:
Gina Clyne; courtesy Clockshop,
Los Angeles
150 (bottom): Photo: Christopher
Wormald
151, 173: Photo: Ashley Hunt
154 (bottom): Photo: Stuart Whipps
155 (top): Photo: FD13, Minneapolis

158, 159, 160, 161: Photo: Tisa Bryant
165: Work and image: Courtesy
the artist and Ghebaly Gallery, Los
Angeles. Photo: Robert Wedemeyer
166: Work and image: Courtesy
the artist and Ghebaly Gallery,
Los Angeles. Photo: Andy Keate
167 (top): Work and image: Courtesy
the artist and Ghebaly Gallery,
Los Angeles. Photo: Jeff McLane
170 (top): Work and image:
Courtesy the artist and Paramo
Gallery, Guadalajara, Mexico City
and New York City
177: Image: Courtesy the artist
and Instituto de Visión, Bogotá
178 (top), 179 (top), 185, 187 (top):
Work and image: Courtesy
the artist and Commonwealth
and Council, Los Angeles.
Photo: Ruben Diaz
178 (bottom): Photo: Rogerio Canella
182: Image: Courtesy UCR
ARTSblock, Riverside, CA. Photo:
Nikolay Maslov
186: Photo: Sergey Illin/
PinChukArtCentre
187 (middle): Work and image:
Courtesy the artist and
Commonwealth and Council,
Los Angeles. Photo: Craig Kirk
187 (bottom), 191 (bottom):
Image: Courtesy the artist and
Studio Museum in Harlem,
New York. Photo: Adam Reich
191 (top): Photo: Texas Isaiah;
courtesy the artist and Studio
Museum in Harlem, New York
194 (top): Photo © Paula Court;
courtesy Whitney Museum of
American Art, New York
195 (bottom): Photo: Chiara Giovando
201: Photo: Kathryn Brennan

Published on the occasion of the exhibition *Made in L.A. 2018*, organized and presented by the Hammer Museum, Los Angeles, June 3–September 2, 2018.

Made in L.A. 2018 is organized by Anne Ellegood, senior curator, and Erin Christovale, assistant curator, with MacKenzie Stevens, curatorial associate.

The exhibition is made possible in part by the Mohn Family Foundation and members of the Hammer Circle.

Major support is provided by The Andy Warhol Foundation for the Visual Arts, the Vera R. Campbell Foundation, Eugenio López Alonso, the Offield Family Foundation, and Darren Star. Generous funding is also provided by Bill Hair, Dori and Charles Mostov, Mark Sandelson and Nirvana Bravo, The Fran and Ray Stark Foundation, and the Kerry and Simone Vickar Family Foundation, with additional support from the Pasadena Art Alliance, Emily and Teddy Greenspan, Stephen O. Lesser, and Kimm and Alessandro Uzielli.

Published in 2018 by the Hammer Museum, Los Angeles

10899 Wilshire Boulevard
Los Angeles, CA
90024-4201
www.hammer.ucla.edu

The Hammer Museum is operated and partially funded by the University of California, Los Angeles. Occidental Petroleum Corporation built the museum's building and established its endowment.

Distributed worldwide by DelMonico Books·Prestel

DelMonico Books, an imprint of Prestel, a member of Verlagsgruppe Random House GmbH

Prestel Verlag
Neumarkter Strasse 28
81673 Munich

Prestel Publishing Ltd.
14-17 Wells Street
London W1T 3PD

Prestel Publishing
900 Broadway, Suite 603
New York, NY 10003

www.prestel.com

Designer: Commonwealth Projects
Editor: Michelle Piranio
Proofreader: Dianne Woo
Director of publication management: Melanie Crader
Project manager: Courtney Smith
Project coordinator: Vanessa Arizmendi
Color separations: Echelon, Santa Monica
Printer: The Avery Group at Shapco Printing, Minneapolis, USA

The book is typeset in Visuelt, Druk, and Atlas Typewriter and printed on Cougar paper.

ISBN: 978-3-7913-5741-6
ISSN: 2334-3842